ASSEMBLAGE OF SPIRITS
Idea and Image in New Ireland

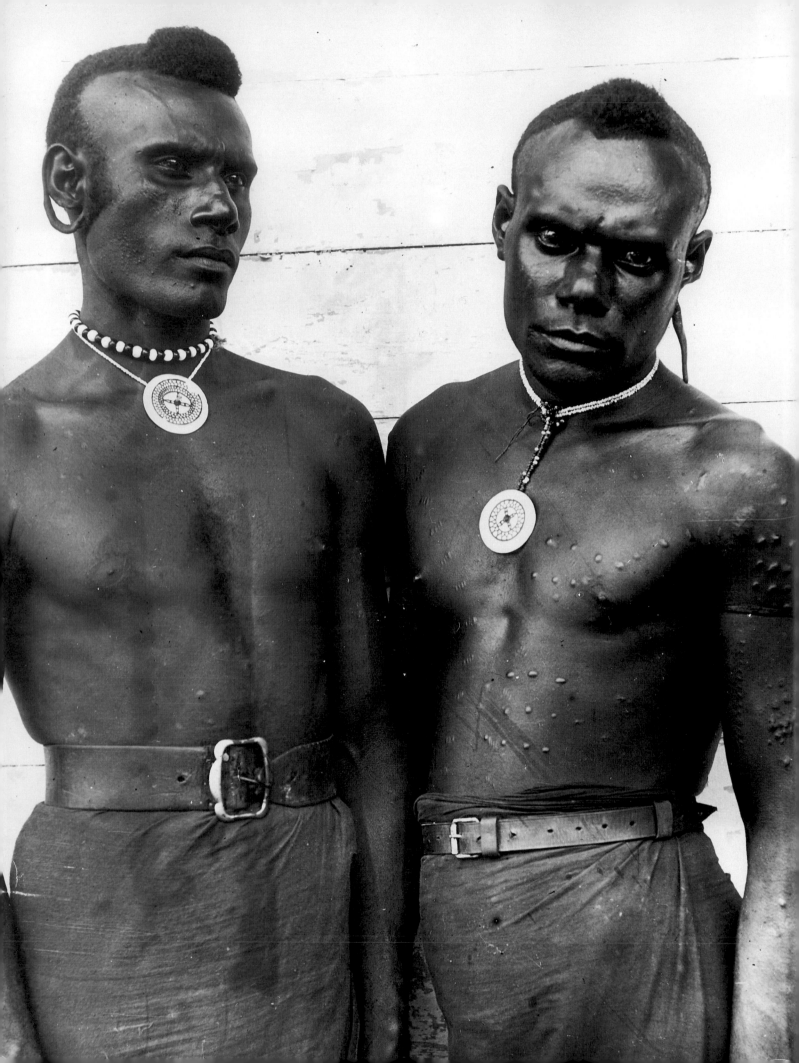

ASSEMBLAGE
OF
SPIRITS

Idea and Image
in New Ireland

Louise Lincoln

with essays by
Tibor Bodrogi, Brenda Clay, Michael Gunn,
Dieter Heintze, Louise Lincoln and Roy Wagner

George Braziller, New York
in association with
The Minneapolis Institute of Arts

EXHIBITION SCHEDULE

The Minneapolis Institute of Arts	October 10, 1987–January 3, 1988
The Brooklyn Museum	February 12–May 8, 1988
The Kimbell Museum, Fort Worth	June 11–September 4, 1988
The M. H. de Young Memorial Museum, San Francisco	November 23, 1988–February 19, 1989

First published in 1987 in the United States of America by George Braziller, Inc., New York in association with the Minneapolis Institute of Arts, on the occasion of an exhibition organized by The Minneapolis Institute of Arts.

 George Braziller, Inc.
 60 Madison Avenue
 New York, New York 10010

Library of Congress Cataloging-in-Publication Data

Lincoln, Louise.
 Assemblage of spirits.

 Bibliography: p.
 "Exhibition schedule: the Minneapolis Institute of Arts, October 11, 1987–January 3, 1988; Brooklyn Museum, February 12–May 1, 1988; Kimbell Museum, June 11–September 4, 1988; M.H. de Young Memorial Museum, October 8, 1988–January 1, 1989"—Copr. p.
 1. Sculpture, Primitive—Papua New Guinea—New Ireland—Exhibitions. 2. Sculpture—Papua New Guinea—New Ireland—Exhibitions. 3. Rites and ceremonies—Papua New Guinea—New Ireland—Exhibitions. 4. New Ireland (Papua New Guinea)—Social life and customs—Exhibitions. I. Minneapolis Institute of Arts. II. Title.
 NB1111.N44L53 1987 730′.933′6 87-15779
 ISBN 0–8076–1187–5
 ISBN 0–8076–1188–3 (pbk.)

15171

Designed by Gerald Pryor
Printed in Japan by Dai Nippon
First Edition
Major funding for this publication was provided by the National Endowment for the Humanities, a federal agency.

Cover illustration: Set of Wall Panels, Berlin, Museum für Völkerkunde, Cat. no. 5.

Frontispiece: Lajos Biró, New Hanover Men (Photograph courtesy of the Ethnographical Institute, Budapest)

Table of Contents

In memory of Tibor Bodrogi

1924-1986

Foreword

It is a great pleasure to present, for the first time in the United States, an exhibition of traditional sculpture from the island of New Ireland, a province of Papua New Guinea. These dramatic and beautiful works of art, associated with a complex ceremony known as malagan, have been brought together from numerous lenders throughout the world, and are eloquent testimony to the brilliance and inventiveness of New Ireland artists.

In their traditional use, malagan sculptures carried meaning in the moment of their creation and display, and thus were not always preserved long after the ceremony for which they were made. The drastic changes that have come to New Ireland and to the world in the twentieth century have made the materials of the past even more difficult to retain. It is thus almost by chance, by a quirk of history, that some of these works have in various ways survived. Many were collected by Europeans as curios, before Western eyes were prepared to recognize the artistic importance of their dynamic and expressive style. Although they have now come to rest in places distant from their birthplace, we can be grateful that they have been preserved, just as we can be grateful that the artistic heritage of New Ireland has not been diminished. New Ireland artists of the present and the future will undoubtedly continue to draw inspiration from their past, from one of the great artistic traditions of the world.

This exhibition came into being as a result of the initiative of Louise Lincoln of the Minneapolis Institute of Arts, who served as the coordinator of the project. We are grateful to her for the time, energy, and intelligence she expended in organizing the exhibition and this fine catalogue, the first comprehensive publication in English on the subject. It is our hope that this exhibition will encourage a wider understanding of this distinguished tradition, and of the ways that art has helped to perpetuate the complex patterns and ideas of New Ireland culture.

The Honorable Pedi Anis, M.P.A.
Premier, New Ireland Province
Papua New Guinea

Alan Shestack, *Director*
The Minneapolis Institute of Arts

Edmund Pillsbury, *Director*
The Kimbell Museum

Harry S. Parker III, *Director*
The Fine Arts Museums
of San Francisco

Robert T. Buck, Jr., *Director*
The Brooklyn Museum

List of Lenders

The American Museum of Natural History, New York
The Australian Museum, Sydney
The Brooklyn Museum
Mr. and Mrs. Loed van Bussel, Amsterdam
The de Young Museum, San Francisco
The Field Museum, Chicago
The Linden-Museum, Stuttgart
The Minneapolis Institute of Arts
The Museum of Cultural History, Los Angeles
The Museum für Völkerkunde, Berlin
The Museum für Völkerkunde, Hamburg
The Peabody Museum, Salem
The Übersee-Museum, Bremen
Dr. and Mrs. Jack Wallinga, Minneapolis

Acknowledgments

As a cooperative undertaking a museum exhibition is perhaps surpassed in complexity only by a malagan ceremony. Both require a massive pooling of financial resources, material goods, labor, and specialized knowledge. And in both instances, the successful accomplishment of the objective reflects well on the contributions of all participants. In organizing this exhibition we have received extraordinary assistance from many people and many institutions, and we hope that the completed project will do justice to the efforts of all who had a hand in its realization.

For their generous financial support we are grateful to the National Endowment for the Humanities which, having provided a planning grant at the early stages, renewed its commitment to the project with a second grant for implementation, and to the National Endowment for the Arts, which likewise provided funding for the exhibition.

Lenders to the exhibition, both institutions and private collectors, have enthusiastically supported the project, and have been as generous as the condition of their objects would permit. Because New Ireland sculpture is notoriously fragile, we have had to disallow many interesting and important pieces, but the lenders, who are listed elsewhere, are to be thanked both for their judiciousness and their generosity.

To acknowledge my many colleagues and friends at the Minneapolis Institute of Arts who have worked on various aspects of the exhibition would virtually require a list of the entire staff. The assistance of Karen Duncan, Associate Registrar, Mary Mancuso, Exhibitions Coordinator, Gary Mortensen, Photographer, and Mark Stanley, Media Producer, has been particularly crucial. I wish to call special attention to the efforts of Colleen Denney, Lia Hostetler, and Lynn Zecca, interns in the Department of African, Oceanic, and New World Cultures, who have attended to some of the least stimulating details of exhibition organization with intelligence and care. Bea Antholtz, Mary Brink, and Bob Rowlands deciphered many long passages from nineteenth-century ship logbooks, and the results of their work have helped to establish the early date of European presence in New Ireland. I am especially grateful to Michael Conforti, Chairman of the Curatorial Division; Timothy Fiske, Associate Director; and Alan Shestack, Director, who have provided unfailing support and encouragement throughout the project.

Scholars in this country and abroad have been generous with time and expertise. Philip Dark, professor emeritus at Southern Illinois University; Philip Gifford of the American Museum of Natural History; and Douglas Newton, Chairman of the Department of Primitive Art at the Metropolitan Museum, provided invaluable advice at early stages of the project. At the lending museums curators have patiently assembled information, documents, and photographs: Kathleen Berrin and Ellen Werner at the de Young Museum, San Francisco; Lissant Boulton at the Australian Museum; Victoria Ebin and Diane Fane at the Brooklyn Museum; John Grimes of the Peabody Museum, Salem, and the staff of the Peabody Library; Ingrid Heermann of the Linden-Museum, Stuttgart; Klaus Helfrich and Markus Schindlbeck at the Museum für Völkerkunde, Berlin; Belinda Kaye of the American Museum of Natural History; Phillip Lewis at the Field Museum; Doran Ross at the Museum of Cultural History at the University of California, Los Angeles; and Clara Wilpert of the Hamburgisches Museum für Völkerkunde.

Colleagues at many museums permitted me to examine works in their care; among these I am particularly grateful to Anton Claerhout of the Ethnographic Museum, Antwerp; William Davenport, University of Penn-

sylvania Museum; Jean Guiart, Musée de l'Homme, Paris; and Adrienne Kaeppler of the Smithsonian Institution. I also thank the many private collectors who made their holdings available for study.

Other scholars have given assistance in numerous ways. Elizabeth Brouwer of the Australian High Commission made the results of her extensive research in New Ireland available to me; Gabor Vargyas of the Ethnographical Institute, Budapest, has been most generous with information and photographs; and Eugene Ogan and Steven Gudeman of the Department of Anthropology, the University of Minnesota, have imparted advice and knowledge at crucial points. The insights of my husband, Bruce Lincoln, from a related discipline have elucidated numerous aspects of New Ireland art and thought.

I thank Chris Owen of the Institute of Papua New Guinea Studies both for his remarkable film *Malagan Labadama* and for his assistance in producing the videotape that accompanies the exhibition. George Braziller and his staff have executed a silk purse from a sow's ear, transforming a stack of manuscripts and photographs into a unified and handsome book.

The contributors to the catalogue, Brenda Clay, Michael Gunn, Dieter Heintze, and Roy Wagner, have not only permitted us to publish the results of their recent field researches in New Ireland, but have also freely shared their expertise in other ways, patiently reviewing the many works considered for inclusion and helping to place the materials in their appropriate context. Their varying approaches to the subject, and the remarkable depth of their knowledge, made for many stimulating and productive discussions. Marianne George shed much light on the obscure subject of girls' initiation houses in New Ireland, and her contribution appears in cat. no. 4. Before his untimely death in 1986 Tibor Bodrogi presented a manuscript based on extensive research and his access to the writings and notes of Lajos Biró, a Hungarian ethnographer whose observations on New Ireland are little known and of great interest. His daughter, Krisztina Kehl-Bodrogi, has kindly permitted us to publish his work.

The interest and support of the Premier of the Province of New Ireland, the Honorable Pedi Anis, and the New Ireland Minister for Mining, Commerce, Culture, and Tourism, Ferdinand Smare, are gratefully acknowledged. Finally, I wish to express my warmest thanks to my friends and teachers in New Ireland: Mandai Babai, Ezekiel Biang, Roger Dixon, Demas Kavavu, Langiri, David Lasisi, Ebes Palau, and Simion Sau, for their extraordinary hospitality, generosity, and wisdom.

Louise Lincoln
Associate Curator
African, Oceanic, and
New World Cultures

Fig. no. 7, detail ▷

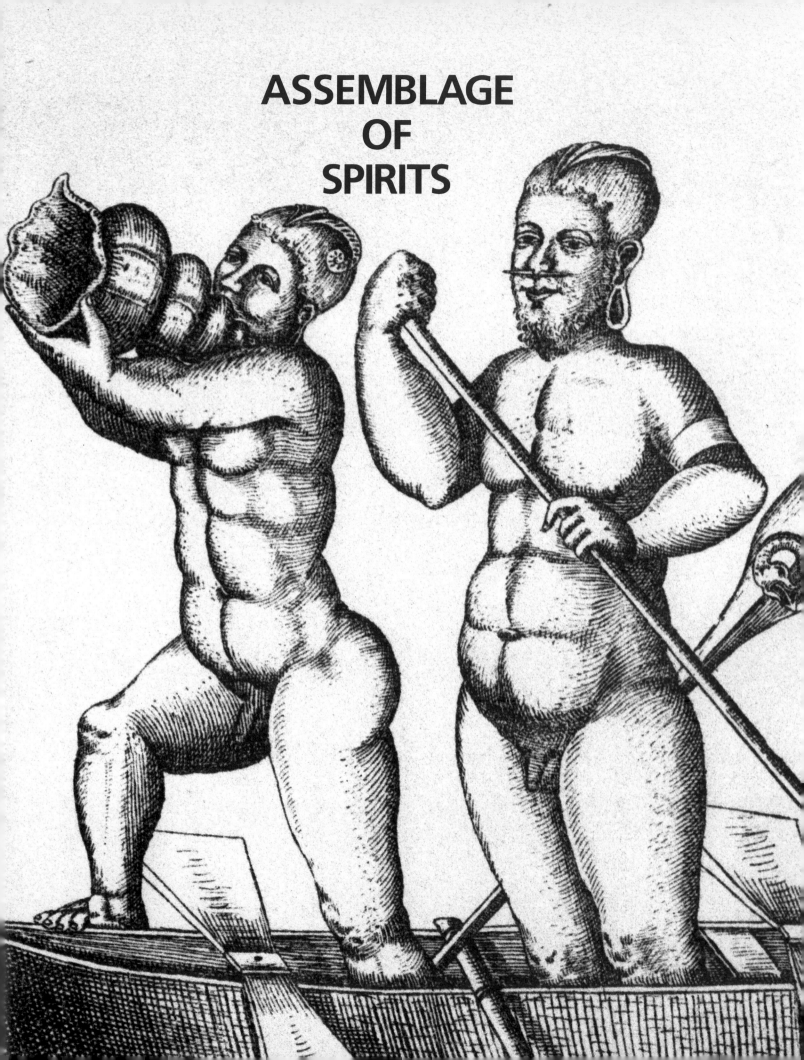

ASSEMBLAGE
OF
SPIRITS

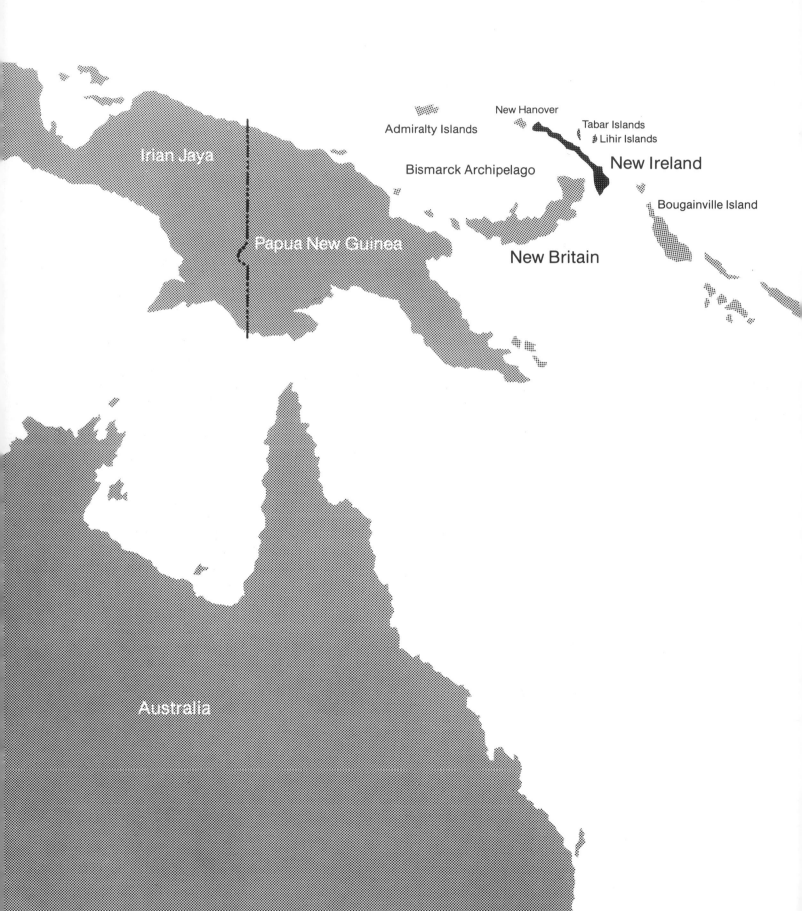

PACIFIC OCEAN

Irian Jaya

Admiralty Islands

New Hanover

Tabar Islands
Lihir Islands

Bismarck Archipelago

New Ireland

Papua New Guinea

Bougainville Island

New Britain

Australia

Introduction

Louise Lincoln

This book, and the exhibition it accompanies, are about the relationship of art and society on the Melanesian island of New Ireland. We have defined the project in the broadest possible terms, because such an approach seems to offer the best opportunity for those outside the culture to understand how art functions in a social structure very different from our own. Thus, while we hope to shed as much light as possible on the meaning and use of the various extraordinary art objects themselves, we also want to examine the nature, purpose, and effect of art production, the ways in which the making, the meaning, and the use of art objects relate to and reflect other aspects of social structure, history, economy, and patterns of thought.

Although the approach to the subject has been broad, however, the selection of subject matter has been rather restricted. In terms of art production, the island of New Ireland is frequently divided into three distinct areas of sculptural style. In the southeastern portion, small human representations are made in chalk, related stylistically to the material culture of the adjacent Gazelle Peninsula of New Britain. From the central belt of the island come the well-known, emphatically hermaphroditic *uli* figures. It is on the north coast, however, where the inhabitants produced and, in limited and somewhat altered fashion, continue to produce the complex masks and multi-figured poles most commonly associated with New Ireland carving styles. These objects are often referred to by the neo-Melanesian term "malagan" or its variants, a term which is also used for the ceremonial complex that dominates the religious and social spheres of the region. From among these three style areas, we have chosen to focus on the north coast, and the pieces in the exhibition are all related in one way or another to *malagan* practices.

To the Western eye, malagan art is forceful and disturbing. In earlier times it provoked much facile and ill-founded speculation about its makers: it was said to be the product of "feverish nightmares," of schizophrenia, of the darkest side of the unconscious. It is easy to reject such superficial characterizations, but it is considerably more difficult to make a more sophisticated interpretation of these works. In many instances the information available about New Ireland art is as baroque and as ambiguous as the pieces themselves. Although many aspects of culture are held in common among the people of northern New Ireland, there are significant differences as well. Language is one of these: there are seventeen distinct languages spoken on the island. Anthropological field reports, based on work done at different times and in different locations, do not present a coherent picture of New Ireland life and thought; they are, in fact, sometimes contradictory. The term "malagan" itself is variously spelled and defined; there are disputes in the literature about whether it refers to art, to ceremony, or to both. With regard to sculpture, there are radically different interpretations for apparently similar objects. Different terms are sometimes applied to the same object, and the same term may be used for two seemingly different objects. Shown a malagan sculpture, three knowledgeable New Irelanders may well offer three interpretations or refer to three different mythic sources. This confusion is frustrating to Western scholars, who prefer a tidy system of categorization. Despairing of finding the "correct" interpretation, they often conclude that knowledge is irretrievably lost or that informants have witheld the esoteric information that would open the way to a coherent scheme.

It must certainly be true, as Michael Gunn points out below, that much information is indeed lost. We

may be able to gather fragments of data—what kind of snake is represented by black and white bands, the name of a particular leaf in a painted pattern. But what these "mean" in a larger sense, or what certain elements may mean in combination, remains enshadowed. When the ceremony for which an individual sculpture has been made is completed, the immediate and specific context of the work vanishes. We cannot reconstruct the intended meaning of particular malagan configuration, which may have its source in the dreams of its creator. At the level of individual objects, we may never be able to achieve single, concrete interpretations.

At a broader level of meaning, however, we may identify highly significant themes and recurrent patterns. For example, New Ireland sculptors choose to depict a relatively small number of animal species and systematically exclude other logical possibilities. Snakes, birds, and fish predominate in the sculptures, and boars also appear; in contrast, many common fauna of New Ireland (lizards, crustaceans, dogs, turtles, insects) appear rarely or not at all. Such a distribution is neither accidental nor arbitrary. Rather, at one level of signification, the animals selected correlate to and encode important aspects of social structure. New

Irelanders order their society by categorizing people into two groups, or moieties, usually designated "Hawk" and "Eagle." Within each moiety people are further subdivided into clans, each of which is associated with a different totemic animal, nearly always a kind of snake, bird, or fish—the animals that appear most frequently in sculpture.

Such associations are not based upon some perceived resemblance between the animal and the people associated with it—that is, those of the eagle moiety are not so designated because they are assumed to be sharp-eyed or predatory. Rather, as Claude Lévi-Strauss has demonstrated, the divisions that separate animal species provide a convenient analogue to the divisions characteristic of human society: we are all humans, just as hawks and eagles are all birds, but one moiety differs slightly from the other, as eagles differ slightly from hawks. A system of animal categories has been adopted as a model that recognizes minute social distinctions among humans. Beyond this social level of signification, snakes, birds, and fish also have a cosmic reference, by virtue of their association with earth, air, and sea respectively. These animal images imply that the divisions of society are as immutable as those of natural order.

Within this vocabulary of animal forms, moreover, certain themes and images recur with great fre-

Fig. 1. Horizontal frieze, Northern New Ireland. Museum für Völkerkunde, Hamburg.

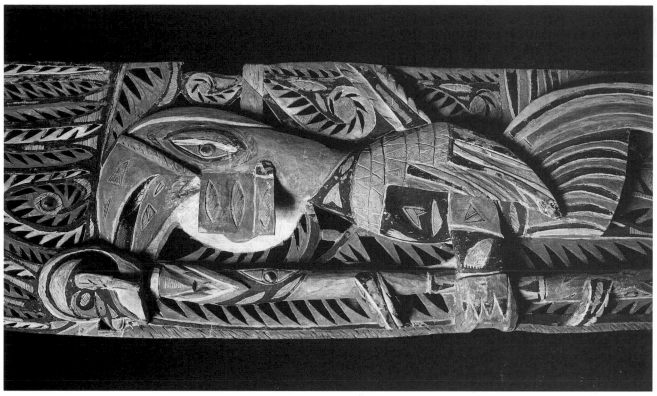

Fig. 2. Horizontal frieze, Northern New Ireland. University Museum, University of Pennsylvania.

quency. Among the most common are a bird and snake engaged in struggle and a fish swallowing a human (or sometimes a bird). These often have stories attached to them, of varying content. Yet in all instances, at a deep structural level, they depict the opposition of cosmic categories. Snakes and birds are thus a way of talking about the contrasted nature of earth and air; fish and humans are a way of talking about water and land. Struggling or swallowing, although it could be interpreted as conflict between cosmic realms, seems more probably to suggest transition or mediation between two forms, a literal incorporation of one into the other.

This brings us to a third notable characteristic of New Ireland art: an overwhelming motivation to depict transformation, reversal, and ambiguity. The common motif of a fish with broad lateral fins can just as easily be read as a bird with a fishlike head. There are many examples of birds with human ears, hands, or feet. A horizontal frieze in the collections at the Museum für Völkerkunde, Hamburg (fig. 1), bears such a close resemblance to a frieze from Stuttgart (cat. no. 38) that attributing both to the same hand seems reasonable. According to New Ireland infor-

mants, the basic form in each case represents a bat. The Hamburg example shows the animal head clearly: the eyes at the sides of the head, the pointed jaws. The feet, however, are those of a human. And although the two works resemble each other so closely, in the Stuttgart frieze the head has been translated very subtly into a human one: the eyes have been moved to the upper surface, a small mouth had been added, and the jaws have become a beard.

A further example of transformation and reversal can be found at the University Museum in Philadelphia. A frieze (fig. 2) shows a bird bearing in its mouth a dance ornament in the form of a human head—a variant of the normal model of a man holding a dance ornament in the form of a bird head. Such inversions were among the qualities that attracted Surrealist artists to New Ireland sculpture, for they saw in them the same kind of visual puns that populated their own work. Yet several of these ambiguous or shifting works in the exhibition clearly indicate that something far more sophisticated is at work.

Let us take the fragmentary frieze from Bremen (cat. no. 43) as an example. At first, the ambiguity here seems to be one of the more common ones in

New Ireland art: are the small creatures that make up the latticework birds or flying fish? But there is another layer of meaning: the creatures themselves are arranged in a fashion to suggest a fishnet, which is held by the human figures at either end. They are simultaneously container and thing contained.

A still more striking instance can be found in the large representation of a filleted fish (cat. no. 35). At first glance the body of the fish appears to be a splayed fish skeleton, reminiscent, perhaps, of the similarly skeletal treatment sometimes given to human torsos (for example, in cat. no. 24). But, as an informant in New Ireland pointed out to me, fish bones do not really look quite this way. He explained that the carver was also alluding to the leaf of the coconut palm, and further noted that these two images had to be thought of together—the dead fish and the living plant—for the piece is not simply a representation of one or the other, but, rather, deals with the relation, the unexpected unity of the two.

I do not mean to suggest that these comments were the definitive interpretation of the piece; indeed, another New Irelander merely described it as "fish bones." A sculpture may, as we have suggested above, be deliberately ambiguous; it may represent several stories overlaid, or it may even have different meaning and implications for different people within the group for which it was made, depending on the individual's age, sex, or degree of knowledge of malagan practice. As Roy Wagner discusses in his essay below, these pieces both contain and elicit meaning. Malagan sculptures, like other cultural manifestations, contain broad cultural meaning even as they evoke a variety of interpretations among their audience. For all that they may have in common with the responses of others in the group, these responses are based on individual factors. But one must always consider the full range of interpretations that these pieces elicit, as Dieter Heintze points out with regard to both myth and malagan sculpture.

A large horizontal frieze in the exhibition (cat. no. 46) bears at one end an animal that looks like a lizard. In New Ireland, however, everyone who saw a photograph of the work agreed that it did not show a lizard, but a snake. My objection that the animal had feet provoked much discussion, and ultimately was resolved by the explanation that it was a *masalai* snake—a snake associated to malevolent spirits—that had acquired attributes of another species. It might resemble a lizard superficially, even deliberately, but it was in fact something very different. That ability to transform—to combine and contain aspects of two different forms—is what gives the image and the idea of the *masalai* snake its power: in Wagner's Barok term, its a *lolos*.

If, as we hypothesized above, the representation of animals offers a way of talking about categories of human social structure, one might further propose that the creation of liminal animals (those with mixed attributes) is a way of talking about the relationship of the categories themselves. A system of categories may "work," it may seem to offer an adequate description of reality, but it is never as subtle or as complex as reality itself. Even if one insists that categories of whatever sort are distinct and clearly demarcated, one must also recognize that categories also overlap or flow into one another—that they are, in Lévi-Strauss's term, "chromatic." Thus, an animal that overlaps or confuses the neatly ordered categories of an animal taxonomy—a *masalai*, that is—reminds one of the richness and complexity of an existence that defies simple classification. Rather than functioning as signs in a semiological sense, malagans are instead invitations to speculation, as is suggested by the theme of ambiguity.

In their spectrum of meaning and implication, malagans are perhaps not unlike the term "malagan" itself, the meaning of which, as we noted above, is not so much elusive as it is elastic. Indeed, like malagans it continues to change over time; the term is now applied to sculptures made to decorate Christian churches in New Ireland, and Dieter Heintze has reported that in Fisoa the term was applied to his tape recorder, a rich usage implying concepts of retention of history or encoding of the past. The word, like the objects, accrues new meanings over time.

It is easy to assert that malagan sculptures and ceremonies are "about" many things at once. Indeed, it is because they impinge on so many aspects of life and thought that we have sought such a diversity of approaches in the following essays. Malagans are about the memory of the deceased, about families, hierarchies, power, and social organization. They are about the maintenance of social order and networks of interdependence; they are about myth and history, the economic status of their owners, about aesthetic preferences and cultural change. And at their most abstract level, they are concerned with philosophical speculation of a very high order; mirroring their own most visible characteristics, they are about complexity, subtlety, and change.

New Ireland Art in Cultural Context

Tibor Bodrogi

Although Spanish seamen probably sighted the island in 1595, the Dutch navigator Jacques le Maire, who in 1616 navigated along the eastern coast of the island, is generally considered the discoverer of New Ireland. But neither he nor subsequent explorers, including Abel Janszoon Tasman and William Dampier, understood that the land they had found was an island. Some 150 years after le Maire's discovery, Philipp Carteret sailed into the waters Dampier had called the Bay of St. George. ". . . [H]aving now ascertained the supposed bay to be a Streight," he wrote on 11 September 1767, "I called it Saint George's Channel, and to the northern island I gave the name of Nova Hibernia, or New Ireland."[1]

In the century following Carteret's voyage, the island was only rarely visited by seamen-explorers sailing around the world, but it was a fairly well-frequented port of call for whalers, labor recruiters, and traders. The colonization of the area by Germany in 1885 marked the beginning of intensive commercial and missionary activity. By the early twentieth century, European plantations had been established, especially in the northern regions of the island. At the beginning of the First World War, Australia took over the administration of the island from Germany. In 1920 New Ireland became part of the Mandated Territory of New Guinea, with Kavieng as its seat. The process of cultural change that started with European contacts culminated in the battles of the Second World War. Today one finds only remnants of the old indigenous culture.

New Ireland is the second biggest island in the Bismarck Archipelago, which is situated in the northern part of Melanesia.[2] The island, stretching in a northwest-southeast direction, is 470 kilometers (295 miles) long and has an area of about 8,000 square ki-

lometers (about 3,090 square miles). The heavy rainfalls and the moist and hot climate, as well as favorable soil conditions, are conducive to the tropical rain forests that almost cover the island. Grassy plateaus occupy the less fertile areas. Deciduous forests with lianas and orchids are the dominant vegetation. There are few mammals: apart from pigs and dogs, only small marsupials inhabit the woods. The scarcity of mammals is offset by a wide variety of birds and by many different kinds of reptiles and sea animals, whose different species not only contribute to the local diet, but also play a part in social and cultic life.

New Ireland is not well-known ethnologically. The first systematic studies were made during the survey voyages of the man-of-war *Möwe*, by Emil Stephan. Stephan sketched the ethnography of South New Ireland in 1904, and, following him, between 1907 and 1909, the members of the Deutsche Marine-Expedition carried out investigations, with E. Walden exploring the north, A. Krämer the middle areas, and O. Schlaginhaufen the south and the southern offshore islands. The writings of these men provided the foundations for our present knowledge of the inhabitants' culture. German missionaries, in particular G. Peekel and K. Neuhaus, furnished additional ethnographic research between the two world wars. In the 1930s the Swiss A. Bühler carried on investigations chiefly in the northern region. Studies with a functional approach were conducted by Hortense Powdermaker in Lesu, on the northeast coast, by W. C. Groves in the Tabar Islands, and by F. L. S. Bell on the Tanga Islands further to the south.

Because this work was done in various areas, at various times, and in different ways, it is doubtful whether cultural patterns can be established within a given area. Any analysis of the art of this out-of-the-

way Melanesian island remains necessarily incomplete. It is clear, however, that the complex of rites carried out at the time of death are central to the social and aesthetic life of the community.

MALAGAN

Throughout New Ireland funerals and the subsequent memorial festivities for the deceased are occasions that concern not only the family but the larger social units as well. There is every justification for F. L. S. Bell's statement, made in connection with the inhabitants of the Tanga Islands, that "With these people death is the Leitmotif of their culture and their mortuary rites, which last for years and have endless social repercussions, are undoubtedly the most culturally satisfying and sustaining elements in the native life."[3] Of Fisoa, on the northeast shore, W. C. Groves wrote that in order to give a full description of the mortuary rites, the entire culture would have to be sketched, for "every other item is in one way or another bound with, dependent upon, preparation for, or outcome of this one dominating cultural influence of malagan."[4]

The complexes of rites connected with the mortuary festivities make it possible to reduce the fundamentally unified culture of New Ireland to its components and to distinguish in its cultural and style units. This study will concentrate on the malagan style district, which includes the part of New Ireland north of the Hamba-Panaras line, including New Hanover, Djaul, and the Tabar Islands.

The term "malagan" has a dual meaning.[5] It is the name given to the memorial festivals held in honor of the deceased; it also applies to the carvings and various representations made for these festivals. Malagan is, then, everything connected in some way with these mortuary rites for the dead and generally with religion.[6] They fulfill three essential tasks. The religious function is foremost, for religious concepts were the most prominent in the development of the festivities and the objects of art connected with them. Essentially, these festivities are part of an ancestor cult. In addition to commemorating of the dead, these rites facilitate the departure of the soul from the world of the living.

The concept of the soul in New Ireland is extremely complex and not fully understood by outsiders. Available sources suggest that in the New Irelander's view, an individual has three different kinds of soul. The life-principle is represented by the body-soul principle called *tatanu* or *tanuato*. This can be found everywhere in the body, but particularly in the head. This soul remains close to the body after death. Some of the procedures with the skull and bones indicate that it is invisible but in some way still part of the body. The second spirit could be called the breath-soul, for it leaves the dying person through the mouth. It seems in some way related to the *masalai*, the animal that inhabits a specific piece of land or sea held in common by a clan. After death it moves into the subterranean land of the dead. The third soul, the *ges*, is a ghost-like spirit living in the *masalai* places, and is considered to be an individual's double and perishes at death.

The soul, then, would seem to leave the world of the living and move to its final place of accommodation with the completion of the mortuary rites held in its honor. We know from Bühler's information that the explicit purpose of these festivities is "to be done with the dead," that is, "to let us forget the dead and allow them to enter the realm of the dead."[7] At the same time, portrayals of deceased people for whom the rites have already been held are included in the ceremonies. Further, the young men's initiation is also linked with the malagan rites. Thus, although the ceremony's purpose is to get rid of the soul, there is also some wish to maintain contact with it. The social and economic functions which later became attached to these ceremonies ensured their continuity. As was convincingly shown by M. F. Girard in his paper on the problem,[8] the malagan festivities provide opportunity for the moiety (or two marriage classes)[9] and especially the clan, whose members are scattered over several villages, to act as a unit. This affirms their solidarity and so ensures survival.

The festivities contribute to social integration by large-scale economic means as well. The provision of the food and the payment of all the shell money spur each clan to joint effort. Because spending is a measure of prestige, malagan festivities stimulate the economy. They press the members of the clan to produce more than is directly required for subsistence in order to increase the clan's prestige. All this promotes more intensive activity, not merely by the clan concerned, but also in the larger economic units and production structures, because contact between the individual clans gives rise to a certain reciprocity between the groups: the clan which sells on one occasion may be purchaser the next time, and the supplier of food or services may soon change into the party which places the order.

Although the historical background of the malagan rites has not been established, some evidence suggests that the offshore islands of Tabar were the place of origin. H. H. Romilly, who was the first to write about these islands, reported in 1883 that here "are carved the most fantastic and extraordinary of the idols

which occasionally find their way over to New Ireland."[10] In the early 1930s W. C. Groves was told by the best carvers and the most reliable "big men" that his questions about malagan could be answered only on Tabar.[11]

THE FUNERAL

In the northern areas the rites connected with the deceased consist of two major phases. The first of these begins with the death and lasts until the end of the mourning period. The second is the phase of the memorial ceremonies, the malagan rites proper.

When death is close at hand, the dying person is carried to the house of his or her parents or children, who, with the spouse, look after the sufferer. All dances are stopped in the village and the relatives begin to gather the food for the funeral feast. When death occurs, the lamentations begin. In addition to the immediate family of the deceased, clansmen and the villagers participate. The relatives of the deceased paint themselves black. The wailing is interrupted by the washing of the body by those of the same sex but opposite moiety of the deceased. The body is then taken either to the men's house or to its own house and is laid out in festive wear on a flower-decorated mortuary chair with a high back and sides. Horizontal sticks are tied on to hold the body erect and prevent the head from dropping forward. The wailing continues by the bier, and in the meantime the clansmen arrive from the more distant villages. Depending on the age and prestige of the deceased, the period of mourning may last for three days while preparations are being made for the funeral festivity. The bereaved relatives abstain from certain foods when the death occurs and resume a normal diet only at the conclusion of the entire ceremonial cycle. The guests stay in the hamlet where the funeral takes place, each house accommodating either only men or only women, for during the period of the funeral and mourning, sexual intercourse is forbidden. If the deceased was very old, dancing is part of the rite: each night until the funeral there is dancing from dusk to dawn, the entire community participating. Men and women dance separately. During the daytime the feast is organized: the women get taro ready, the men prepare pigs and fish.

The funeral procedure differs with geographic location. North of Fisoa and in the Nusa Islands, the dead are cremated. In the region between Fisoa and Hamba, interment is usual. In New Hanover and the Tabar group several forms coexist: cremation, interment, and burial at sea (casting the corpse into the water or setting it adrift in a boat), probably depending on whether the deceased belonged to the snake group (interment) or shark group (casting into the sea). In some areas a second funeral is customary following cremation or decomposition of the body; at that time the remains or exhumed bones are thrown into the sea or deposited in some remote place.

In the case of cremation the body is taken together with its chair to the place of cremation and is there burned on a pile of dry coconut leaves about one or one-and-a-half meters high. Where the dead are not placed on biers of this kind or burned separately, as in Tabar, faggots are placed between two long tree trunks, the body is placed on this pile and covered with twigs, and the pyre is lit. After it has burned down, the main bones are picked out and preserved in a cover of leaves in the house. This bundle is held by a woman during the malagan rites and is also used for magical purposes.

If interment is practiced—this was the case in Lesu, as we know from Powdermaker[12]—the deceased is placed in a coffin, usually an old boat whose stern and prow have been cut off. The corpse is carried in the coffin to the cemetery by the members of the opposite moiety. At this point the wailing reaches its culmination. The coffin is lowered into the grave and the pit is filled in, and here the lamentation ends. An earlier custom was to choke the widow after her husband's death, the act carried out with a rope by two men belonging to the widow's moiety, generally her classificatory brothers (who are not blood brothers but called "brothers" by her) or by her sons.

Women stay outside of the cemetery and men inside during the funeral. The distribution of the food that has been prepared begins in both places. The man who provides the feast—a close matrilineal relative of the deceased[13]—gives a short opening speech saying that the festivity is held in honor of the person who has just died. Neither the closest clansmen and women, the sponsors of the festivity, those who pay for it, nor the husband participate. At the end of the feast the men leave the cemetery, and the sponsors of the festivity hand out the payments. Payment is given to the owners of the pigs consumed at the feast, to the dancers, and to the coffin bearers. Payment is in strings of shell money, and the person who distributes it shouts the name of the recipient and the reason for the compensation.

In the mourning period that follows the funeral, close clan relatives stay at the hamlet. Sexual abstinence is maintained and the food restrictions also remain in effect. At the end of the mourning period the taboos are lifted and a feast is held.

19

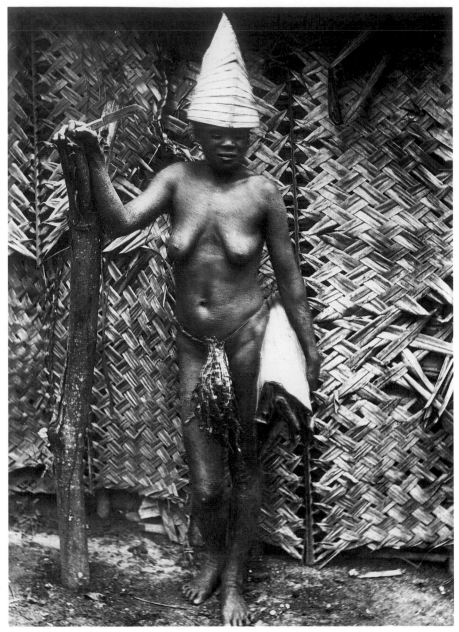

Fig. 3. Rudolf Festetich: Aboriginal woman, Naking, New Hanover (Photograph courtesy of the Ethnographical Institute, Budapest).

Groves's description of the rites of the mourning period in the more northern Fisoa differ somewhat from Powdermaker's Lesu data. In Fisoa, a pig is killed after cremation of the body, and the mourners cleanse their hands with the ashes. This marks the beginning of the so-called *hot* period. Two months after the cremation the mourners remove their distinctive skin paint as part of a feast for which a small number of pigs is killed. The bereaved retain only the black paint of the hair. The concluding festival takes place when the taro crop is ready for the harvest on the land of the deceased. Then six to eight pigs are killed. The inhabitants of nearby settlements are invited for the feast, prepared by the relatives of the deceased.[14] Before the feast there is the usual ceremonial payment for the food. Then the eating and dancing begin. Later the dancers receive a payment for their performance, too.

The dance lasts until morning, and in the meantime, as Walden writes, there is considerable sexual freedom: the men from other settlements have inter-

course with the women of the community giving the feast, and the men of the feast-providing villages do so with the visiting women—probably adhering to the rules of exogamy according to moiety and clan.[15] This feast closes the *bot* period, and now the mourners may wash their hair and whiten it with lime.

The purpose of the first phase is to remove the deceased from the living in the physical sense and to give vent to the emotions connected with death. Accordingly, parts of it stress getting attuned to the state of mourning and then the gradual abandonment of mourning.

In their social content, the rites express the clan and moiety allegiances of the survivors. Clan affiliation is expressed through the tasks connected with burial and the payment of the expenses; care and handling of the corpse are duties assumed by members of the opposite moiety. Entering a state of mourning is manifested by the food taboo and sexual abstinence, and is expressed visually by body paint.

THE MORTUARY FESTIVAL

The mortuary festival is held several months, and sometimes several years, after death. Its purpose is to free the living from the soul of the dead and to enable the deceased's spirit to acclimate itself to the world of the dead. The time of the feast depends on the financial circumstances of the clan sponsoring it. As the expenses are very high, a single feast is usually held in tribute to several deceased people. The festive presentation and unveiling of the malagan figures representing the dead are always in the center of these festivities, which generally consist of two parts. The first part is devoted to the ritual making of the malagan figures. The second concerns the ritual presentation of the malagans, closing the entire mortuary cycle. This is the occasion for ceremonial compensation of all services rendered.

The several types of malagans are owned by some respectable, old, male member of the clan, but anyone in the clan has a right to make use of them. This "ownership," which attaches to the form of the malagan and the know-how of the connected rites, actually constitutes a kind of copyright. For when the license is sold, not the figure itself but the description of the form and associated rites are made available to the purchaser. With the sale of the copyright the earlier owner is deprived of all rights to make the type sold or to present the rites. Payment is made during the closing festivities.

When the date of the malagan festivity has been decided, the taro intended for the feast is planted, and various related magic practices are performed some ten months in advance. The owner of the malagan commissions a carver to undertake the sculptures, explains the design, and exerts further control over the work. The commission may take several months, depending on the number of figures ordered.

Krämer provides the most detailed description of the various phases of the carving, based on observations of the same area later studied by Powdermaker and Lewis.[16] The work starts with the felling of the trees needed for the carving, an activity in which men from the neighboring villages also participate. The logs are taken to the workplace by helpers, who are then paid in shell money for their services. In the ensuing days the bark is stripped off the trunk and the wood is dried in the sun. On the seventh day after the beginning of the drying procedure, the modeling begins with an accompanying smaller feast consisting of pork and taro. A few days later comes the piercing of the wood, which is attended by spectators who pay the carvers. The nearly finished carvings are put on the roof-beams of the communal men's house and dried for about two months over a continuous fire.

The next phase is the "deposition" from the roof-beams and the final polishing of the carvings, attended by a feast. Next an enclosure is made for the malagan. With the help of men from the neighboring villages this is accomplished in a single day. On the following day sea-snail valves are placed into the eye sockets of the figures. With this the work of the carving has come to an end, and the painting begins. The colors are applied to the wood one after the other. The preparatory phase closes with the building of the structures that will display the malagans. The closing begins with dance rehearsals on the first day and then, on the second day, dancing in front of the malagan house, the house of the sponsors of the festivity, and finally in front of the houses of others. In their mouths the dancers hold carved figures depicting the heads of hornbills. Finally, a man with spear in hand pays the owners for all the pigs slaughtered in the course of the festivities.

The malagan enclosure is an oblong area surrounded by a bamboo fence several meters tall. The entrance is located in the middle of one of the narrower sides, with a forked branch facilitating entrance in front of it.[17] The square is separated roughly into three parts. Opposite the gate stands the malagan house, in some places with an adjoining hut for the accommodation of the masks. In the center, or along the longer sides, there are conical containers for holding the taro, sometimes a stand for the pigs, and opposite the malagan house rises a guest house.

The form of the display house varies according to the figures to be put in it. Some of them are low structures open in front for showing the statues, and there are others that are several meters high, partitioned off into two parts with a mat wall on which horizontal friezes or long poles are placed. The malagan enclosure is near the cemetery and may even surround the graves themselves. Bühler describes a malagan enclosure in Tabar in which four women and a child were buried. The four statues in the malagan house (one of them presented two figures) depicted the deceased.[18]

An early report from Kapsu mentions a malagan enclosure of labyrinthine character. The corridors of the maze were made of wicker and were so low that one had to crawl along them on all fours. The display house contained six or seven figures, each about three or four feet tall, a great many little carvings of birds and fish, and some half dozen tatanua masks on a shelf.[19]

The closing festivities of the mortuary cycle, held at the presentation of the malagan figures, vary. Specific features probably depend on the prestige of the deceased and on the kind of malagans to be displayed. A festivity on the island of Tatau in the Tabar group, according to Bühler's account,[20] took place as follows:

The village is quiet. In the malagan enclosure, a few men are busy with the preparation of five pigs killed by choking. At about eleven o'clock a sharp scream is heard which drives everybody into the houses. Six masked men advance from the woods and march through the village in bold leaps. With their movements and their dress made of leaves they seem to imitate birds. This group is followed by another ensemble of masked men in wooden and bark masks and armed with spears. The masked men go from house to house claiming gifts. They share their loot at an out-of-the-way men's house and then, divesting themselves of the masks, they appear in the malagan enclosure. At about noontime, following a signal by a slit drum called *garamut*, the men go to the malagan enclosure, where roast pigs already lie next to the big mounds of taro. After another signal by the drum, the organizer of the festival, an old man, touches one of the statues standing in the malagan house and, with a few strings of shell money in his hand, declares that he has arranged the festivity and is now paying for it. He calls out loudly to the dead, showing the shell money and the piled-up food. An intermission follows, after which six men measure the pigs with a string of shell money and pay the owners for them. The feast begins. The best parts of the pigs are laid for a short time under the feet of the malagan figures. What food remains after the feast is taken home by the peo-

ple. The drum is heard once again, marking the end of the festivity, and then the guests, laden with food, don their masks and leave the village.

Another ceremony, which took place in Logagon, along the northeastern coast, was described by Powdermaker.[21] On this occasion the sponsors purchased the malagan pattern and the attending rites from Lesu, and consequently people from Lesu took an active part in the ceremonies.

The rites began outside the malagan enclosure, with two men in grass skirts and plumed headdresses representing the *ges* spirit coming out from the bush into the open square and shaking shell rattles. Catching sight of them, those present went into the malagan enclosure where the still unpainted malagans stood. After this the dancers presented their program. They all wore plumed headdresses and held bird beaks in their mouths. The dancers represented birds perched on the coral reef and on the lookout for sharks. The feast followed the dance, men remaining inside, women outside the enclosure. In the meantime, strings of shell money were given to the earlier owner of the malagan, and it was explained why the payment was made. For a few days after the preliminary rites everybody was busy with the preparation of the principal affair. Early in the morning the women went into the gardens, where they remained until late in the afternoon or evening; they began the dance rehearsals at sunset. The men were engaged in making masks and costumes and in dance rehearsals. Four days later, in the late afternoon, the drum was beaten, and the men went to the malagan enclosure to partake of a small feast. The malagans were already removed from the enclosure. After the feast the man who had sold the malagan pattern delivered a speech and received a gift of shell money, as he had complained of insufficient payment. Then the festivities resumed. Again food was distributed among those present. While they were eating, a man stood up and announced that the closing rites would be held five days later. Then an old man addressed those present, praising past times; walking around in a circle, he touched the pigs with his spear and mentioned the names of all those who helped to defray the expenses of the malagan.

Three days later the painted malagans were set up in the house erected within the malagan enclosure. This was again attended by a smaller feast. Again shell money was handed to the person who sold the malagan, who shares this payment with fellow clansmen. The next day was spent in preparation of the food for the final feast. In the evening men, women, and children participated in collective dance. The next

afternoon the dance continued as part of the rites, but on this occasion men and women performed their dances separately. After the dance food was distributed, but this time the food was taken home rather than eaten immediately. The festivity had now ended for the inhabitants of Logagon; the people of Lesu were expected to perform an additional rite upon their return home. Two days after their homecoming they cleaned the house in which they had carved the malagan for the festivity in Logagon. The house-cleaning was followed by a feast and then a speech in which the speaker reported on the events, the rites, and the payments received. With this the festivities closed for both villages.

Bühler's account, supplemented by data from other researchers, provides the essential features of the

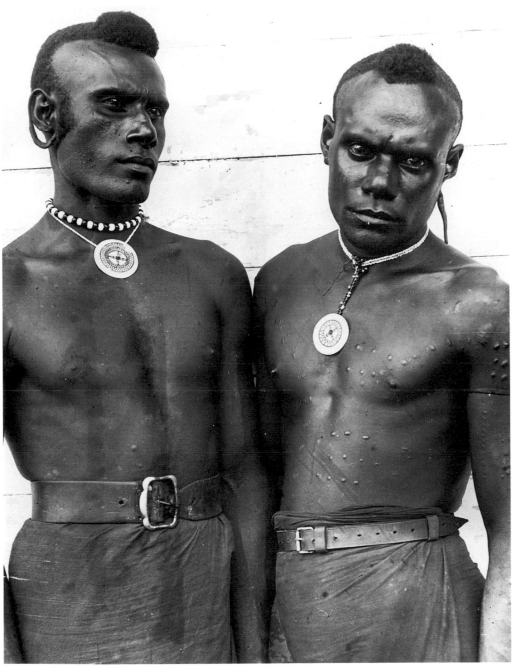

Fig. 4. Lajos Biró: New Hanover Men (Photograph courtesy of the Ethnographical Institute, Budapest).

closing ceremonies. The malagan figures, each of which represents someone deceased, obviously play a central part at the mortuary festivities. The ceremony is attended by the spirits in the form of the masked figures, who usually present a dance as well. These masked figures are called *tatanua*s. That this word and the name of the life-soul that leaves the body at death are identical indicates that the spirits of the dead are thought to participate in the festivity. Dances are another characteristic feature and often represent the struggle between birds and snakes in pantomime. The dancers impersonate the birds by holding bird heads or carved bird figures in their mouths; those supposed to be snakes wear masks bearing snake designs.

The ceremonial public presentation of payments is another important part of the festivities. As mentioned above, the bundle of leaves containing the major bones of the deceased, which are cast into the sea or deposited at some remote spot in the woods at the conclusion of the ceremony, are temporarily laid in front of the carving. This seems to mark the definitive end to all action connected with the dead: the funeral removed the dead physically from the world of the living; now the soul has also been situated in a new context.

Malagan figures are made and presented not only for mortuary festivities, but also in the initiation of boys. Initiation consists of two parts, the first connected with the circumcision and seclusion of the boys, the second linked with the display of the malagans. This close correspondence between the rites of entering life and departing from it is not surprising. Initiation into religious mysteries and a sense of connectedness with the ancestors are regularly an important part of the initiation of young men. It seems only logical that the malagan rites, so closely connected with the dead ancestors, would be employed to achieve this link of past and future. Groves's account of Tabar ceremonies suggests such a relationship with the ancestors.[22] There the boys are removed from their accustomed environment for a duration of time in which they are ritually "dead," and after their seclusion masked *murua* figures, representing certain deceased ancestors, enter the malagan enclosure carrying the initiated boys, called *dzafunfun*, under their arms. Lewis sees the initiation ceremonies for young men as equal in significance to the final rites arranged for the dead. In his interpretation the malagan festivities are nothing but "a kind of replacement of the dead members of a clan with new members reaching adult status."[23]

The close relationship is also indicated by the schedule of initiation for young men recorded by

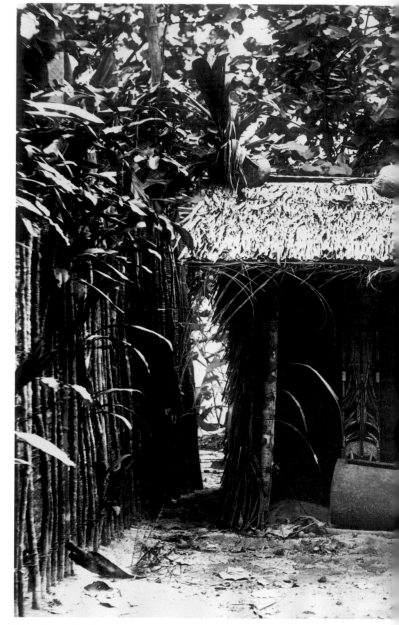

Fig. 5. Rudolf Festetich: Malagan house, Naking, New Hanover (Photograph courtesy of the Ethnographical Institute, Budapest).

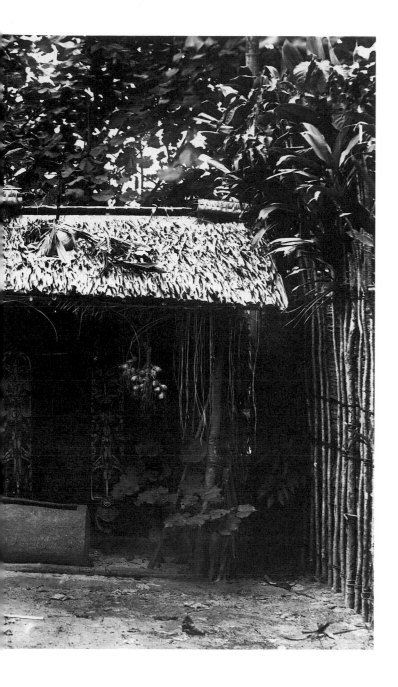

Lewis. According to his report, the rites are divided into five clearly distinct parts: 1. Prerequisite events, which include with equal emphasis the event of death and the presence of the young men looking forward to initiation. 2. The provision of the goods required for the main events of the festivities. 3. The initiation of the boys, consisting of the preliminary phase and the circumcision rites. 4. The making of the malagan objects. 5. The final rites, in course of which the initiated boys are presented to the community, the malagan objects are put on display, the payments are made, and finally the malagans are removed from sight and the guests return to their villages. Here again the reference to the two main phases is clear, although with a different sense than in the case of the mortuary rites. In the first phase the initiate leaves the world as a child (seclusion). Then, reinforced by contact with the ancestors through the malagan figures, he returns into the world as an adult.

MALAGAN SCULPTURE

FIGURES. The making of the malagan statues takes a long time. The raw material used is the wood of the *alstonia villosa*, a tree resembling the European linden. During carving there are pauses to permit the wood to dry evenly and to prevent cracking. The carving is done without the aid of any preliminary drawing, but in accordance with the model described by the owner of the malagan pattern. An axe with shell or stone blade is used for the rough work, and specially sharpened pieces of shell are employed for the finer finish. Shark teeth serve as drills, and the polishing is done with pieces of the skin of sharks and rays. European contact introduced the use of adzes and knives as tools. The insertion of the eyes into the already formed sockets is a special phase of the work. For this the valve of the sea snail *Turbo petholatus* is generally used.

Painting consists of applying various colors in sequence: white made from lime powder; then red ocher; black from the ashes of charcoal or from burnt Calophyllum nuts; yellow and blue from vegetable materials. The stalk of a fibrous *Alpinia* leaf is used for a paintbrush. On some figures even the hair is suggested: into a paste made of the fruit of the parinarium is pressed the fruit of a pandanus in such a fashion that the fibers of the parted fruit give the appearance of coarse hair. The hair over the pubic regions is indicated in the same way. The beard, on the other hand, is represented by a black, thin-stemmed swamp plant. Occasionally, short wooden sticks pinned into the head of the figure signify the hair.

Among the malagan carvings and figures there are a few clearly distinct types, each of which has its own name and peculiar form, and to each of which specialized rites are attached. Even within the larger groups, carvings that are more or less identical in form may have individual names whose exact meanings are not always known.

Regardless of their forms, the malagans can be divided into three groups by meaning: personal, impersonal, and mythic references. The personal malagans each represent someone dead and are usually named after the deceased. Without such distinction the impersonal figures may generally relate to those departed, to the dead ancestors. The mythic malagans include some figures that depict mythic characters, others that are in some way related to the celestial bodies, and some that may represent spirits. Unfortunately, our knowledge so far is insufficient for a more thorough characterization of the individual categories. It can be established, however, that the malagans do more than merely represent dead persons or spirits. During the presentation rite the spirit the malagan stands for is present in the work, whether a personal, impersonal, or mythological malagan is in question. This is demonstrated above all by an established pattern of allowing the carvings to perish after the festivity. When they are on display, and in certain phases of the rites, they are shown the highest respect; later they are no longer revered. Lewis noted that when the *tagapa* malagans were arranged in one display house, their makers sang behind a screen made of coconut leaves. Afterwards they pulled away the screen to reveal the images to the spectators. "The chant," it was explained, "brought supernatural presence into the figures. After that was accomplished, from that moment and throughout the time they were to stand in the display houses until such time as they were destroyed, they were considered dangerous."[24]

As to form, it is evident that a given content may assume various forms, and conversely the same form may carry different meanings. In the following description the malagans are grouped primarily on the basis of distinctions in form.[25]

Human-scaled sitting figures, their raised arms bent at the elbows, make up the first group. We know their several variations both from the Tabar Islands and the northeast coastal areas of New Ireland.

The *marada* is a black figure in a sitting position, generally larger than life size. The body was made of the trunk of the banana tree, and the limbs of sticks of the proper thickness. This core was wound with liana vines until something resembling the shape of the human body was produced. The figure was smeared with a black paste made of charcoal ashes and some vegetal matter which filled the crevices and produced a smooth surface. The head of the *marada* is carved of wood and is 45 to 60 centimeters in height. It is colored black or black and white. On top there is a wide black crest, recalling the former hairstyle of the men. For the *marada* festivity two or three figures of this kind are set outside or in a structure open in the front. The *marada* cult, spreading from Tatau to some localities on the northeast shore, originated in Tabar.

The *fudumasi* figures are made in the same way but rarely reach life size. The body is covered with powdered lime colored yellow. The head is also carved of wood, but it is distinguished by four vertical rods called plumage. The basic color of the head is red with black and white designs. Whereas the other malagan figures are left to perish after the festivities, the heads of the sitting figures are carefully wrapped and stored in the men's house in order to loan them out later to people who lack the means to have new figures made. Some of the figures described by Lewis from a malagan festivity held in 1954 can also be included in this first group.[26] For two types of figures he described, the material of the body, the technique used for making it, and also the form are the same as for the *marada* and *fudumasi* figures.

The figure called *malanggatsak* is characterized by a carved head—anthropomorphic, though stylized—a complicated, tall headdress, and ornamental paint of black, yellow, and red. Cylindrical pegs fitting into the hole on the back part of the trunk project from the botton.

The wooden head of the figure called *ges*, with its grey-yellow color and three-quarter life size, recalls the *fudumasi* malagan. It has tusks reaching from the corners of the mouth way up above the head, and there are incised, stave-like projections on each side and in the back. The top of the head bears a bird looking forward and thorns intended to suggest hair. This, too, ends in a bottom peg for fitting it into the neck.

The third form of figure, the *tagapa*, also has arms raised and palms turned outward. However, the trunk is conical and plaited of bamboo and rattan, and the figure has no legs. The body is decorated with white and yellow stripes. Two short tusks extend from the white, wooden head, and on each side of the head long staves serving as feather ornaments point upward.

We have no definite data on the meaning of the sitting figures. According to an early source, they are impersonal malagans, symbolic figures made in honor of several deceased persons or of all the dead collec-

tively. It is nonetheless probable that their significance goes beyond this, and that these figures served as dwelling places of specific spirits or souls during the celebrations. This is indicated, for instance, by the name *ges*, and by Lewis's statement that the *ilua* spirits stay in the *tagapa* figures, and consequently the latter are dangerous.[27] The *iluas*, that is, the spirits of those killed in battle, were introduced in a separate rite into the *tagapa* figures where they were supposed to stay until the end of the festivity. Then the figures were destroyed but the heads were retained.

During the mortuary ceremonies and the initiation of young men, then, not only the spirits of the recently deceased, but also other spirits that played some part in the life of the clan or moiety inhabit the sitting figures. In this way the dead receive last respects in the world of the living and an introduction, as it were, to their new spiritual context. And at their initiation young men are at the same time put in contact with the whole world of the spirits, with the spirits of their ancestors collectively.

It is quite possible that the head carvings found in museum collections were originally parts of such sitting figures. At subsequent festivities the heads were either fitted to the body of newly made figures or were used independently. In the latter case the heads were pegged into the ground in front of the baskets containing the bones.

A second group of malagan figures is vertical, carved entirely of wood. The most frequent of these are the standing anthropomorphic figures called *totok*, which can be personal, impersonal, or mythic in meaning. The *totok* is set up in the malagan house, stuck into the earth by its bottom peg. Like most malagan representations of humans, *totoks* are basically cylindrical in shape, with stylized animal motifs and ornamental rods enclosing the body, with painted decoration in black, white, red, yellow, and blue over the entire surface. In the *totok* form, the human figure, its legs slightly bent, stands on a carved animal head, shell, or some other form of pedestal. The pedestal can depict a shell, pig mouth, pig head, or a flowercup whose petals surround the legs. The trunk is cylindrical and fairly naturalistic in appearance; the position of the arms varies, but often the hands hold a bird or flying fish at chest height. Some statues also show a rib cage. Gender is often indicated, except in those statues having a triangular apron or loincloth modeled from the waist downward. The nose is broad, squat, and somewhat bent, with wide nostrils and pierced septum. The mouth is either closed, or open in a somewhat elongated oval, sometimes disproportionately large. Teeth may be indicated by black and white triangles. The ears are elongated and the lobes slit, an artificial deformation once widely practiced on the islands.

Figures often include animal representations, the most frequent being cockerels, hornbills, and snakes. The birds are usually on the head, whereas the snakes are placed on either side of the body. Sticks, staves, and flat boards placed by the head or the body may indicate the festive adornment of plumes or the spears and sticks by which the corpse is attached to the chair-like bier. The marking of a shell bracelet on the upper arm and the *kapkap* motif on the chest is the most common representation of jewelry.[28]

The interpretation of the animal representations on the human figures, and in the malagan style as a whole, poses a special problem. Clearly there is some connection with the totemic system, with the animals providing the names of the moieties. But the infrequent representation of the fish hawk or sea eagle would indicate the showing of *masalai* animals, which bear a special meaning for the moiety.[29] This is also supported by the fact that the malagan festivities are arranged by the clans rather than the moieties. Bühler suggests the portrayal of man's animal-shaped life-soul as a possibility. Bühler supports the suggestion by noting that, particularly on the older statues, the birds or carved flying fish look downward before the chest, as if they were coming out of the mouth of the human figure.

POLES. In the next group of standing wooden carvings are poles reaching heights of several meters. These often include two to five human figures standing one atop the next. The poles are carved of a single piece of wood, oblong in shape. The back is usually cut flat, the front rounded. The formal characteristics of the stacked figures are similar to, though less elaborate than, those of the standing figures. Often there are four long, feather-like ornamental laths framing the wood carving, and the figures are modeled in the round within them, holding the staves with their hands. Masts of this kind are done completely in openwork, their decorative carvings forming an ornamental lattice. Although we do not exactly know the meaning of these poles, there is a possibility that these figures represent the dead, for the representations are ritually equivalent to the standing statues. The same may be the case with the friezes.

FRIEZES. A large, distinctive group of the wooden malagans is the friezes, which are arranged horizontally and placed one above the other on the mat wall in tall malagan houses. One of the most

common types is the *walik* malagan, an oblong, symmetrical carving that originated in Tabar.[30] On each end there is either a human head or, more frequently, a fish head; in the middle is a human head, human figure, or somewhat irregular circular ornament with a four-part division carved in relief. One or several human and animal figures are shown on each side of this central design. The human figures may be horizontal or vertical; in the latter case they have separately carved and pegged-in heads. Sometimes the human figure in the middle is carved in the round. The human figures generally represent the dead who can be named, usually the members of a family or closely related people.

A variation of the *walik* is the punched malagan called *mat*. This is a frieze pierced either in the center or in several places. In the older carvings this spot was reserved for the figure of a human face, pig head, or hornbill. Peekel believes that the malagan carvers conceived the idea of doing away with the relief figure and filling the space so gained with living human faces.[31] The *mat* malagan is usually carved with a thin plate of wood left filling the hole, and this weak plate is punched at the time of presentation. Behind the wall on which the friezes are hung, a platform is built with levels of various heights. Men, with their faces painted in various colors, stand on this platform putting their heads through the holes during the presentation. On each side of the central opening there are human and animal figures, and the ends of the frieze are usually carved in the shape of a fish head.

The purpose of the relief carving called *kata* is not clear. Girard lists it with the dance paraphernalia, as its reverse side has a handle.[32] The *kata* is an oblong-shaped plate, with openwork decoration presenting a bird with its wings spread and a snake coiling in its beak or between its legs. Occasionally, human figures are also seen on the *kata*, either in the middle of each wing or carved in front of the bird between the beak and the claws.

Sometimes the horizontal relief called *turu* appears independently among the malagans, though generally it is an ornament placed on top of the head of the human figures whose arms are spread. In the latter case the lower part is furnished with a peg to be inserted in the hole cut into the top of the head of the human figure. The *turu* is a profile representation of a cockerel, and less often of a hornbill, with a complicated openwork ornamentation suggesting the plumage. One sees the occasional piece without openwork design; on these the feathers are painted. Also grouped as *turus* are the bird (cockerel) representations, which are vertical, carved in relief, and depict a

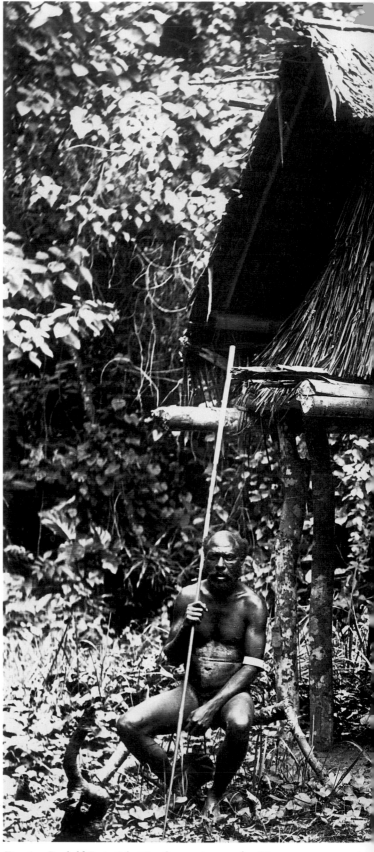

Fig. 6. Rudolf Festetich: Hut for storing masks, New Hanover (Photograph courtesy of the Ethnographical Institute, Budapest).

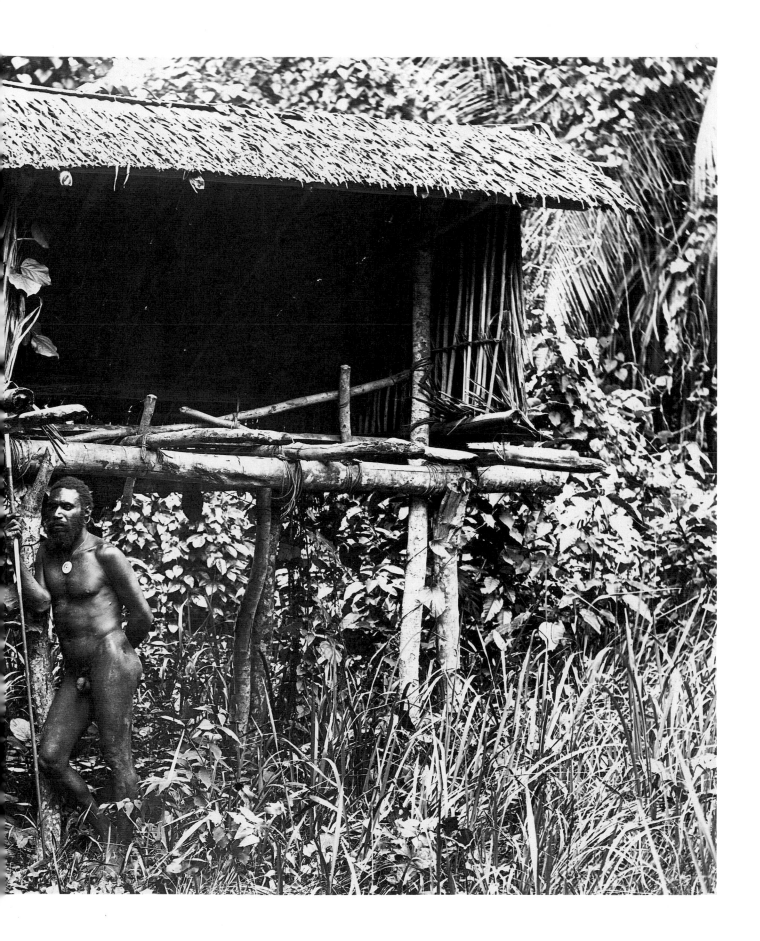

bird head with plumage suggested by an oblong open-work design, sometimes in combination with human and animal figures.

The moon malagan called *flen* also belongs to the friezes. This is a large, oblong board with a snake frame carved in relief. A human figure stands in the middle, and on each side there are motifs of concentric circles reminiscent of the *kapkap*. The moon is either under the feet of the figure or on each side, but always protruding from the surface of the frieze.

ANIMAL REPRESENTATION. Animal representations occur within the malagan style not only as attributes of the human figures and as supplementary decoration for the poles and friezes, but also as independent sculptures in the round even apart from the *kata* and *turu* malagans. Sculptures of fish holding a human figure horizontally or vertically in its mouth (called *aiateraf* by Walden and *eiaideruf* by Powdermaker)[33] stem from Tabar and are not a personal malagan, but rather are made for the dead collectively. We can include with the fish malagans all the representations that show human form attached to the fish. In these works the fish probably represents a *masalai* animal. Solitary birds, chiefly cockerels, can be featured as animal malagans, especially in the carvings that link a human shape with the animal. However, the majority of similar carvings that show only the animal should probably be regarded as accessory decoration for the malagan house, probably without any definite cultic significance. This is indicated by Romilly's description of the malagan house at Kapsu, which contained a great many little bird and fish figures in addition to six or seven large figures.[34]

MASKS. Another malagan object is the mask, which may be personal or impersonal. The personal masks represent individuals who have died, for their names are identical to those of the deceased. The impersonal masks usually depict spirits and souls of the dead, suggested by the fact that in Tabar the masked figures are called *ges* and *tatanu*, the former being spiritual doubles of people, as described above, and the latter name doubtlessly deriving from the word *tanua* —soul or spirit.

We know of two uses for the masks. Some mask-like objects are not worn, but rather are set up in the malagan house as works of cultic value equal to the standing figures, or are put as heads on the neck of the sitting figures. The majority of the masks, however, are worn on the faces of heads of dancers. The masks are supplemented by a costume which ear-

lier consisted of a bark shirt and a skirt of leaves. In the presentation of female spirits, men occasionally dress as women and fasten breasts of carved wood or split coconut shells to their bodies.

The masks can be formally classified into a few larger groups. Most prevalent are the *tatanua* masks with their protruding facial parts carved of the soft wood of the *alstonia villosa* and the upper part made of vegetable fibers bound on a split rattan framework. The finish of the face recalls that of the statues, except that the head has openings for eyes, nose, and mouth. The eyes are marked—as on the statues—by the shell of the *Turbo* snail. The upper head section, consisting of a crest running through the middle with hair painted a different color on each side or plastered with a thick coating of lime, is especially characteristic. This is an exact replica of the old hairstyle of the men.[35]

Other masks of similar structure are not so unified in form. Only the anthropomorphic face and the fiber-decorated head section are identical for all of them. Parts suggesting the skull bear a variety of carvings, such as snake-ornamented ears, usually in openwork. Sometimes the ears are made of bark.

The large wooden masks constitute the richest and most varied group. Our sources say little about their names, meaning, or function, and the few names we know cannot be linked to definite types. Only the mask called *murua, merue* (or *nit kulegula* by Lewis)[36] can be identified with any certainty. There are three-part masks consisting of a carved face and head section with separately attached openwork ears. In addition to these, masks modeled of a single piece of wood, showing considerable variety in form and sometimes reaching heights of one-and-a-half meters, are very striking. Above the face, generally elongated and oblong and only rarely anthropomorphic, is a complex arrangement of human and animal figures carved in the round, usually birds and snakes, less often pigs and dogs. The little laths protruding upward with their triangularly engraved and painted decorations recall the feathers worn for festive occasions. Zoomorphic and anthropomorphic figures occur on the three-part masks as well. On this type of mask, the decorations of the ear with human figures, snakes, and birds (chiefly cockerels) are particularly striking.

A number of masks, especially those originating in the north, are made of two squares with slanting eye openings and separately attached openwork beak-like noses. The section below the squares is often fashioned like a bill. It may therefore be assumed that these are representations of birds. The pig heads are done in a more naturalistic manner.

Bark masks fashioned of two round plates sewn together in the middle are relatively rare and probably restricted to the Tabar Islands. Their ground color is white, the linear decoration executed in black and red. Each piece is equipped with a carved nose and a pair of bark ears stretched over oval frames. They probably represent birds.

The masks mentioned so far were intended to be worn repeatedly; *kipong* masks, popular chiefly in New Hanover, are worn only once because of their perishable material. The facial part of the *kipong* is made of the lower part of the stalk of the sago leaf, and consequently the chin does not protrude like that of a *tatanua* mask. *Kipong* masks, with their simple finish, do not attain the aesthetic level of the wooden masks.

RITUAL ORNAMENT. The dance paraphernalia, usually held in the mouth and less frequently in the hands, are also malagan objects. They are most often representations of the hornbill. Their cultic association is indicated by Bühler's note that at the closing festivity the dancers held natural hornbill heads, or wooden representations of them, in their mouths. After they received payment in the village square for their dancing they went to the malagan enclosure, tore down the fence, and, imitating the movements of the hornbill, cast their ornaments at the feet of the malagan statues. Local people referred to this as the part of the ceremony where "the birds fly away." On these carvings the hornbill is stylized and is sometimes linked with a tiny human figure. Similar paraphernalia are also occasionally placed in the mouth of the masks.

DECORATIVE MOTIFS. Painters tend to break down the larger surface areas, especially where the colors play no functional part (as, for instance, the alternating black and white of the teeth), to the smallest possible parts. The dynamic visual effect is produced not by the details but by the whole. The number of motifs used is rather limited, and the method of their application is more or less uniform. Suitable parts of the white ground are often filled in with parallel red lines in ovals or oblongs, or vertical and horizontal lines are crossed in a lattice pattern. Independent motifs include triangular forms; "ladder" and zigzag lines; series of lines perpendicular to a longer line; stylized feather motifs; a line with closed triangles above it; and so on. The motifs are arranged in definite association with one another, and the effect comes from this composition. It is enhanced by the alternation of the colors—for instance, a series of rectangles consisting of pairs of black and white triangles, a line of triangles with their bases arched as if pushed in toward the center, the apex of each triangle pointing into the arched base of the triangle above it, and so on.

———————————

Malagan festivities are occasions for the expression of solidarity with the moiety and clan. They contribute to the maintenance of the existing economic structure, social prestige, and traditional ideology. Furthermore, practically every kind of northern New Ireland art is attached in some way to the mortuary rites. The social, economic, and aesthetic centrality of these rites is thus established.

NOTES

1. Philipp Carteret, *Carteret's Voyage Round the World*, ed. Helen Wallis, Hakluyt Society Series II, No. CXXIV (Cambridge: Cambridge University Press, 1965): Vol I, 188–89.

2. South of the Equator, between 2 and 5 degrees south, and 150 to 154 degrees east. North of it lie the St. Matthias Islands and to the west the Admiralty group. The vast territory of New Britain lies to the southwest, the chain of the Solomon Islands to the southeast.

3. F. L. S. Bell, "Report on Field Work in Tanga," *Oceania* 4 (1934): 291.

4. W. C. Groves, "Report on Field Work in New Ireland," *Oceania* 3 (1933): 340.

5. In the records available "malagan" is hardly ever spelled the same way. Krämer wrote about *Malanggane*, Bühler about *mulligan*, Girard preferred to call it *malangan*, Walden and Groves stuck to *malagan*, and Peekel too spelled the term *malangan*.

6. This is the term applied today even to Christian ceremonies, to the stained glass windows of churches, to the religious statues, and so forth.

7. A. Bühler, "Totenfeste in Neuirland," *Verhandlungen Schweizerischen Naturforschende Gesellschaft Jahresversammlung* 114 (1933): 252.

8. M. F. Girard, "L'Importance Sociale et Religieuse des Cérémonies Exécutées pour les Malanggan Sculptés de Nouvelle-Irlande," *L'Anthropologie* 58 (1954).

9. There are two exogamous marriage classes or moieties in each village. Usually one of them is named after the fish hawk (*Pandion leucocephalus*) and the other after the sea eagle (*Haliaetus leucogaster*), though occasionally other animal names are attached. The moieties are matrilineal, and despite the fact that they have been named after animals, no legends suggest belief in original animal ancestors. Mythological heroes are supposed to have established the social organization and culture.

10. H. H. Romilly, *The Western Pacific and New Guinea* (London: John Murray, 1886): 42.

11. W. C. Groves, "Tabar Today: A Study of a Melanesian Community in Contact with Alien Non-Primitive Cultural Forces," *Oceania* 5 (1934–35): 355.

12. Hortense Powdermaker, *Life in Lesu*, (New York: W. W. Norton, 1933): 309–13.

13. In the case of a woman her son; otherwise, a maternal nephew or maternal uncle.

14. Powdermaker, in 1929, mentioned a radius of from 25 to 30 miles; Lewis in 1954 mentioned a 30-mile radius. P. H. Lewis, *The Social Context of Art in Northern New Ireland.* Fieldiana Anthropology Series 58 (Chicago: Field Museum of Natural History, 1969): 45.

15. E. Walden, "Die ethnographischen und sprachlichen Verhältnisse im nordlichen Teile Neu-Mecklenburgs und auf den umliegenden Inseln," *Korrespondent-Blatt der Deutschen Gesellschaft für Anthropologie, Ethnologie und Urgeschichte* 42 (1911): 30.

16. A. Krämer, *Die Malaggane von Tombara* (Munich: Georg Müller, 1925): 77–79.

17. Roy Wagner discusses the significance of this forked branch in his essay below.

18. Bühler, "Totenfeste in Neuirland," 249–50.

19. Romilly, *The Western Pacific and New Guinea,* 44–45.

20. Buhler, "Totenfeste in Neuirland," 249–50.

21. Powdermaker, *Life in Lesu,* 213–21.

22. Groves, "Tabar Today," 347.

23. Lewis, *The Social Context of Art in Northern New Ireland,* 45, n.23.

24. Ibid., 60.

25. Up to now the malagan figures have not been satisfactorily grouped by form. Our enumeration does not pretend to be complete. No terminology has been developed in naming the individual forms, so we have adopted the terms used by Girard, which have become more or less accepted. We have supplemented them with Peekel's and Walden's usage.

26. Lewis, *The Social Context of Art in Northern New Ireland,* 92–96.

27. Ibid., 98.

28. The *kapkap* is a polished disc made of the Tridacna gigas shell to which was attached a brownish tortoiseshell plate, usually radially divided into four sections and cut in an openwork design. This piece of jewelry makes its appearance, in both carved and painted form, on the statues and flat friezes.

29. The individual clans trace their descent from eminent ancestors. But a closer link than common ancestry is the small piece of land, sea reef, or tree which they hold in common and which, according to their belief, is inhabited by a certain *masalai* animal, on land a pig or snake, on sea usually a shark. This animal is friendly to the members of the clan, but is hostile towards all other people.

30. According to Walden, Walik was one of those people who fled to Tabar from the main island to escape the mythical monster pig, and we know from Powdermaker that the license to make the *walik* malagans of Lesu was purchased in Tabar. E. Walden, "Totenfeiern und Malagane von Nord-Neumecklenburg," *Z. Ethnol.* 72 (1940): 21; Powdermaker, *Life in Lesu,* 210–23.

31. G. Peekel, "Die Ahnenbilder von Nord-Mecklenburg," *Anthropos,* XXI, 1926, pp. 806–824.

32. Girard, "L'Importance Sociale et Religieuse des Cérémonies," 256.

33. Walden, "Totenfeiern und Malagane von Nord-Neumecklenburg," 27; Powdermaker, *Life in Lesu,* 316.

34. Romilly, *The Western Pacific and New Guinea,* 45.

35. It was customary to cut the hair quite short on one side of the head and to leave it black, whereas on the other side the hair in its original, unclipped length was colored white or yellow; the top section was peaked up in a crest. Those who did not regard this decorative enough fashioned symmetrical steps of thickly applied lime on one side of the head, built up a crest in the middle, and dyed the hair black on the other side.

36. Lewis, *The Social Context of Art in Northern New Ireland,* 114–20.

Art and Money in New Ireland:
History, Economy, and Cultural Production

Louise Lincoln

Preparing to leave New Ireland after a year of anthropological fieldwork in 1929, Hortense Powdermaker asked the old men of her village what she should tell her own people about the malagan sculptures she was taking with her. One might expect that their responses would have emphasized the aesthetic or iconographic features of these art works, their commemorative function as memorials to the dead and links to past generations, or their relation to myth and history. Instead, the old men unhesitatingly instructed her "to tell these people who would look at the malagans that they were not just carved, painted pieces of wood, but that I must make the people understand all the work and wealth that had gone into the making of them—the large taro crops, the many pigs, all the shell money, the cooking for the feast, and other essentials of the rites. These, said the old men of Lesu, are the important things to remember about malagans."[1] The old men thus called foremost attention not to the objects themselves, but to their economic and symbolic value, the way in which they represent vast quantities of labor and time and massive stocks of various goods. In their seemingly materialist view, the sculptures are not self-contained objects, but rather the end result of a complex process of production that involves long-standing social cooperation and economic activity.

The social context of malagans is extremely complex. The memorial ceremonies held following the death of important persons bring distant visitors to the host village for elaborate dance and musical performances, orations, feasting, exchange of pigs and other valuables, and, at a climatic moment, the display of works of art specially commissioned for the occasion. The sponsorship of malagan ceremonies requires a structured, cooperative effort, thus reinforcing kinship ties and realigning the social order following the death of the person in whose honor the feast is held. While arrangements are made for the food, the festivities, the dancers, and the sculptures, the older men of the village also review and adjudicate legal, political, and economic disputes, discussing kinship lines, land tenure, and division of power. This aspect of periodic adjudication is so effective and so important that some scholars consider it to be the crucial factor in the continued performance of malagan in the face of present-day external pressures against traditional practices.[2] At the same time, the malagan affects the group's external relations: inhabitants of distant villages are invited to attend the ceremonies, sometimes to participate as dancers, and are the beneficiaries of lavish hospitality and gifts. The host village adds to the web of exchange of goods and exchange of women within the exogamous system of marriage, thereby maintaining the extensive network of interdependent relationships.

Simultaneously, the ceremonies are deeply embedded in the economic structure of New Ireland life, functioning as a stimulus to production and a focal point for redistribution of wealth in the form of food, especially pigs, and currency, both shell money and cash. Planning for and production of the requisite enormous amount of food can take as long as a year; the slaughter of fifty pigs would not be unusual. The material exchange is elaborate, takes place in several restricted spheres (shell money for pigs, for example, but not taro root for pigs), and is carefully recorded towards the requirement of reciprocity in the future.

Like other aspects of the malagan ceremonies, the carvings themselves result from processes of social cooperation and economic activity. Before any sculptures can be made, it is necessary that the hosts of the ritual possess the rights to those traditional,

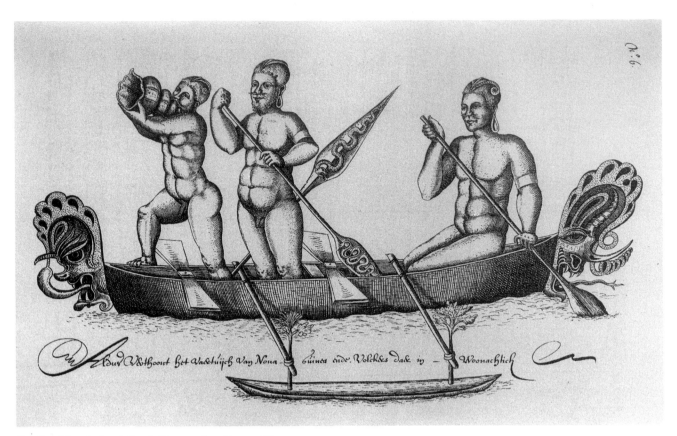

Fig. 7. New Ireland Shark Hunters in a Canoe. Plate from *Abel Janszoon Tasman's* Journal, April 1643. Amsterdam: F. Muller and Co. (Photograph courtesy of Special Collections and Rare Books, University of Minnesota Library).

individually named designs they wish to have carved. In the event that they do not already possess the rights to these designs, they must obtain them by presenting shell money (*mis,* sometimes also cash) to the one who does possess those rights but is willing to relinquish them by dint of this exchange. Thereafter, a carver must be located, commissioned, and maintained while he executes the designs, which now properly belong to the ceremony's hosts.

When a malagan ceremony has been staged, the community in attendance implicitly passes judgment upon its success in light of the quality and quantity of the food, the nature and skill of the dance performances, the aesthetic quality of the carvings. Attention is also focused upon whether the hosts possessed proper rights to the malagan designs they had executed, with serious social consequences if they are charged with any improprieties in this regard. At the conclusion of a successful malagan ceremony, the material resources of the sponsors may well be depleted, but their degree of prestige and influence will have

correspondingly increased. Moreover, they will have accrued obligations of others who have received goods from them, thus enhancing their material success in the future. Buyers of malagan rights thus convert labor, goods, and money into a material, an "artistic," representation of their social prestige, and although the malagan sculptures may disappear from view after the ceremonies (when they are either stored or abandoned), the enhanced standing of their owners remains, and the ownership rights, which will likely be resold, constitute a sort of semiliquid asset. It is here, perhaps, that the social and economic aspects of malagan ceremonies are most closely interwoven.

On the authority of Powdermaker's informants, it is important to bear in mind the social and economic aspects of malagans, and much of the literature on New Ireland reflects this. Yet society and economy have changed over time, particularly during the colo-

nial and postcolonial periods of the past century. Given the drastic changes that have come to New Ireland in that time, it is astonishing that historic factors have received so little attention, particularly in the anthropological accounts, which make few references to diachronic events. In nearly all accounts, the impression one receives of village life is of a tranquil, eternally stable cycle of planting and harvesting and a sporadic but all-consuming ceremonial life. Change brought about through contact with the external world is noted but minimized; contact with Europeans seems infrequent and of little effect. It is an emphatically and at times deliberately ahistorical view, for many field accounts, particularly the earlier ones, attempted to reconstruct the "pure," untouched culture of the past.

If one turns, however, to external historical accounts, a startlingly different picture emerges. Contact with the Western world began remarkably early and was sustained and influential. The relationship between New Irelanders and Europeans was tempestuous, at times violent. The first ethnographic data we have relating to New Ireland come from the Dutch navigator Abel Janszoon Tasman, who, following his voyage of 1643, made not only an astonishingly clear account of the highly distinctive and still employed New Ireland methods of snaring sharks, but also a sketch of New Ireland men wearing an equally dis-

tinctive hairstyle and paddling an elaborately decorated canoe filled with shark-catching paraphernalia (figure 7).[3] By the late eighteenth century, European trading houses were sending numerous expeditions to the South Pacific in search of trade commodities, and by mid-century New Ireland had been charted and named (in view of its location near the neighboring land mass christened New Britain). Somewhat later, American whalers began to exploit the South Pacific, and whaling ship logs as early as 1837 mention routine stops on the coast of New Ireland to replenish stocks of food and fresh water. Some of these logbooks also provide ethnographic data, most often commenting on shark-catching, sculpture, or boatbuilding.[4] What is most striking about logbook entries regarding New Ireland, however, is their frequency, and the encounters with New Ireland people the logs mention. Numerous books note daily contact and trade with villagers, sometimes for a period of weeks: "canoes came out and we traded small knives and cloth for yams and cocoanuts." Trade goods such as metal and cloth could not have been uncommon in certain coastal areas of New Ireland by the middle of the nineteenth century.

At that time the European presence in the South Seas increased dramatically, in part because of the development of improved methods for obtaining coco-

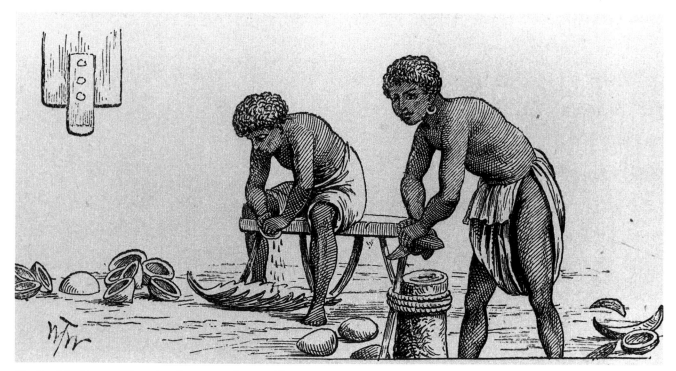

Fig. 8. Husking and Scraping Coconuts. From William Wawn, *The South Sea Islanders.*

nut oil. Instead of pressing the oil in the islands and then shipping it, a method that sometimes resulted in losses from rancidity and leaking casks, the German firm of Godeffroy began to ship dried coconut meat, or copra, to Europe for pressing; the industry was revolutionized. German and British entrepreneurs began to establish plantations in Melanesia and elsewhere to grow coconuts systematically, often obtaining land by methods that were highly irregular at best. Laborers for the plantations were recruited under even worse conditions; workers were frequently kidnapped, transported to distant islands, and literally worked to death. Already in 1885 the practice of "running down" canoes and capturing those aboard was sufficiently widespread that some Europeans condemned it for alienating the local population.[5] Raids on coastal villages by recruiters' ships (the notorious practice of blackbirding) were particularly severe in northern New Ireland.

As Europeans recognized the profits to be made from raw materials and labor in the South Pacific, they also noted the region's potential as a market for manufactured goods. The trading stations set up to collect copra and other commodities, such as sandalwood, shells, and beche-de-mer, exchanged these for metalwork and cloth and also for liquor and firearms, the value of which was more dubious. On New Ireland the traders were at first apparently as welcome as were the calls of whaling ships. In 1880 the German trader Eduard Hernsheim established a trading post at Nusa and quickly expanded down the coast of New Ireland.

Several German companies were in the forefront of copra importing from the South Seas, and it was therefore not surprising that as the nations of Europe entered a hasty competition for empire in the 1880s, Germany laid claim to a number of islands in Melanesia, sending a warship in 1885 to plant the flag and the Kaiser's claim. The western names of the territories were changed (New Ireland became Neu-Mecklenburg), and other changes gradually followed, As the number of plantations increased, with consequent pressures for land and labor, hostilities arose. In the early 1880s there were over 20 trading posts operating in New Ireland. In 1885 six trading posts were burned and the traders killed in attacks provoked in large measure by the abuses of labor recruitment.[6] Five years later only four posts remained in operation.

Yet the opportunity for exploitation remained great, and the German traders exerted increasing pressure on the home government to establish administrative posts and, more importantly, military forces on the islands. In 1901 this was done; a government

Fig. 9. Lajos Biró: Interior view of the living quarters of New Ireland plantation workers, Madang, German New Guinea, about 1900 (Photograph courtesy of the Ethnographical Institute, Budapest).

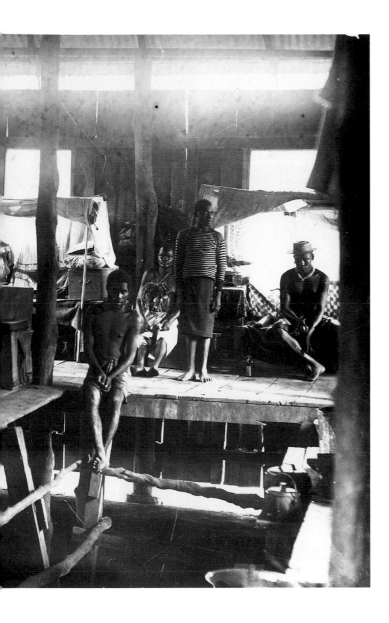

post was established at the northern tip of New Ireland, and a road was built along the northern coast of the island using forced labor. In order to maintain better military control, colonial administrators relocated the population from inland villages to coastal areas bordering the road. And in the classic technique of a colonizing government, they imposed a head tax, not to generate revenue but to create an ongoing need for currency among the colonial population that would drive them into the labor market.

Between the establishment of the Protectorate in 1885 and the loss of their Melanesian colonies in the First World War, the Germans oversaw a complete alteration of the economic base of New Ireland and other Pacific regions. From small-scale subsistence agriculture and local trade networks, these areas moved to a predominantly wage-labor plantation economy that was externally oriented. In the early period of contact most trade was barter: exchange of one kind of goods for another. The European traders, however, adapted shell money, previously used in ceremonial contexts, to function as a uniform standard of currency, and Western finished goods, introduced through the trading posts, provided a powerful incentive to acquire this currency. German missionaries, working closely with colonial administrators, also brought dramatic changes to the traditional religious practices of New Ireland society, as well as to marriage regulation, medicine and healing, dress, and personal deportment. Political structures were altered when the colonialists vested village authority in a single "big man" and appointed *luluais*, or local constables. Decision-making, formerly collective among village elders, was now carried out in a hierarchical system, with any decisions of importance being made by outside authorities.

The magnitude of these transformations notwithstanding, it was probably labor recruitment and the labor trade that brought the greatest changes to the people of New Ireland. The northern coast was a favored area for recruitment from the earliest days of plantations because its shoreline was more accessible than that of the rest of the island. The sheer number of recruits from this area is staggering. In 1906 fully one-third of all plantation workers in the entire German Protectorate came from New Ireland, many working in Queensland and Samoa, where the local people, who had had a closer view of plantation life, resisted recruitment. By 1914 a colonial administrator estimated that 70 percent of all adult male New Irelanders had undertaken at least one three-year labor contract.[7] Large numbers of workers died during their service as a result of disease, abuse, the effects of alchohol, or

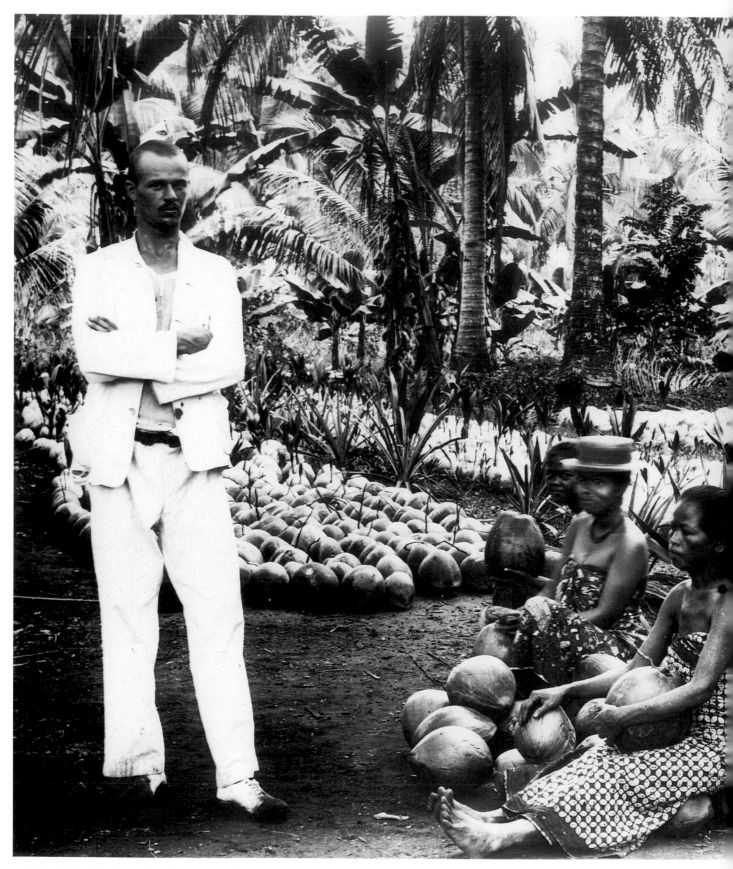

Fig. 10. Lajos Biró: Germinating coconuts, Bongu, German New Guinea, about 1900 (Photograph courtesy of the Ethnographical Institute, Budapest).

intertribal hostilities; the German governor estimated a death rate for plantation laborers between 25 and 40 percent annually.[8]

Women were recruited too, although in somewhat smaller numbers, for plantation work, for domestic service, for common-law "marriages" to Europeans, and for sexual services to male workers. New Ireland women were particularly sought after, for the white colonists considered them particularly attractive and compliant. Lajos Biró's remarkably frank account in "My Three Papuan Wives" of the selection of his "bride" from a boatload of newly arrived New Ireland recruits is a rather chilling testimony to their desirability.[9]

It is difficult to overestimate the disruptive effects of labor recruitment on so massive a scale. Even if it is true, as some have argued, that those who were susceptible to recruitment, or in the early days who were chosen to go by village leaders, may have been somewhat socially alienated,[10] their experiences while under labor contract and their exposure to colonialist culture must have increased their estrangement. Moreover, the absence of a large proportion of the able-bodied male population from their villages—in some years as high as one-third—led not only to a serious loss of productive labor, but to a drop in reproductive capacity as well. From the earliest period of colonial administration, officials were concerned by the extent of depopulation on the north coast. German colonial authorities banned the recruiting of northern New Ireland women in 1909 and placed ever greater restrictions upon male recruitment.[11] Nevertheless, the social fabric of the villages was destroyed to such an extent that when Australian administrators took over following World War I, they closed the north coast to all recruiting for more than a decade. Adult males, the primary participants in ceremonial life, had become an endangered species.

It is hard to imagine how any aspect of the precontact cultural fabric, under the circumstances described above, could remain untouched. Art is certainly no exception. Thus, for instance, the introduction in the 1850s of new technology, particularly metal carving tools, undoubtedly had an effect, particularly in that these permitted sculptors to define color areas with fine incised lines and to achieve a more angular style and more openwork than had been possible with old techniques of charring and abrasion. Some of the few pieces collected in the very early contact period do show softer contours and somewhat more massive

form than later works. Other, more obvious visual changes appear later, in the mid-twentieth century, following the introduction of such new materials as manufactured yarn, paints, and various kinds of metal trim.

Yet beyond the effect of technological innovations, historic processes have had other effects on malagan carvings that are less apparent but more profound. The level of art production from the north coast provides a rather startling statistic: from the German colonial period, 1885–1914, no fewer than 15,000 New Ireland material-culture objects, principally masks and sculptures, have found their way to European and American museums.[12] How can such astonishingly prolific cultural production be resolved with the massively disruptive forces of colonialization?

Geography is a contributing factor. We have already seen how the navigable coastline of the north invited trade and labor recruitment and then brought a population drain. The extensive interaction between New Irelanders and whites in this region is undoubtedly part of the reason so much north-coast art found its way to Europe. With contact came the development of a new market for art objects: at first among curio-seeking sailors, then colonists, scientific collecting expeditions, and finally art collectors and dealers.

The market was not, however, the only stimulus to production. Coincident with the growth of an external demand for their art objects was the New Irelanders' own rapidly growing need to obtain wealth in the form of shell money or cash. Currency had become necessary to acquire such highly desired manufactured goods as knives, cloth, ornaments, and firearms; to pay the head tax imposed by the colonial administration; and to avoid the onerous and unsalaried work of road maintenance otherwise required of all individuals several days each month. All of these factors combined to create a greatly increased demand for money,[13] which could be obtained, as we have seen, primarily through a period of contract labor on European plantations (though in practice it often happened that a high percentage of workers' salaries was returned to the plantation companies through company stores). As an alternative to contract labor, one might sell indigenous goods for currency, but salable commodities were few in number; art, either removed from its normal ceremonial context, or produced specifically for sale, was one of them.

A pattern of florescence in art production at the time of severe cultural disruption is not unknown elsewhere. Among North American Indian groups of the Plains region, beadwork became more widely practiced and more visually flamboyant during the very period when the people were being confined to reservation lands. Maori sculpture of the early nineteenth century provides another example of the same phenomenon. An examination of this stimulated production may provide a resolution of the paradox laid out above, that is, of the conjunction of drastic depopulation and prodigious art production (and export), for it seems hardly credible that the 15,000 pieces tabulated in European and American collections represent solely the discarded products of normal ceremonial life on New Ireland between the years 1885 and 1914. Moreover, one must ask whether these pieces could possibly all have been produced for the needs of local malagan ceremonies, particularly in a period when the practice of such ceremonies must have declined, as a result both of missionary activity and the absence of a large segment of the population.

If it is legitimate to talk about production of sculpture outside ceremonial use—that is, production for an outside market—what effects did this have on the objects themselves? Certainly it is no secret that the objects categorized in the West as "tribal art" and invested with an almost reverential, if purely aesthetic, significance are not always made purely for ceremonial or religious use. In New Ireland there is good evidence that some art was produced early for an external market. Otto Finsch, who was on the island before the turn of the century, noted of warclubs that "there are new ones somewhat on the old pattern, which the natives have made recently for trade."[14] And in 1900 Lajos Biró observed that "resourceful natives make a profession of carving at some points of New Ireland where there are comparatively many Europeans. These artists give free play to their fantasy, especially when they see that the more bizarre their products the better they sell. The stores of some merchant houses in the vicinity of Herbertshöhe contain large stocks of such carvings; they are mixed with pieces of genuine style, but only experts would be able to pick out the latter."[15] In ways, Biró's comments seem self-contradictory, for directly after he stresses how "bizarre" were the pieces produced for export, he states that only a true expert could distinguish them from more traditional pieces.

In this regard, a comment elicited by Elizabeth Brouwer from a malagan organizer in Panatgin village in 1979 is extremely interesting. Shown photographs of carvings in German museum collections, her informant told her that some of the pieces contained elements from several different traditional and individually named malagan designs, which had been artificially—and, in his view, incorrectly—recombined in a single piece. He further speculated that these pieces

might have been made in secret and sold quickly to Europeans before they could be seen and challenged by knowledgeable malagan experts.[16] Without major violation of cultural expectations and restraints, carvers may have produced hybridized carvings devoid of name, tradition, or ownership rights: a "bizarre" or atypical piece, but one whose style might well closely resemble other pieces.

To be sure, not all objects that entered Western collections during this period were of this type, and it is clear that many pieces initially made for traditional use were later converted to trade goods in order to obtain currency. At other times, as was suggested to me by informants from the Notsi-speaking area of northern New Ireland, malagan owners were implicitly coerced, and thought that they could not refuse the demand of colonial authorities and other whites to sell desired pieces. These sorts of transactions contrast strongly with those of traditional New Ireland social and ceremonial life, wherein malagan sculptures reflect the social position of the deceased, in whose honor the festivities are organized, and that of the survivors who sponsor them. As Powdermaker's informants observed, such malagans are the product of extensive social cooperation and economic activity, being "not just carved, painted pieces of wood," but objects that resulted from "all the work and wealth that had gone into the making of them—the large taro crops, the many pigs, all the shell money, the cooking for the feast, and other essentials of the rites.

Powdermaker's informants undoubtedly were correct in their insistence that malagan carvings, like any work of art, must be considered not merely in and of themselves, but within their broader social and economic context, as objects that come into being only as the result of a process in which the artist draws on the traditions, the expectations, the material and ideological support of a complex social network. Yet one must also take into account not only the social and economic context of any piece, but also its historic context: not only the forces and relations relevant to its production, but also those relevant to its consumption. The nature of a given work is of course shaped by its creator, but it is also shaped by those for whom it is ultimately intended, and by the nature of the relations between producers and consumers. The case of malagan sculpture in New Ireland, the traditional and the "bizarre," is a particularly instructive one in this regard.

NOTES

1. Powdermaker, *Life in Lesu* (London 1933), p. 319.

2. Lomas, "Malagans and Manipulators," *Oceania* 50, no. 1 (1979), pp. 53–65.

3. *The Voyages of Abel Janszoon Tasman*, March 1693 (Oxford, 1968).

4. One of the richest of these sources is a logbook now held at the Old Dartmouth Whaling Museum, New Bedford, Mass., from the bark *Coronet*, which spent the month of February 1838 off the coast of northern New Ireland: "While cruising here every day that we stood in toward the island several canoes came off to us and the natives brought with them cocoa nuts, yams, sugar cane, tarrow [sic] root, spears, clubs, shells, tortise [sic] shell, nets, calabashes, and various other articles, which they gave for small pieces of iron, balls of cotton, [illegible] of red shirt, and such like. These natives do not trouble themselves with the least particle of dress of any kind, But they paint themselves very much and the most predominat [sic] colours are white and red.... They appear to fancy making themselves look like Barndoor Cocks—for this reason the hair is cut close off on each side of the head and in the middle from the forehead to the nape of the neck it is allowed to grow about 1 inch broad & 2 high this is thickly painted red and looks just like a cock's comb. Some had one side of the face painted white the other a dark blue.... I think their canoes very great curiosities. Some of them will carry 12 or 14 men each and the carving about them is beautiful how they do it I can not tell but I have seen cocks, lizards, snakes cut out of the solid wood as perfect and good as any work of our schools at home...."

5. Romilly, *The Western Pacific and New Guinea* (London, 1886), pp. 186–87.

6. Hempenstall, *Pacific Islanders under German Rule* (Canberra, 1978), p. 138.

7. *Ibid.*, p. 152.

8. Firth, *New Guinea under the Germans* (Melbourne, 1982), p. 179.

9. Vargyas, *Pictorial Data* (Budapest, 1986), p. 66.

10. Powdermaker, *Life in Lesu*, p. 203–4, recounts an episode in which a man who had caused a village scandal signed on as a plantation laborer at the first opportunity. "...no one expressed any regret when he left. It was obviously an escape from an intolerable social position."

11. Firth, *New Guinea under the Germans*, p. 126.

12. Lewis, "Changing Memorial Ceremonies in Northern New Ireland," *Journal of the Polynesian Society*, 82, no. 2 (1973).

13. In part, the demand for shell money was met through the importation of large quantities from neighboring islands, particularly New Hanover, This, however, proved very disruptive, as the result was serious inflation. See Godin, "Note sur la Production des Malanggan," *Journal de la Société des Oceanistes* 35, no. 65, 283–85.

14. Finsch, *Südseearbeiten* (Hamburg, 1914), p. 494.

15. Bodrogi, "Malagans in North New Ireland," *Acta Ethnographica* 16, no. 2 (Budapest, 1967), p. 76.

16. Brouwer, "A Malagan to Cover the Grave," (Ph.D. diss., 1980), p. 427.

On Trying to Understand some Malagans

Dieter Heintze

In January 1968 there was to be a malagan ceremony at Tovabe, a small village near Fisoa. Its purpose was not, as in most instances, to mark the conclusion of a mourning period, but was instead a *mida*, which is the traditional way of reconciling parties engaged in a serious quarrel. In this case, the quarreling parties were real (not classificatory) siblings. The owner of the malagans to be displayed and of the songs and dances to be performed was Baie, the classificatory mother's brother of the siblings. The rights to these malagans were to be passed on to two of the siblings, the brothers Waika and Tou; eventually, it was expected, they would become the possession of Tou's son, R. Lando. With that transfer, the rights would pass from the Monga-Komade clan to the clan of Lando's mother, the Manga-Nuas, because New Ireland's societies are matrilineal.

Baie, who explained the malagans to the ethnographer and general audience, and who directed the ceremonies, was born in the village of Sambuari on the Island of Tatau. He had received the knowledge concerning these malagans from two "big men" of his clan, Buraun and Sale. But, he admitted, his knowledge was fragmentary because the two "big men" had carried part of it with them to their graves.[1] A brief description of the malagan and of the proceedings at Tovabe may, nonetheless, illustrate some points of general significance. Every malagan has a story connected with it. Just as the production of a malagan is legitimized by the knowledge of that story, its authentic version can be told only by the owner of the rights to the malagan, regardless of the storyteller's grasp of the completeness, coherence, or significance of the story. Certainly the competence of the many storytellers varies greatly. And because most of the malagans now in collections around the world were gathered by people whose main interest was their aesthetic aspects, by people who had little sensitivity to the works' symbolic ramifications in New Ireland society, those works have lost their stories; that is to say, they have been artificially silenced. A major part of the iconographer's difficulty is this removal of the malagans from their context.

Malagan stories relate the origins of a particular piece and its passage through time and space "until today." They are therefore to be regarded as the method by which New Irelanders communicate their history. And with the stories told about the wanderings of the clans and their subdivisions, with which they are closely linked, malagans can be said to be the New Irelanders' history book.[2]

It can be supposed that in the beginning there was the creation of malagan designs and patterns, though this is not as evident historically, inasmuch as to legitimize a malagan is to trace its origin back to the supernatural world.[3] In the end, details of the designs, or whole patterns, and the knowledge connected with them, disappear; such a loss is comparable to the disappearance of clans and their subdivisions.

The institution of malagan is not to be seen as a static complex of repetitive patterns, but as a living complex of changing syntheses that uses a limited but changing stock of motifs. Consequently, a once prominent malagan or a named grouping may become mere history—or may be entirely forgotten.[4] Taking into account the discontinuities caused by economic changes and the varying attitudes of the governments and churches since the 1880s, one may imagine that for

many malagans in the collections, the best we can now do is to make iconographic interpretations of certain details.[5]

The artistic quality of Baie's figures and decorations was rather low, the designs apparently having been reduced to an indispensible minimum. Baie had also freely used modern materials such as paper, burlap, insulating tape, and European paints.

The central focus of Baie's display was the so-called house of the malagan,[6] which was actually a sort of sedan chair, to which all of the malagan figures (except the *vanis* mask) had been fixed. The house of the malagan had been prepared in an enclosure. On the eve of the great day a segment of the enclosure was removed, and the house was carried into the open (fig. no. 11). The figures were positioned against a wall made of dark green leaves called the "picture of a cloud."[7]

The upper composition was a carved and painted malagan frieze (fig. no. 12). The fish heads at each end were said to be marine fish, without further specification. The four figures of similar appearance that stood on the upper edge of the frieze were called (from left to right) *songsong*, *walik*, *kuletmo*, and *malanggatsak*. The concentric circles painted on the plank were called the "eyes of the malagan." The story of this malagan narrated by Baie is the following: once a *ges* (a kind of

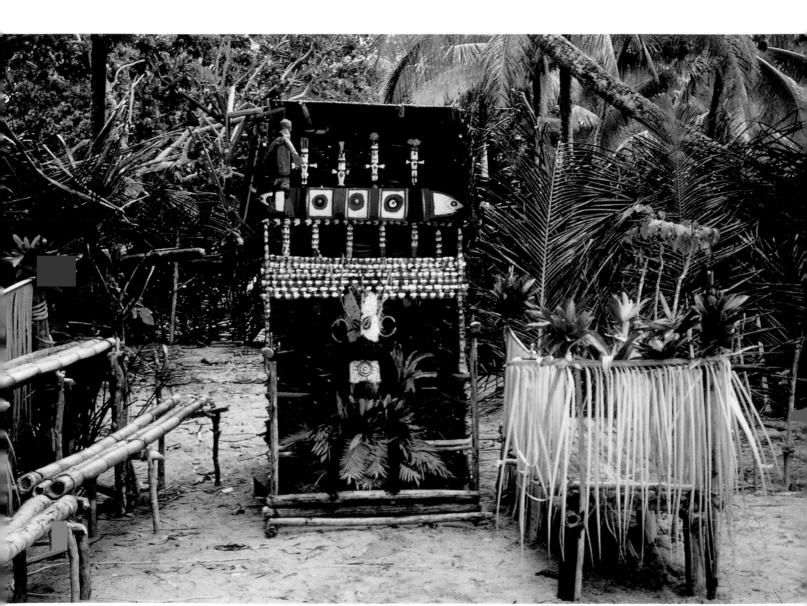

Fig. 11. A display of malagans in Tovabe, 1968 (Photograph by the author).

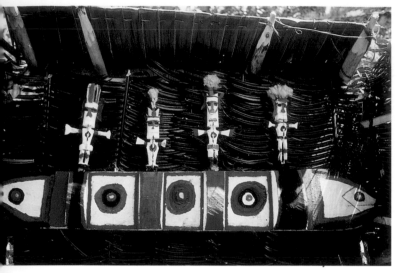

Fig. 12. Baie's frieze (Photograph by the author).

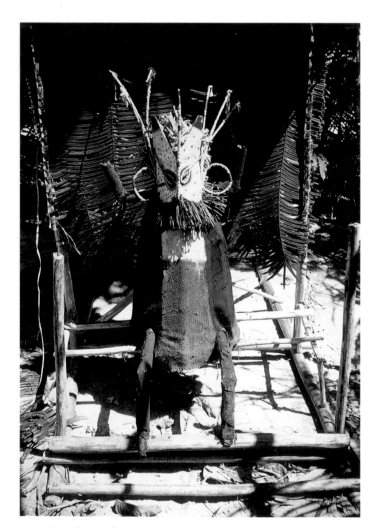

Fig. 13. The *ges* figure (Photograph by the author).

bush spirit) was working on his small malagans, when he heard that some people were fishing on his part of the reef. He went down to the beach and saw a group of *lulura.* (These anthropomorphic beings of small size, and usually gifted with extraordinary strength, are regarded as masters of useful arts and crafts.) He asked them whether they knew that his part of the reef was placed under a taboo. The *lulura,* afraid of the *ges's* anger, gave him the fish. The *ges,* who had been wondering where to put all of his little malagans, placed them on the fish. Then he went up to his place, where he removed the malagans from the fish and stored them in their resting place. He then cooked and ate the fish. The place where the *ges* is said to have made the platform to store the malagans is a cave behind Sambuari.

The lower malagan (fig. no. 13) is a *ges.* He is depicted as a sitting figure with arms raised, in a manner similar to the gesture of supplication in traditional European art. The story tells how a child chased a phalanger (a tree-living marsupial) while its mother was working in the garden. The phalanger fled into a crevice. When the child reached in for it, its hand became stuck. The child cried, and the *ges* found it. He freed the child and caught the phalanger too. Then the *ges* took the child along and showed it his cave. In the cave the child saw the malagan figure of the *ges,* and when asked whether it would like to have it, the child answered "yes." But as the child could not pay for the figure, it went back to its father and told him about the *ges's* offer. The father raised an immense amount of shell money and purchased the malagan from the *ges.* Afterwards, the father staged a big malagan feast. People from all over attended, to see the *ges* malagan. Some purchased the rights to it, and they again celebrated the malagan feast; still others purchased the malagan from them. So it went on and on until today.

A third malagan, visible in the upper left corner of the "house," is a "tree of the birds," consisting of sticks with carved birds sitting on them; there is also a hanging human figure. The story relates how birds returning to their tree found the woman Lukep, who had commited suicide by hanging herself. (Formerly, to hang oneself was often the response to an accusation of incest.) They carried her back to her house. Her brother wailed, and she was buried. This story was also the theme of one of the songs sung during the ceremonies.

A fourth malagan was a mask of the type known in Tatau as *wanis,* though commonly called *tatanua* in the ethnographic literature. Baie had no story to tell about it. A dancer wearing this mask was dressed as a traditional shark-catcher (fig. no. 14).

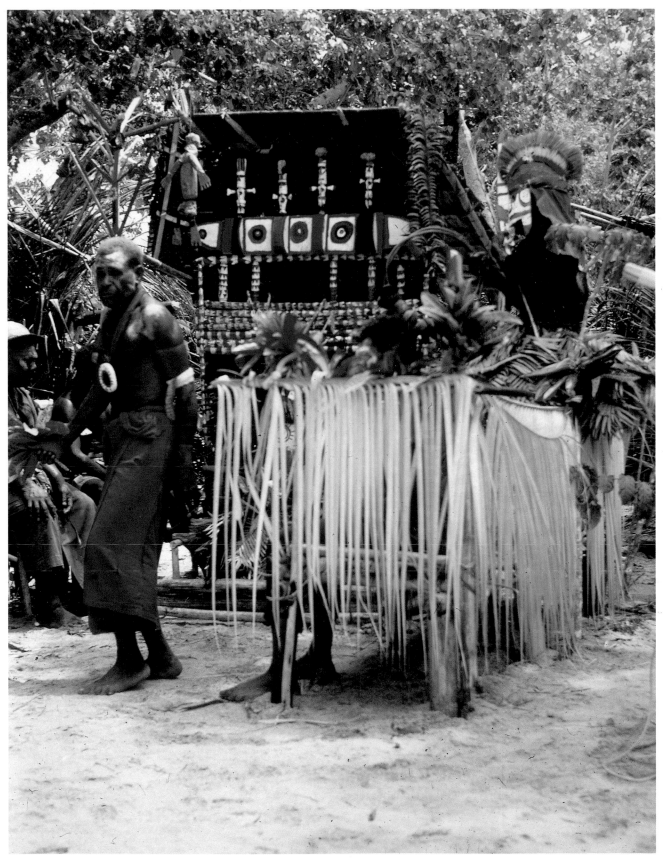

Fig. 14.　Dancer dressed as shark catcher at upper right;
Baie at left (Photograph by the author).

This combination of malagans was called *kosolik ngas*. It is said that just as a village comprises all of its named hamlets, so too does the big name of a malagan comprise its small names. During the ceremony some children received the names of the malagans displayed, except *malanggatsak*, because the suffix *–tsak–* has a pejorative meaning. A few days after the ceremonies, all the malagans were burnt.[8]

On Baie's frieze the four figures stand on its upper edge. Although this position seems unusual—as a rule the figures stand in front of the plank—it is not without precedent.[9] The names given to the four figures are familiar ones (*songsong, walik, kuletmo* and *malanggatsak*) as they are among the approximately 20 big-name malagan groups to be found on the Tabar Islands. Data for Songsong are too rare to permit a detailed discussion, so we shall concentrate our inquiry on the other three names.[10] The *malanggatsak* category is divided up into various named descent-groups, each of which includes malagans of different sculptural shapes: single statues and friezes, vertical poles showing figures standing one on top of the next, carved heads to be placed on a body made of other materials, and masks. Where anthropomorphic beings are represented, they belong to one of three classes: human, *ges*, or *tangala*. Another source says that the *malanggatsak* "family" is made up entirely of *ges* images.[11]

Among the works identified as *malanggatsak* by New Irelanders themselves, there are single statues, poles, and wooden carved heads placed on figures made of other materials. Most of the motifs in these images can be found on other types of malagans; for example, the figure of a man standing in the mouth of a fish, or the "feather" crown which sometimes resembles the inverted bird head motif used on the large ears of masks and formerly worn as a warrior's headdress.[13] As in other malagan families, *malanggatsak* also includes images of deceased persons. However, other motifs are said to be common to a particular "family" and should be represented on all its variants. All *malanggatsak* under consideration show a particular face shape, a towering headdress with a central column and feather decoration (either carved or real feathers), and a "helmet" that looks like a mitre, the cleft worn lengthwise instead of crosswise (see cat. no. 34). According to one source, the distinctive mark of *malanggatsak* is the stylized image of a snake on the sides of the "helmet."[14]

There is only a remote resemblance between these samples of *malanggatsak* and the figure bearing the same name carved by Baie. The similarity does not go beyond the feather headdress, the expanded arms, and the thin staff in front of the figure, traits which can be observed on some, but not all, of the other *malanggatsak*. On the other hand, traits observed on the *malanggatsak* are indicated on Baie's three other figures—the "mitre" and the central column of the headdress on the two inner figures. However, these were named differently. Judging by iconographic elements alone, it would not be possible to subsume Baie's figures under one of the name-bearing malagan groups hitherto known.

The iconography of malagan art does not seem to be canonized to the same degree as, for instance, medieval art. A medieval female figure with a particular composition of motifs can surely be recognized as an image of the Holy Virgin. There will be less certainty, though, when we try to recognize a New Ireland carving as a particular malagan without having heard its attendant story. Some patterns are passed on only by memory, not by material images.[15] It must also be assumed that what we have learned about malagans over the last hundred years is but a fragmentary record of the total array of malagan patterns.

Was Baie's rendering of *malanggatsak* inaccurate? In a sense, every actual malagan figure represents a single interpretation of a remembered pattern. There may be richer or poorer interpretations, the profound or the superficial ones, but to decide which one is the more accurate would be to declare one of a series of manifestations as the standard. Even the more deviant interpretations do follow a set of rules and emphasize certain concepts. During a big malagan feast at Munawai in July 1968, a speaker explained one malagan by telling the story of a man who was stealing nuts by climbing a coconut frond fastened to the stem of an areca palm which had been declared taboo. Another man was angry about the thief and climbed the areca palm to beat him up. This story sounds like a trivialized version of a more complex tale, but it seemed to be precisely the version the carver had followed. The artist has rendered the story in a narrative style learned at mission school. The effect of this was to produce an illustration of unusual directness that dispenses with many of the traditional nuances of the story (fig. no. 15).[16] Claude Lévi-Strauss advised looking at all versions of a myth with equal seriousness because a myth comprises all its versions, and only when analyzed in its entirety does a myth reveal those multidimensional symbolic relations that provide a key to its seemingly obscure meaning.[17]

There may have been some fanciful specimens produced as early as 1900 to satisfy the demands of the European market.[18] Because a carver would not have dared produce a traditional malagan pattern with-

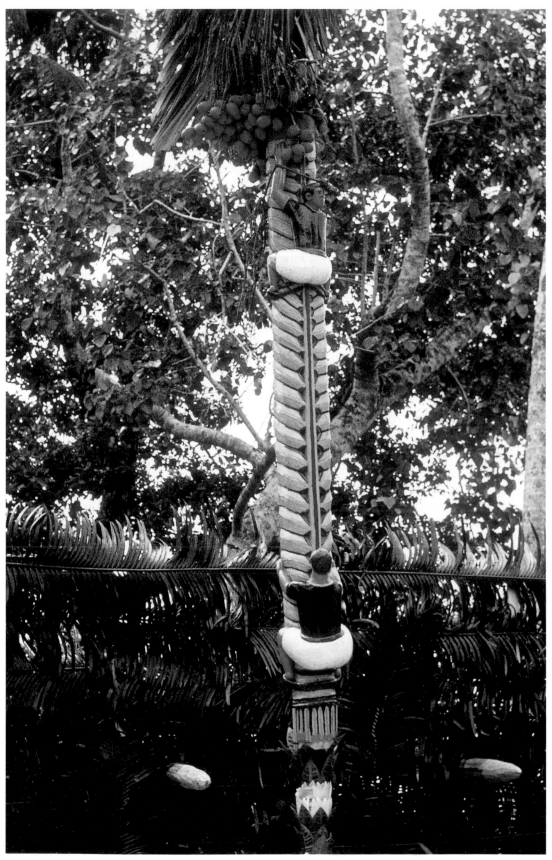

Fig. 15. Malagan carving depicting story of the man who stole *areca* nuts, Munawai, 1968 (Photograph by the author).

Fig. 16. Cement grave markers, Munawai, 1968 (Photograph by the author).

out being authorized to do so by a "big man," he might have resorted to his fantasy. In doing so, however, he departed neither from the range of possible motifs nor from the structural and stylistic formulae of malagan art. But from this we must conclude that such "inauthentic" malagans cannot nowadays be distinguished from genuine ones. Tabar Island men say that they often follow a similar practice when trading malagan rights to mainland New Ireland, by inventing designs rather than using inherited ones. Some Tabar men are even suspected of celebrating a newly created malagan on the mainland in order to claim the pattern as their own on Tabar, thus improving their chances of acquiring the status of a "big man."[19] But insinuations of this kind point only to the dynamics of the whole system. In a sense, the very act of a properly executed transfer has the effect of bestowing authenticity of a malagan pattern.

Walik and *Kuletmo*, the names given to two of

the figures on Baie's frieze, are usually used to designate the whole horizontal composition.[20] A central openwork pattern seems to be the distinctive design of *walik* (see cat. no. 45).[21] This pattern is made up of a cross and two symmetrically arranged half-discs, each of which consists of a continuous black band with white dots and a serrated red fringe laid out in narrow parallel loops. These form quarter-circles, except for the outermost and innermost loops where the band traverses the bar and connects the two quarters. As a rule, an eye rises from the center of the pattern. The pattern is called "fire," or "eye of the fire."[22] The concentric circles on Baie's frieze might have been a simplified rendering of this motif. "Eye of the fire" is also a metaphorical expression for the cemetery, the former cremation place (Nalik *mara-na-gheif*) identical with the men's enclosure wherein malagans are produced. It is tempting to see the central design as a direct translation of a metaphor into

sculptural form. One of the knowledgeable old men of Fisoa even directly associated the pattern with the dead persons in whose commemoration a *walik* is being carved.[23]

In discussing the fire pattern, some said that on other malagans it could be replaced by a traditional coconut water-container. This substitution does not seem to be accidental, as the central opening on other types of friezes is sometimes associated with water, such as when the two birds often seen beside the opening are said to be drinking at a pool (see cat. no. 44).[24] When there is a fire, the two birds are said to be blowing into it. Sometimes the fire pattern was recognized both as a fire and as a water-container.[25] The contrast of fire to water seems to find its true "coincidence of the opposites" in two secret objects observed and described by Powdermaker. Called *pundän*, "some water," they consisted of coconut shells painted black with white dots and topped with a "carved piece of wood just like the center of the *walik malanggans*."[26]

The placement of a hole in the center instead of the fire is sometimes said to be what distinguishes the *kuletmo* from the *walik* malagan. On the other hand, friezes showing the fire are sometimes also classified as *kuletmo*.[27] If we regard *walik* and *kuletmo* as two different "families" of malagan, then they seem to be closely related even to the point of being confused.

We may speculate that it is their opposition that affiliates them. We may here be touching on some underlying principle of the New Ireland malagan taxonomy which differs from a straightforward system of exclusive categories. If New Irelanders use the metaphor "family" to explain their malagan categories, they do so for a reason. In the same way that clans and their subdivisions can only be understood as individual units when viewed in contrast with others, the crossing of malagan categories may also provide a deeper insight.

There are some additional facts to consider. The central hole was said to be ritually opened by throwing a stick or a nut at it. In two of the reported cases this ritual came before the friezes had been given their final coat of paint.[28] Another example: a man standing behind the screen looks through the hole during the ceremonies.[29] Or, the head filling the hole may be a carved one. If there are *drongos* on either side of the hole, the hole itself was looked upon as the place in a tree where "the birds put their eggs."[30] A frieze showing two lobsters (Nalik *urang*) beside the central motif was called the "hole of the lobster" (*boulurang*). None of these interpretations can be thought irrelevant to the symbolism of the central motif.

I want to comment briefly on just one of the other transformations of the central motif. A *walik-*

Fig. 17. Marada malagan, Munawai, 1968 (Photograph by the author).

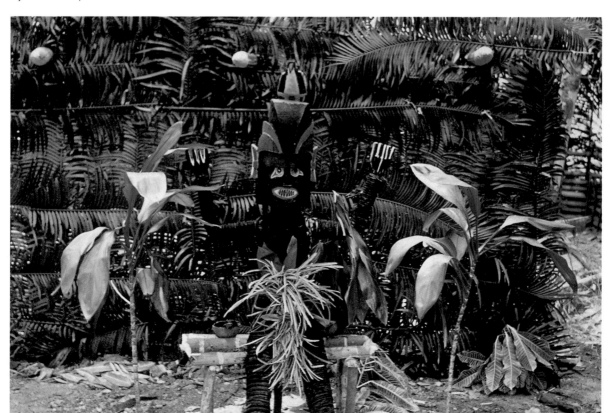

mantelingling displayed in 1954 at Sali, near Ḥamba, showed only the central motif, executed as a plaited disc. *Mantelingling* means "morning star."[31] The central motif of a malagan carved in Lesu in 1929 was called *mutenalin*, representing "the dawn, or the light just before sunrise."[32] The star can be found quite often on the large ears of the *marua* masks (see fig. nos. 18, 20, 22). The star on the mask in fig. 22 was said definitely to be the morning star. *Drongos*, too, so prominent a motif on friezes (see cat. no. 48), are associated with the early morning as time-markers.[33] It may be rewarding to give some attention to the moment just before sunrise as a time of particular symbolic significance.

The fish heads at the ends of friezes seem to be symbolically comparable to the pig heads. On Tabar, people assume "that a pig's head indicates bush ancestry, the fish head a saltwater origin."[34] And there is a motif which indicates the close relationship between pigs and fish: on some friezes, the fishes have boar tusks (see cat. no. 44). (The key to this peculiar motif may be found in a metaphorical expression: a "big man" who has great authority, who rules well and brings well-being to a village, is said to be "a man with teeth.") Pigs are the symbol of wealth and prestige; the fishes shown on the friezes seem to be edible ones, as far as their species could be determined.[35] Therefore, the common denominator making pigs and fish a symbolic alternative is that both are food. A big man's ability and power determines how plentiful the supply of pigs and fish will be on ceremonial occa-

sions. This argument is suggested by a metaphor that explains the boar tusks on fishes. The fish motif in general has also been more speculatively associated with the concept, found elsewhere in Oceania, of soul fishes.[36]

Two kinds of birds with long tail feathers, the *drongo* and the frigate bird are used on friezes and other types of malagan. It is not clear by what criteria the artist chooses between the two. There is also the fact that these two birds can be replaced by other birds, or by other animals, such as dogs (see cat. no. 45). The unsatisfactory state of our knowledge, in this case about bird lore, again makes itself painfully felt.[37] For, if of all the natural species—or phenomena in general —some are selected for symbols "not because they are 'good to eat'," as Lévi-Strauss said, "but because they are 'good to think',"[38] then we have to look for the characteristics ascribed to them within the symbolic world of a society. Why are the *drongo*, or the owl, so central to malagan symbolism, and not certain other birds?

When I inquired about *kuletmo*, what often came to informants' minds besides the central motif was the multiplicity of figures of the dead.[39] The horizontal or vertical alignment of the figures was looked upon only as alternative sculptural formulae. These figures of the dead also appear as single statues or on other malagans, where they represent the individual person in whose commemoration the pieces are carved. They do not reflect individuality in a psychological sense, but, rather, the social personality. Consequently, the decorations worn by the figures are signs of the deceased person's status. The facepaint depends on the clan and subclan affiliation and the malagan group owned.[40] Most of the figures wear a *kapkap*, the men's round breastplate made of Tridacna shell overlaid with a tortoiseshell openwork ornament. The *kapkap* belongs to the insignia bestowed on a man who is ritually appointed as *maimai*, a kind of orator chief and herald. Interestingly, figures representing women, too, can wear the *kapkap*. Also, both sexes are shown wearing the apron (see cat. no. 48), as they traditionally did during certain malagan ceremonies, whereas in ordinary life of bygone times only women wore an apron.[41] These figures of the dead have nowadays often been replaced by inscribed cement gravestones (see fig. no. 6).

In Baie's malagan house the *ges* was a seated figure. Usually consisting of a carved human head and a separately constructed body, the seated figure is one of the basic forms of malagan art, used for various images.[42] *Ges* images are also found on masks and carved statues,[43] and are said to be included in at least

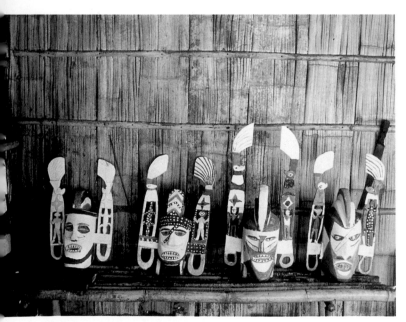

Fig. 18. Waika's unfinished *marua* masks, Tovabe, 1968 (Photograph by the author).

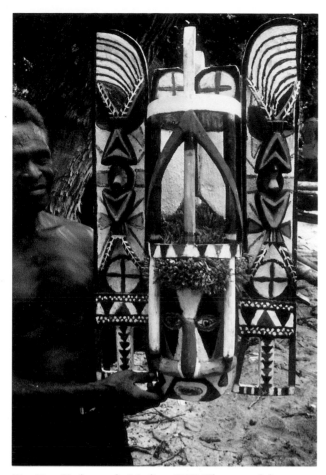

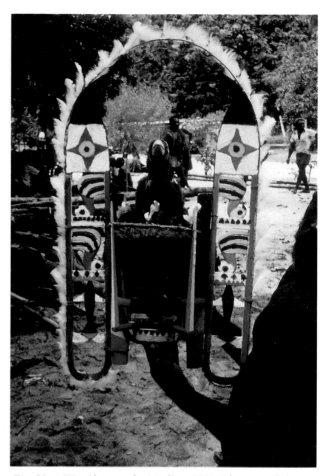

Fig. 19. Pitalot mask, Madina, 1980 (Photograph by the author).

Fig. 20. Waneskan mask, Madina, 1980 (Photograph by the author).

five big-name groupings on the Tabar Islands.[44] If compared to a *marada* of the same basic form (see fig. no. 17) some characteristic *ges* features become recognizable. There are the "slitted" eyes in a diagonal position (cat. no. 9), the upright rods decorated with cloth and feathers, and the voluminous black beard. A *ges* malagan displayed at Nou, near Libba, in 1954 had no "slitted" eyes, but had "tusks rising from the corners of the mouth" and a pierced nasal septum with some decoration put through.[45] *Ges* are also said to have straight, long hair hanging down from their heads all around (in contrast to New Irelanders), or two long teeth. One may speculate that the distinguishing marks of *ges* images are those elements that distort the human shape and thus cause fear. Gunn has suggested that one might see the "wild man" or the "anti-culture anti-hero" in the *ges*.[46] But, in the origin tales of the malagans, it is frequently a *ges* who creates the various sculptures and passes them on to human beings.[47] In the Notsi area the *ges* is also reported to be the spirit double of a living person, dwelling on the clan land and dying with its human counterpart.[48]

Seated figures with carved heads and bodies composed of vines and other materials usually have raised arms. No explanation was given for this motif, and so far we are left with a still more indirect and speculative approach. According to an early source, the corpse itself was displayed in a seated position, its arms kept raised by threads, and was buried or cremated in this position.[49] The *tabaran* figures (spirits of the dead) of the Tolai people of neighboring East New Britain make the same gesture, possibly an indication of the transcendental status of the beings depicted.[50] Whatever the appropriate interpretation of the gesture, the iconographer should be aware that the language of images is partly independent of verbal traditions. The two traditions may meet only on a deeper structural level.

Though *tatanua* and *marua* are often used as synonyms, they can also be distinguished. The *marua* are true malagans, whereas the *tatanua* are only "half a mala-

gan."[51] The area of Fisoa and Madina was said to be a "true place of the *marua*," the elaborately carved masks. *Marua* is a "big name" embracing quite a number of subtypes, and the celebration of a *marua* feast would require many pigs and much produce. The *marua* clear all traces of a dead person from where he lived; they also remove the taboos under which the deceased's house and part of his property had automatically been put. The *marua* masks are said to be pictures of the dead. But the masks also appear during the initiation ceremonies and during the rites for a small child born and brought up in the enclosure; as with other malagans, children may be given the name of a particular *marua* during the ceremonies.

In 1968 Waika of Tovabe explained to me several *marua* he was working on (see fig. no. 18). The first and the fourth were looked upon as identical, though in fact the first, on the left, is not a *marua*. The second mask has the *tatanua* crest—the ornaments on the front of the crest consist of angular stripes, the red ones being called "rainbow," the black ones with white

Fig. 21. Dancers wearing *pitalot* and *waneskande* masks, Madina, 1980 (Photograph by the author).

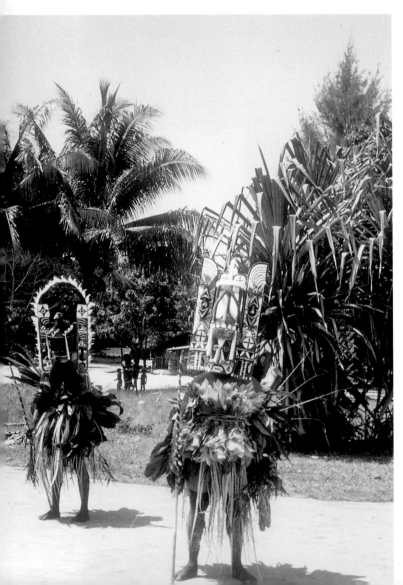

dots named after a snake on the reef. The snake motif also covers the forehead and part of the ear. The ears are crowned by a carved headdress with feathers from the red bird *ghilghilong*. On the right ear there is the figure of a *lulura* and a star, on the left a lizard. The lizard is a servant of a *ghulghul*, a *masalai* of Waika's family, and lives at the *ghulghul's* place. The *ghulghul* was said to be the originator of this *marua*. On the third mask there are *lulura* on both ears and the same feather headdresses as before. The two small, black areas above the star on the right ear were said to be clouds going to form a heavy raincloud. The comb-like patterns beneath the eyes were called the legs of a crab. The fourth mask also depicts the lizard and the *lulura*; the ornaments on the face were the legs of a crab and an unnamed one. All four mask faces had a beard indicated by a black chin. It should not be misleading that almost all ornaments bear names, because many of them are indeed mere ornaments. But we remain ignorant of their possible iconographic significance.

When an old lady of Madina died in 1980 she was cremated in the traditional way, to fulfill her last wish. *Marua* masks had to dance before the cremation platform could be removed. For this ceremony Ahomarang of Madina made two of his *marua* appear, a *pitalot* (fig. no. 19) and a *waneskande* (fig. no. 20). The *pitalot*, a male mask, depicted four *drongos*, the old warrior's headdress, and a star-like motif on his ears.[52] The *waneskande* was crowned by a real hornbill. The ears showed fishes, stars, and four feather headdresses arranged in an intricate symmetry.

Inquiries on this level seem to turn up only isolated motifs. But an initial ordering of data is possible if we classify the motifs by their iconographic function. A *marua* mask, interpreted for me by Mr. Demas Kavavu of Fatmilak in 1980, may serve as an example (fig. no. 22). The mask was a *vaneriu*, a type of *marua* which is itself also divided into various subtypes. It originally came from Lesu, whence it was taken to a small place behind Fatmilak. There, the present owner's ancestors acquired its rights. It was handed down within this family of the clan Manga-Tirin until today. The *vaneriu* of 1980 had been carved to commemorate the owner's mother and one of his babies who had died a few years earlier. As a result, there are the "figures of the dead" on the ears, both of them women wearing the traditional women's cap made of pandanus leaves. The star above the figures is the morning star. The lobster was originally part of another malagan which came from the island of Simberi; the owner of the *vaneriu* later acquired the rights to this part and incorporated the lobsters into

his *vaneriu*. This amalgamation is of particular interest because it points to a factor possibly responsible for the great variability of malagans.

There is a group of motifs which are common to all masks and should, as a rule, be used, among them the four croton leaves seen under the lobsters and the feathers bound to the borders of the ears. Other motifs serve to distinguish this kind of *vaneriu* from another, such as the horizontal yellow croton leaves extending from the nose to the cheeks, and the upward-stretched tongue that has the particular function of threatening all offenders against the owner's copyright. Finally, there are those purely aesthetic motifs, such as the leaves added to fill the space, or lines separating areas of different color.

———————

I have deliberately refrained from more speculative considerations. For several decades far-reaching historical questions have dominated the study of malagan art without producing more than a few (admittedly interesting) hints. Though it is tempting to consider some formal characteristics, such as the subtle play of symmetries or the ingenuity of the malagan "ars combinatoria," an ordering of motifs by their iconographic function can never be done in an *a priori* manner. This fact demonstrates the limits of all secondary studies.

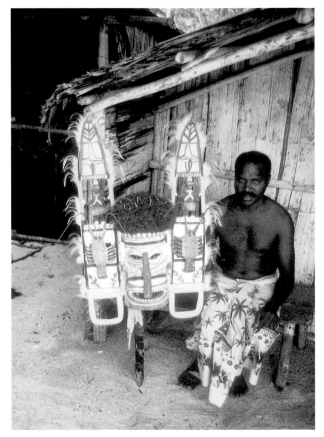

Fig. 22. *Vaneriu*, Fatmilak, 1980 (Photograph by the author).

Field research made possible by a grant from the Deutsche Forschungsgemeinschaft was carried out in New Ireland (Nalik language area) in 1968. I also stayed for a few weeks in the same area in 1980. I thank Mrs. Elizabeth Wever for many valuable improvements to the text.

1. Cf. Michael Gunn, "Tabar Malagan—An outline of the Emic Taxonomy," *Development of the Arts in the Pacific*, ed. Philip J. Dark. Occasional Papers of the Pacific Arts Association, no. 1 (Wellington, 1984): 88.

2. When Leleu of Fisoa told the story of the malagan *virinus*, he emphatically included the episode of the annexation of the place Bura by people of the *Manga-Nuas* clan. As was to be expected in a society without any group of sufficient power to enforce one version of the story, Leleu's story did not remain unchallenged by members of other clans.

3. Powdermaker was written of how a malagan originated in a man's dream. Shortly before his death, the man passed on this malagan to his relatives. Characteristically, in the dream he was shown the malagan by a *ges*. Hortense Powdermaker, *Life in Lesu* (London: Williams & Norgate, 1933), pp. 317–8.

4. This seems to have been the case with a malagan bearing the overall name of *lounuet*, the name of the so-called friction drum.

5. The situation may be better on the Tabar Islands. See Gunn, p. 81.

6. In the Tatau language, *vanua malangga*; in Nalik, *a val a malagan*. Baie used the Tatau terms. Whenever there was one, the Nalik term was given too.

7. According to information provided by my Nalik informants, *tulangi* means "picture of a cloud," and *bara* means "cloud." Baie gave the name of the leaves used. I observed a *tulangi* being used as a background for the plaited round *oara*.

8. Baie's malagan did not go without criticism. Luwindi of Lawaupul, who was also born on Tabar, declared that the malagan was his. He was also dissatisfied with the frieze, which was not, he said, the appropriate rendering of this malagan.

9. For example, Basel Vb 10581. See Carl A. Schmitz, *Oceanic Art* (New York: Harry N. Abrams, 1969), pl. 178.

10. For a convenient synoptic listing of malagan names recorded before 1969, see Phillip H. Lewis, "The Social Context of Art in Northern New Ireland," 58 (Chicago: Field Museum, 1969), fig. 46.

11. G. N. Wilkinson, "Carving a Social Message: The Malanggans of Tabar," *Art in Society*, eds. Michael Greenhalgh and Vincent Megaw (London: Duckworth, 1978), p. 237. This statement contradicts others, such as Gunn, pp. 82–89. But there is also some confusion about the concept of *ges*. For a brief discussion, see Lewis, pp. 88–89.

12. In Bühler's collection of 1931 in the Museum für Völkerkunde in Basel there are six *malanggatsak* figures, four single statues, and two poles. Five of the figures belong to one malagan house. See the photograph in *Ozeanische Kunst* (Basel: Museum für Völkerkunde, 1980), p. 5.

13. Cf. Krämer, pl. 36.

14. Wilkinson, p. 237.

15. See Gunn's remark, p. 89, that "often a person will receive the rights to a malagan without having seen an example of it, . . ." I made it a habit to ask informants on malagan art whether or not they had actually seen the piece.

16. Walden described a malagan *vilvilai* he had seen in Logagun: "The malagan represented an areca palm. . . . In addition, two men, Landau and Longe, are represented who want to steal nuts though the palm is tabooed and therefore marked with a wreath made of sago-palm leaves. Landau has climbed the tree and hands down the nuts to Longe who clings to the lower part of the stem and is said to be warning against the theft." Hans Nevermann, "Totenfeiern und Malagane von Nord-Neumecklenburg. Nach Aufzeichnungen von E. Walden," *Zeitschrift für Ethnologie* 72 (Berlin, 1940), p. 27.

17. Claude Lévi-Strauss, "The structural study of myth," *The Journal of American Folklore* 68 (1955), p. 436.

18. See Tibor Bodrogi, "Malagans in North New Ireland. L. Biró's unpublished notes," *Acta Ethnographica*, 16 (Budapest, 1967), p. 76.

19. Michael Gunn, "Rock Art on Tabar, New Ireland Province, Papua New Guinea," *Anthropos* 81 (1986), p. 464.

20. Wilkinson refers to a single statue *molangeniuwinepuris valik*, p. 239, fig. 12. Regrettably, only the head is depicted. One would like to know whether there is also any visible mark that indicates an affiliation of this statue with the *walik* "family."

21. Cf. the drawing made by informants, Krämer, p. 74, fig. 19e. For *waliks* photographed in the field, see Krämer, pl. 38 (Lesu, 1909) and pl. 39 (Lamasong, 1909); and Wilkinson, p. 231, fig. 4.

22. Nalik: *gheif* (-gh- used for [&]), or *auvara*. Cf. Wilkinson, p. 229. Krämer, p. 82, gives *mbane* (Notsi language), saying that it represents "the hearth, the pyre, or heap of ashes, the eye peeping out of it being the fire, or glow."

23. My informant, F. X. Bolaf, says that usually, only the human figures on most *walik* malagans are directly associated with the dead.

24. Richard Parkinson, *Dreissig Jahre in der Südsee* (Stuttgart: Strecker & Schröder, 1907), p. 651. Cf. Wilkinson, p. 229.

25. Museum für Völkerkunde, Basel: Bühler's notes on index card Vb 10583.

26. Powdermaker, p. 132. There is also a frieze in the collection of the Museum für Völkerkunde, Berlin, that shows a water-container in the center and two fires besides it.

27. Krämer, p. 76; Wilkinson, p. 229. When shown pictures of friezes having the fire in the center, informants recognized them as *walik* as well as *kuletmo*.

28. Powdermaker, p. 121. Cf. Gerhard Peekel, "Die Ahnenbilder von Nord-Neu-Mecklenburg (Schluss)," *Anthropos* 22 (1927), pp. 17–18.

29. Krämer, p. 82. Peekel, ibid.

30. The drongo does not make holes, but seems to use existing holes in trees for its nest. See Friedrich Dahl, *Das Leben der Vögel auf den Bismarckinseln* (Berlin: Friedlander & Sohn, 1899), p. 205.

31. Lewis, pp. 112–14, and fig. 27.

32. Powdermaker, p. 212.

33. "If we are in the bush, and there are no fowl, we will hear him, and it is close to sunrise now." (L. Aramis, 1968).

34. Gunn, 1984, p. 82.

35. Traditionally the skulls of pigs killed for feasts were hung on a forked tree set up for that purpose, as could still be seen in some villages on the Lelet plateau in 1968. There are also in the collections some body decorations made of boar tusks. Two species of fish, *belevai* and *aiateraf*, (Nalik language), are often seen on the friezes.

36. Alfred Bühler, "Totenfeste in Nord-Neuirland," *Verhandlungen der Schweizerischen Naturforschenden Gesellschaft*, 114. Jahresversammlung (Aarau, 1933), p. 265. Cf. Nevermann, p. 12.

37. As far as I know, only Krämer gave such details greater attention. In 1909 at Lamasong he recorded a genealogically ordered survey of the avifauna. See Krämer, p. 35, and his posthumously published notes in Hans Nevermann, "Tiergeschichten und mythische Stammbäume aus Neumecklenburg aus dem Nachlass Augustin Krämers," *Zeitschrift für Ethnologie* 81 (1956), p. 181.

38. Claude Lévi-Strauss, *Totemism* (Boston: Beacon Press, 1963), p. 89.

39. Nalik: *ruap*, "size," "skin," "picture."

40. Gunn, 1984, p. 83.

41. There are certainly some traits of at least a partial suspension or even reversal of the normal order of things during some malagan ceremonies, such as when women are admitted to the men's enclosure. See Powdermaker, p. 130.

42. Peekel, 1927, p. 20, identifies the figures consisting of carved heads and separately constructed bodies with *marada*, but this is misleading, for there are also carved *marada*. *Marada* is a "family" of images of various forms.

43. Mask: Basel Vb 10902. Statues: Wilkinson, p. 236, fig. 11.

44. Gunn, 1984, p. 83.

45. Lewis, pp. 84–89. fig. 16, p. 85.

46. Gunn, 1984, p. 83.

47. The other spirits said to create malagans are the *lulura*, the *virua* (spirits of persons who suffered an untimely death), and sometimes also the *masalai*.

48. Powdermaker, p. 39.

49. Parkinson, p. 274.

50. Cf. Hans Damm, "Ethnographische Materialien aus dem Küstengebiet der Gazelle-Halbinsel (Neubritannien)," *Jahrbuch des Museums für Völkerkunde zu Leipzig*, 16 (Berlin, 1959), pp. 110–52.

51. Sometimes the word *marubat* (*bat*, "head") was used to distinguish *marua* from *tatanua*.

52. The male *marua* masks include *vaneriu*, *torughai*, *pitalot* (or *pitalelot*). Some female masks are *takmangaf*, *maruanis*, and *sangararau*. For a brief discussion of the very few masks identified as *pitalot* in the collections, see Klaus Helfrich, *malanggan 1: Bildwerke von Neuirland* (Berlin: Museum für Völkerkunde, 1973), p. 26 and pl. 47 a, b. There is not much similarity between the *pitalot*.

Figure-Ground Reversal Among the Barok

Roy Wagner

What is the relation of art, of thinking and feeling in images, to the form and being of a human culture? We in the modern Western cultures often say that our greatest art transcends the age and cultural surroundings in which it was created. But of course Shakespeare, Vermeer, and Mozart were very much persons of their own times and cultures, and their art, however transcendent, must manifest a significant part of the creativity of the age and culture. My experience in studying the Usen Barok people of central New Ireland has convinced me that their culture is very much a matter of thinking and feeling in images. This means that the conception and motivation behind the malagan and other New Ireland art styles manifests something very basic in the cultures of this remarkable island. The fact that the Barok do not participate in the malagan tradition may serve, through the examples I present, to give the reader a broader and more varied sense of the possibility of a culture organized around art principles—around thinking and feeling in images.

Let me first clarify an important point. By "image" I do not simply mean "visual image," though New Irelanders often show a predilection for the visual. A cultural image can be verbal, as in the tropes, conceits, and other word pictures that carry much of the force of Shakespeare's expression; it can be expressed in the nonrepresentational forms of music; or it can be kinesthetic or architectural, as it often is in New Ireland. An image has the power of synthesis: it condenses whole realms of possible ideas and interpretations and allows complex relationships to be perceived and grasped in an instant.

I shall illustrate this by using a common Barok verbal image as an example. Like other New Irelanders, Barok trace clan membership through the mother's line (though blood connection, traced through the father, is also very important). The Barok term for "clan" is *a bung marapun*, literally "the gathering in the bird's eye." The image is in constant, daily use, though most of those who use it will claim, when asked, that they have no idea what the image means. Older men, knowledgeable about ritual, will often say that the bird involved is the *sek*, a bird that ornithologists call the colonial starling. This bird is distinctive for its ruby-red eyes, perhaps suggestive of maternal blood (since paternal "blood" is semen, and white). But the *sek* is also distinctive for its habit of making its domed, thatch-covered nests in large communal colonies in trees above human gardens or villages. Since the Barok word for "eye," *mara*, likewise connotes "clearing" or "focal epicenter," the "gathering in the bird's eye" might also image the human clearing placed "in view" of the birds' "village." There are other possibilities as well, each bringing its own nuance or creative insight to the understanding of the image. It is, of course, possible that all of these interpretations of *mara* are implied. But it is also possible that the ambiguity itself, the similarity among various interpretations, is more important than the specific interpretations. And there are those who say that the "eye" really refers to the spot of blood in the fertilized egg of another bird, not the *sek*.

The fact of the matter is that whatever interpretations we make, whether specific or general, naïve or subtle, and whatever authority we may base it on, it will always be open to doubt. Only the image itself is certain, and therefore the image itself is all that is needed. It has the power of eliciting (causing to perceive) all sorts of meanings in those who use and hear it, as well as the power of containing all the possible meanings that may be so elicited; for the image itself,

and only the image itself, is equal to all of them. By holding images in common, rather than the interpretations of images, Barok culture makes the synthesizing power of its collective images into the power of culture itself. Interpretation is an individual matter.

Because we can only experience the world through the images of it that we perceive, the Barok culture of collective images exists on the scale of human experience, rather than that of human talk about experience. Thus Barok say that words can trick you, that the only real knowledge is that which is directly experienced—knowledge, that is, of the images of culture or the world around us.

In a world where reality is image, and true knowledge can only be acquired by experiencing images, the ultimate power is power over images and perceptual effects—the power of image-transformations. Barok call this power *a lolos*, and it is the source of all things in the world and all actions in the world, including human action. When it occurs spontaneously, it is identified with form-changing place-spirits called *a tadak. Tadak* have no essential form, for their essence is their ability to change forms; they have no names, other than those of the several forms they habitually assume, and they are immortal, for the *tadak* whose form is threatened or dying need only change into a less evanescent form. *Tadak* are associated with specific locales, and also with specific human clans, whose members are at least nominally under their protection. The spirits are also jealous, willful, and capricious, and those whom they attack do not die, but are "swallowed," to live "within" the *tadak* and do its bidding forever. They are contained, so to speak, within the *tadak's* immortality.

Any sort of natural anomaly—unusual rock formations, strange behavior of plants or animals, the birth of a hydrocephalic child—is attributed to the activities of *tadak*. The *tadak* of Wutom Clan is said to animate the depictions of animals drawn by human beings on the walls of a particular cave, bringing them to life by transforming itself into the creatures depicted. *Tadak* in this case is something like the force of artistic creativity acting spontaneously in the world. But of course the human artists who originally drew the cave pictures were, like the human artists who carve, paint, and prepare malagan, also engaged in image-transformation. Hence, their talent, their creativity, is an instance of *a lolos*, of the power over images.

The great image-transformers of the Western tradition, Michelangelo, Leonardo, Shakespeare, Milton, Beethoven, Rodin, Rilke, may well be *our tadak*. They are unpredictable or antisocial in their spontaneity, impinging upon our conventional forms from the outside, as it were, containing, perhaps, our imaginations within their immortality. This unpredictability arises because Western tradition emphasizes verbal and rationalistic (linear) procedures and identifies itself with the predictable. But the main point of this essay is that the essence of artistic creativity, image-transformation, serves as the conscious center and effective constitutor of Usen Barok culture. It is the power of human ritual, in other words, rather than codified law, group solidarity, individual self-interest, or physical coercion, that guarantees property rights, moral status, and public standing of any kind.

Usen Barok call the power of their public ritual (*kastam*)[1] by the term *iri lolos*, meaning finished or manifest power, qualifying the noun with the perfective verbal affix (*-iri-*). It is power that has been wholly fixed or contained in customary usage. We do not normally think of our public rites, however moving they may be, as rites of power, though we might be persuaded to describe Beethoven's Fifth Symphony, a portrait by Rembrandt, or the integral calculus as "finished power." And so the question arises of just how the Barok consider their *kastam* to embody power.

In my earliest conversations with the Barok, they would often use the borrowed English word "meaning" (many Barok have at least a passing familiarity with the English language) to describe the importance of a ritual object or usage ("You see this tree? It has a big *meaning* for us.") At first I assumed they were simply using an important-sounding word for emphasis, without paying much attention to its more specific sense. But after I came to know something of their ritual life, I realized that the meaning referred to here is in fact that profoundly synthetic, condensed sense of the word that we might use to describe a great work of art or a significant triumph in mathematics.

Iri lolos is power, then, because of its ability to elicit the essential cultural meanings in people, an ability that is inherent in the self-demonstrating, synthetic character of its images. Taken as a whole, it contains, or synthesizes, the ranges of significance in Barok culture, which, in this respect, is self-analytic.

Because it is articulated through images, Barok social structure also reflects, reciprocally, the properties of image itself, elicitation and containment. It contains, and it also elicits, the totality of life and life-process. All the claims that human beings can make regarding one another, and all the claims they can make to property, come down to two things: the male act of conception and of giving food and nurturance to others —the elicitation of life; and the female act of contain-

ing the body in the womb, finalized by the ultimate containment of the body in the ground—the containment of life. The legitimation of all social statuses or claims must be realized through the ritual enactment and resolution of these principles, via feasting and containment.

Because they are matrilineal, tracing group membership and descent through the maternal line, Barok depict the image of group membership through the containment of the body in the mother's womb, and eventually in the ground of the group's territory. All Barok people, and all Barok clans, belong to one or another of the two halves, or moieties, of society. The moieties are designated *malaba*, the sea eagle, or "greater bird," and *tago*, the fish hawk, or "lesser bird." They are exogamous; members of one moiety can only marry those of the other, on pain of universal ostracism for those who do not comply. Each moiety claims both the containment of its own and the animation—the elicitation of life process within—of the other. Thus each moiety contains the proffered nurturance of the other and also nurtures the containment of the other.

The *iri lolos*, or public ritual, of the Barok has, therefore, two main components: feasting and containment. Every major event or social transition (including, for instance, a day spent in preparation for a major feast) requires a feast, and every death requires a cycle of them. With one significant exception (which will be described later), every feast must be held in a men's house, or *taun*, according to a strict protocol.

The *taun* is in fact an enclosure, a large, rectangular, dry stone wall, *a balat*, surrounding an open space. More or less in the center is the men's house proper, *a gunun*, a highly stylized edifice that divides the *taun* space in two. The forepart of the *taun* is the *konono*, or feasting space, with a display table for food in the center and low benches for feasters along the edges. At the front of the *konono* is the only entrance to the *taun*, the *olagabo*, or "gate of the pig." This takes the form of a stile carved at the base of a tree-fork, with the extending branches projecting outward on either side like a giant V. The rear space of the *taun* is the *ligu*, or clan burial ground. Barok say that the forepart of the *taun* is like the upper part of a tree, the branches (imaged by the entrance stile) that "feast" others with fruit, whereas the rear is where the ancestors, like roots of the clan, lie fixed in the ground.

The *taun* is both the image and the enactment of containment, enclosing both the elicitation of feasting and the encompassment of burial. Any male person is welcome to sleep and take refreshment in a *taun* at any time, or to stay there, and all men, regardless of affiliation, are welcome to attend all feasts and are entitled to an equal share of the foods and refreshers served there. By the same token, the *taun* is sacred space, pervaded by the ethic of *malum*—respect and forbearance out of compassion for the deceased; and *malili*—the ethic of good fellowship and generosity in feasting. And the *taun* itself, container of feasting, is literally made out of feasts, for every step in its construction, every few feet of *balat* finished, every detail of the structure, must be solemnized with a feast and with the killing of pigs.

Just as the *taun*'s enclosure is divided between feasting and containment proper, or burial, so the organization of the feast itself includes an initial phase, when the assembled food is contained within the hollow rectangle of seated feasters within the *taun*, and a second phase, when it is distributed and eaten. The first phase includes speeches explaining the purpose of the feast, the purchase and cutting of the cooked pigs, and any criticism (usually vociferous and scathing) the assembled "big men" may wish to make of the protocol followed on the occasion.

Thus the format of the feast itself is an image no less than the layout of the *taun* that contains it. But the *taun* and the feast in the *taun* together make a coordinate image, linking feasting and burial, and Barok say that all important *taun* feasts should follow the sequence of mortuary feasting. This sequence extends the imagery of containment and elicitation featured in the format of the individual feast to a schema involving a succession of kinds of feasts.

When any Usen Barok person dies, the whole Usen area goes under a mortuary interdict called the *lebe*, in which loud talking, displays of anger or unseemly behavior, and the lighting of large fires are prohibited. The *lebe* effectively extends the ethic of *malum* to the whole region; it remains in effect until the imagery of kinds of feasts is realized. Until that time, the feasts that are given (two or three, at the least) are closed feasts, imaging *malum* and containment. The body of the deceased is still in process of being absorbed in the ground; all food for the feasts must be nurturance brought in by the opposite moiety, no food (or even refuse) may be taken out of the *taun*, the pigs are placed facing inwards, toward the burial area, and distribution of the food proceeds from the front toward the rear.

Afterward, ideally when the body has totally decomposed and has been absorbed into the clan ground (but nowadays much sooner, in deference to schedules), the first open feast is held, ending the *lebe*. The moiety has now encompassed the deceased and can turn to nurturing the other; it supplies the food in

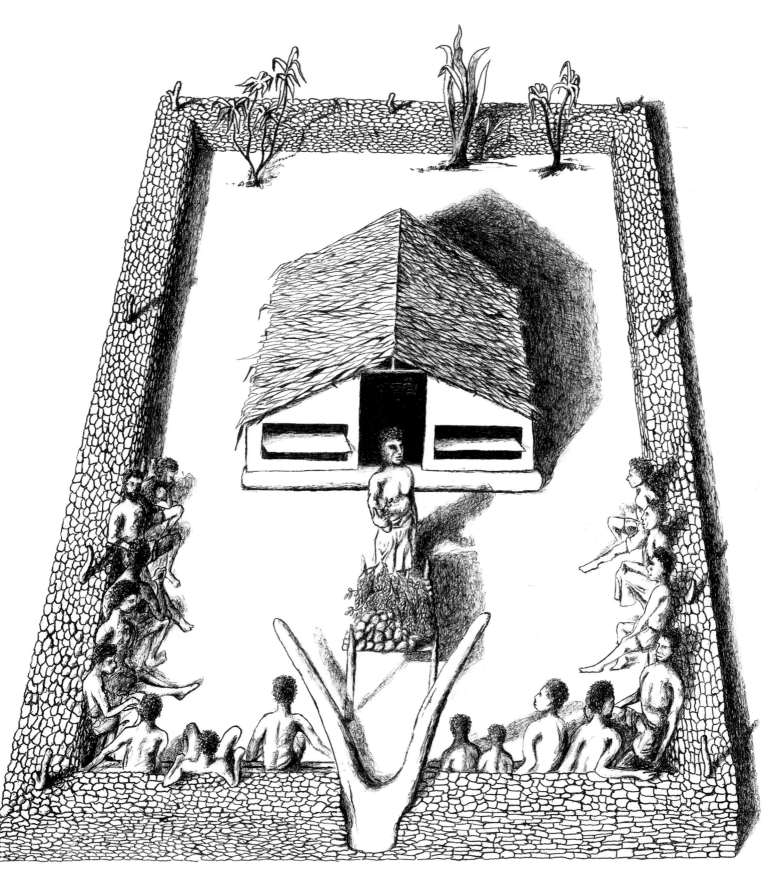

Fig. 23. *Taun* enclosure with *olagabo*, or gate of the pig in foreground (Drawing by the author).

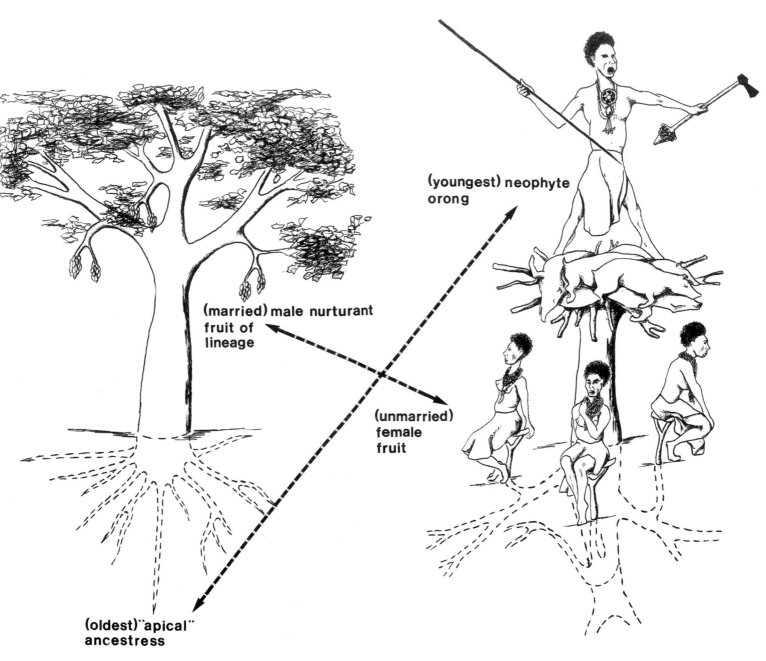

(youngest) neophyte
orong

(married) male nurturant
fruit of
lineage

(unmarried)
female
fruit

(oldest) "apical"
ancestress

Fig. 24. Diagram of feasting display as an inversion of
una ya kaba image (Drawing by the author).

such plenitude that all can (and may) take some home afterward, the pigs are placed facing outward, toward the gate, and distribution of food proceeds from the rear toward the front of the feasting area. When the sequence is applied in a context other than mortuary, two successive feasts, a closed and an open, are sufficient.

Apart from its curious holography—the fact that the ways in which it works (elicitation, containment) are the same as the ways in which it is structured, in other words, that component elements replicate in detail the larger structures that contain them—the system of *iri lolos* described thus far does not differ radically from more familiar forms of organization. Allowing for the peculiarities of image (e.g. holography), it suggests a social order based on certain premises that are translated into nonverbal means, on the principle of the rebus. It looks, in short, very predictable, as we might fondly imagine our own system is. Where, then, is the *tadak*-like creativity, the power of image-transformation that I spoke of earlier?

The answer is given by a final, and most unpredictable, twist of the holography. The distinction between elicitation and containment, feasting and burial, paternal and maternal role, keeps the Barok world in order. The ancestors, buried at the "root" of the *taun*, are guarantors of that world, and the trunk and branches (actually the branching V of the *olagabo*, and a trunk section, known as *bagot*, that serves as a threshold-log of the men's house proper) contain its feasts. But in the great culminating mortuary feast, the *kaba*, performed on behalf of all who have died over a number of years, or of a very distinguished person who has died, the Barok world is overturned and negated. In the *kaba, the feast contains the tree*. A tree is set up *outside* of the *taun* amid great ceremony and numerous feasts, and the *kaba*, at which a great many pigs are slaughtered (over 60, at one I attended in 1979), is held around it.

Of the two kinds of *kaba*, that of the branch (*agana ya*) and that of the rootstock (*una ya*), the latter embodies the imagery at its fullest and is regarded by the Barok as the greater and more important. In this version, a huge forest tree is lopped off six feet from the ground and all the roots are dug out of the soil, one by one; a feast with pork is given for the uncovering of each major root, and an especially large feast for the taproot. The roots are then trimmed to a six-foot radius, and the huge rootstock is raised and taken into the village, with the *winawu* (ideally an *orong*-to-be, a "big man" initiate) standing atop it, crying out the invocation of the *kaba*: "asiwinarong!" ("the need of a big man"). It is erected upside-down in the village,

with the roots in the air. After days of preparation and subsidiary feasting, during which the tree is decorated, the rite reaches its culmination. The roots of the tree are made into a platform, with the aid of poles, and the pigs slaughtered for the feast are piled on it. Around the base of the tree nubile young girls sit on *dawan* chairs (seating frames made in the shape of a branch-fork); on top of the pigs stands the *winawu*, invoking the *kaba* with a standardized formula: "*Asiwinarong!* . . .".[2]

Not only does the feast contain the tree, then, but the main course, the pigs, are placed directly atop the "burial" section of the tree, supported by the upper ("feasting") section, which is buried in the ground! Feasting and burial are collapsed together and shown to be one and the same thing in an act that Barok refer to as "cooking the pigs on top of the ancestors," "cooking the souls of the dead," or "finishing all thought of the dead." Since feasting and burial are equivalent to elicitation and containment, paternity and maternity, and thus also to the ways in which the moieties interrelate and are constituted, the *kaba* accomplishes the negation of gender and of the moiety distinction—indeed, of all social categories in Barok culture. This is especially clear in the positioning of the *winawu*, a man, atop the pigs, for he takes the place of the tree's taproot, which before had been identified with the original ancestress of a clan. The nubile young women seated around the base of the *kaba* on stylized "branches" correspondingly take the role normally ascribed to men, marrying into other clans and giving them nurturance. The young women at the *kaba* are in fact spoken of as "food," as if they were fruit dangling upward from imaginary branches of the inverted, underground tree.

The *una ya kaba* is thus no simple inversion, but a methodical and consistent figure-ground reversal (*pirewuo*) of the meaningful imagery of Barok life. It does not simply negate, it consummates its denial by demonstrating also that the inversion makes as much sense as the order it inverts—that a feast on tree roots is indeed a feast (as well as the burial of all burials), that a man can be taproot of a maternal line, that young women, who constitute lineages, can also be seen as nurturance bestowed elsewhere. Like my earlier example of the image for clan, *a bung marapun*, the significance contained in the *kaba* image is larger and more intense than any verbal interpretation could encompass.

Its implication, however, is perfectly clear. If feasting and containment are completely interchangeable, and there is no difference between the moieties or the gender-roles they manifest, then the force behind so-

ciety cannot simply consist of categories or substantives such as arbitrary social distinctions, human body functions, gender, or nurturance. These are but images, society's illusions, to be projected or dispelled at will by the power of image-transformation, *iri lolos*.

The *kaba* is the revelation of a transcendental power *over* society, rather than a statement of the things society is about, its principles, forces, ideals, or goals. The parallel with art is apt, for, as with a significant work of art, the true power of the *kaba* lies in the transformations of meaning that it elicits in its audience. Barok say that figure-ground reversal, *pire-wuo*, is "the way in which power is put into art," for it elicits a change of perspective within the viewer—an image of transformation formed by the transformation of an image. If so rarefied a basis for human social order seems a bit too far removed from everyday affairs for easy credence, then consider a definition of mankind offered by the Tolai people of Rabaul, speakers of a language closely related to Barok. The Tolai say that man is a *tabapot*, a figure-ground reversal, forever desiring that which is outside of his form (body), only to hunger again for the human form once the external has been attained.[3]

What analogies can be drawn between the Usen Barok transformation of *a lolos*, power in the world, into the *iri lolos* of cultural form, and the malagan of peoples to the north? A suggestion can be found in the work of Dr. Elizabeth Brouwer, who lived among the southern Mandak people of Panatgin Village. In her thesis,[4] Dr. Brouwer speaks of the spirit forms of malagan (as well as those of plants, animals, insects, and birds) being contained *within* the *randa*, the *masalai*-spirit of a clan. The southern Mandak *randa* is thus like the Barok *tadak*, which is said in some cases to animate certain depictions on the walls of caves. Images of the malagan within a *randa* can be communicated to clan members in dreams,[5] then carved, decorated, and revealed (together with a "meaning," or lesson) at a mortuary feast. By analogy, the spirit-forms or images of malagan are like Barok *a lolos*, power in the world, which become human power (*iri lolos*) when carved and presented by human beings at a mortuary feast. Individual malagan are like Barok *pidik*, "mysteries" whose presentation is at the same time a revelation of knowledge.

NOTES

1. This word, actually quite widespread as a synonym for "culture" in modern Melanesia, is a loan-word, borrowed from the English "custom."

2. The complete text is given in R. Wagner, *Asiwinarong: Ethos, Image, and Social Power* *among the Usen Barok of New Ireland* (Princeton: Princeton University Press, 1986) pp. 204–205.

3. Discovery of this concept in Tolai is credited to Roselene Dousset-Leenhardt; see R. Wagner, *Asiwinarong*, p. 100n. In a somewhat different sense, the modern discovery of brain-laterality tends to make man a "figure-ground reversal."

4. Elizabeth C. Brouwer, "A Malagan to Cover the Grave: Funerary Ceremonies in Mandak," Ph.D. diss., University of Queensland, 1980, pp. 80–81.

5. *Ibid.*, p. 165 ff.

A Line Of *Tatanua*

Brenda Clay

A yellow fibrous crest, in form recalling an ancient Greek helmet, distinguishes a type of men's dance mask in central and northern New Ireland and the nearby islands of Tabar and New Hanover. Throughout this region the mask and dance are called *tatanua*, a pidgin term adopted from northern New Ireland, while the genre is also known by other names in the different language areas where it occurs. The *tatanua* is one of the many dances and ritual complexes incorporated in the large-scale mortuary celebrations for which New Ireland is noted.

Although New Ireland hosts peoples linguistically and culturally diverse, a general pattern predominates, of matrilineal social units (moieties and/or clans, and subclans), villages composed of interacting discrete hamlets identified with matrilineal social units, an emphasis on food sharing and exchanging within formal feast contexts, and male political influence achieved through reputations gained in feast organization and from acknowledged skills in magic and ritual endeavors. Despite such similarities, however, there are numerous cultural contrasts from area to area, even between villages of the same linguistic group.

Ceremonial complexes are passed from village to village within broad regions of New Ireland. Whereas the outward forms of a dance or ritual may conform to a recognizable genre, however, it may be elaborated or redefined by a village or area according to the particular nuances of their own cultural patterns. The *tatanua* is found over a relatively wide area, such that a degree of variation in its form and sociocultural significance can be expected from place to place. This account focuses on this genre on the central east coast of New Ireland among the Northern Mandak where the author observed a *tatanua* performance in 1979.[1] Though the *tatanua* is mentioned in early German ethnographic accounts and in brief descriptions of the masks as an art form, detailed cultural data on this complex for other areas of New Ireland are lacking.

Some villages of central and northern New Ireland no longer perform the *tatanua* dance. The presence of German (1884–1914) and, later, Australian (1914–42, 1945–75) colonial forces, and the disruptions caused by the Japanese occupation during World War II played havoc with artistic and ritual traditions in New Ireland, many of which have been lost in a village here, a village there. In recent years, however, the *tatanua* has been reintroduced in some areas where it had not been enacted for many years.[2] One result is an intermingling of earlier mask and music regional styles. For example, in recent years a Tabar Island school teacher residing in a southern Mandak village introduced the Tabar *tatanua* music and mask styles to the southern Mandak, whereas in former times the styles contrasted in these two regions. While kinship relationships between areas have always been channels for the diffusion of art styles, evidence suggests that such exchanges, of a reduced variety of ritual forms, have increased in recent decades.

The following discussion refers to the Northern Mandak version of *tatanua*, or more particularly to the Pinikindu Village *eanis* or *engas anis* (line of *tatanua*), for the dance has been lost to most of the surrounding villages. Here the dance is regarded as a kind of malagan, a New Ireland pidgin term referring to the elaborate carvings and their associated rites traditionally found in central and northern New Ireland. However, the Mandak qualify the dance's malagan status, for although this men's masked dance shares with "true" malagans an aura of power, dangerous unseen energy or potency, and the precautions

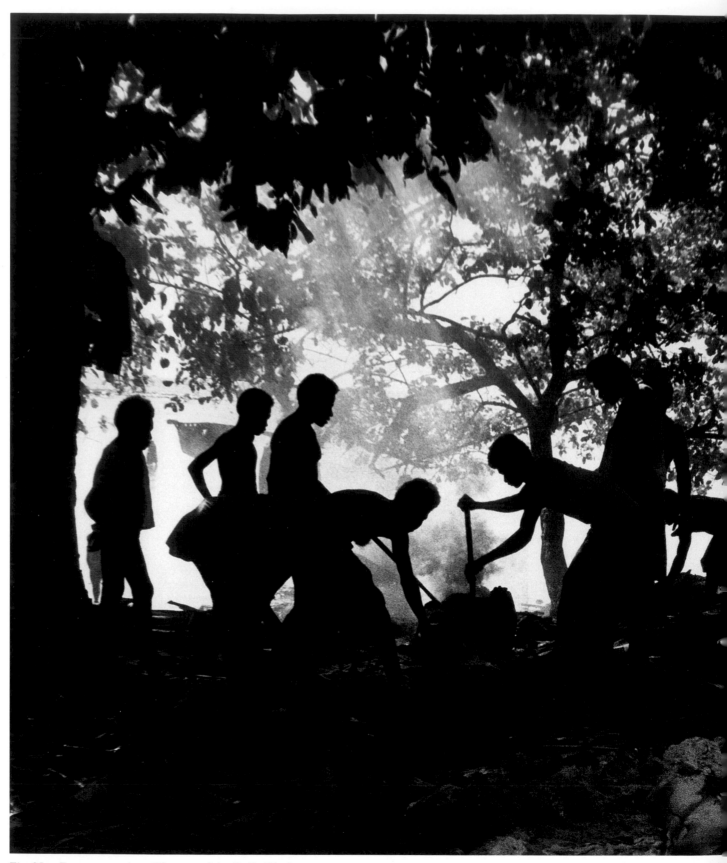

Fig. 25. Feast preparations (Photograph by R. B. Clay).

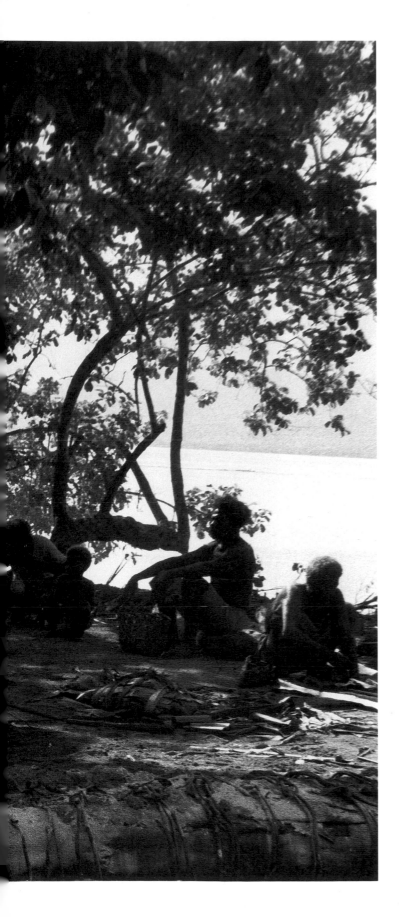

and preparations for handling such power, the *tatanua* is a less elaborated and less potent ritual genre. In a sense, the *tatanua* is regarded as a dance that speaks for malagans, that honors a place where there has been a malagan, for this dance can be held only in hamlets in which there has been a malagan display in the past.[3]

As elsewhere throughout New Ireland, major ceremonial occasions among the Northern Mandak revolve around mortuary feasts sponsored by matrilineal clans for their deceased members (fig. no. 25). The *tatanua* dance may be part of the final, large-scale mortuary celebrations hosted by a clan for members deceased since the last observance, possibly ten or more years earlier. All mortuary feasts must be "over" the deceased, in the hamlet where the dead are buried in the clan or subclan cemetery within the men's enclosure. Whereas the smaller mortuary feasts that follow the death of a single individual are predominantly village affairs, the large-scale mortuary complex entails ten to twelve months of preparation, culminating in a final five days of food distribution and ritual displays attended by guests from some fifty or more villages.

When a clan decides to sponsor a large-scale mortuary celebration, they ask others related through marriage and male descent to support the occasion by bringing dances or possibly a malagan display. These contributions are reciprocated when the donor's clan hosts a mortuary feast. The clan planning the celebration may request someone to bring a "line of *tatanua*" to perform, along with other kinds of dances, on one of the last days of the mortuary complex. Sometimes there will be two or more lines, usually from different villages. Each line includes, in even numbers, from six to twelve or more dancers. An uncommon form of this dance involves only a single masked dancer. The individual asked by the host clan to organize a *tatanua* performance is responsible for selecting the music and dancers and is usually a man who knows the dance sufficiently well to be able to take the role of lead dancer. For music he may select a known *tatanua* song, in which case he makes a payment to the clan that last used the song in a performance. Or, for a small exchange he may ask someone to compose a new song for the occasion. The songs are sung by a male chorus, of all ages, from the sponsor's village. Accompaniment is provided by two men who alternately beat with a stick a two-section bamboo slit gong.

The *tatanua* is an exclusively male ritual complex. All dance preparations take place within the *tatanua* sponsor's men's enclosure, away from the sight and presence of women.

Gender contrasts are part of major cultural dis-

tinctions throughout New Ireland. For the Northern Mandak, female is associated with nurturance and the continuity of social units (moieties, clans, subclans), while male is identified with activation, with "getting up" feasts and ritual performances.[4] Whereas men and women perform cooperative, complementary work in such daily activities as gardening and childrearing, certain endeavors enlist male capabilities that are impaired or negated by contacts with women or female sexual substances. Such contexts generally involve male interaction with strong forms of power, invisible potency manipulated through magic spells. The *tatanua* dance is one such male action. Female sexual substances are dangerous to the power-saturated masks and to the success of the dance. Before the performance women must not see or come close to the masks or the dance preparations. The dancers must avoid physical contact with women in the weeks prior to the performance. During this time they practice a form of abstinence in order to develop male "strength," or capability, to make themselves "strong" and "light" for the performance. Some six weeks before this event the dancers begin sleeping and eating within the sponsor's men's house. Not only are physical contacts with women taboo, the men may not eat peeled, baked taro, a culturally important form of daily sustenance associated with female nurturing. Instead, men receive unpeeled taro cooked over a fire, brought to the men's house by post-menopausal women. A week or more before the performance, the men cook their own food within the enclosure to further avoid potential dangers from indirect female contact. Fish, because it may attract the spirits of individuals who died from violence, is also not eaten. These precautions are designed to prepare the dancers to perform successfully within the power-filled *tatanua* masks. Should a dancer fail to develop this male capability through abstinence, the mask will constrict his head, causing blood to run from his temples and nostrils. Female contagion will also weaken a dancer's strength such that he may fail to withstand surreptitious attacks of negative magic from the occasional spectator who attempts to thwart the dancers. The *tatanua* performance thus tests the dancers before a large assembly of guests from other villages. If the dance is completed without misfortune, the men have proven their capabilities as men in interaction with power.

Earlier German ethnographic accounts suggest that in the New Hanover and northern New Ireland areas *tatanua* masks represented the spirits of particular deceased individuals and were called by their names.[5] Here "tatanua" incorporates the local term for "spirit" (*tanua*). To support this interpretation it has been pointed out that each mask is unique, although following a general pattern, so that characteristics of deceased individuals, such as blindness or a scar, might be indicated on the mask representing that individual's spirit.[6]

The Mandak disclaim this interpretation for their *engas anis*. Here the masked dancer is said "to look just like a true man," but not to represent an individual or his spirit. In an early account of the *tatanua*, Parkinson suggested that the distinguishing helmet-like crest imitated a traditional hairstyle worn by young men on mortuary occasions. At this time the sides of the head were shaved and covered with a plaster of lime dust. Others have supported Parkinson's assertion that the *tatanua* presented an image of idealized masculine appearance.[7] For the Mandak, it may be said today that the *tatanua* dancer presents an image of male personhood, not simply in physical attributes but in a broader sense of culturally defined male capabilities.

Traditional colors used on the masks—black, white, red, and yellow—convey associations with male manipulations of power in warfare magic and sorcery. White, produced traditionally with lime dust from heated, pulverized coral or limestone, is an adjunct of numerous magic spells. Black, a pigment made from the crushed, heated insides of a local nut, is said in the context to have associations with warfare, while red, from a crushed, dark red rock is said to recall the spirits of those who have died from violence. Today the wooden areas of the mask are painted with store-bought paints. Black, white, and red used traditionally on the mask's face may be joined by additional colors such as blue and green.

The mask's eyes are the opercula of sea snails, while the yellow fiber crest is the mask's hair, with yellow replicating the traditional hair coloration with lime dust, an effect achieved today with store-bought peroxide. The hair crest is made from the dried interior fibers of an inland tree, colored yellow by spewing over the fibers a pigment produced from the dried, crushed pulp of another inland plant. The mask sides were traditionally constructed from coconut shells secured to a cane framework and then covered in various arrangements with such materials as black and white pigments, bird feathers, shells, or fibers. Today brightly colored yarns are often wound in different patterns on the mask sides (fig. no. 26).

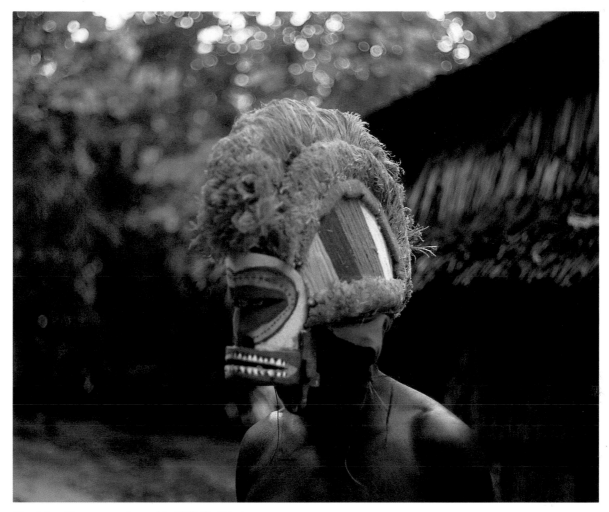

Fig. 26. *Tatanua* mask used in 1979 Pinikindu performance (Photograph by the author).

There are few men in New Ireland today who carve *tatanua* masks. In former years, anyone with the requisite skills could carve the masks, always in enclosures out of the sight of women. Now men usually rent their masks from one of the few practicing carvers scattered in central and northern New Ireland. As in earlier times, the masks are not destroyed after a performance, as malagans were, but are stored for repeated use.

Different carving styles for the *tatanua* face are recognized. The Northern Mandak contrast their preferred style of mask with smaller open areas with the larger openings characteristic of Tabar Island *tatanua* masks. Additional contrasts are noted between short, compact styles and larger, elongated masks.

The *tatanua* headdress is completed with the insertion of long, black feathers from an elusive inland bird or semidomestic rooster. Formerly the feathers were inserted into dried red or green parrot heads attached on short palm spikes in the *tatanua* hair. The bird heads are said to be a decorative element that is also seen on some malagans that have carved birds attached to figures or heads. Bird heads are still used, though other cylindrical feather holders are more common (fig. no. 27). The feathers are also decorative, just as a man may sometimes place a long, black feather in his hair for adornment. Each dancer is identified with a set of feathers, in multiples of ten (ten, twenty, thirty), that he receives for a small exchange from his father, brother, or other male relative. A man may wear less, but never more than his set during a performance. Today some men may add an exotic feather, such as from a bird of paradise, as long as they keep within their specified number. The feathers and bird

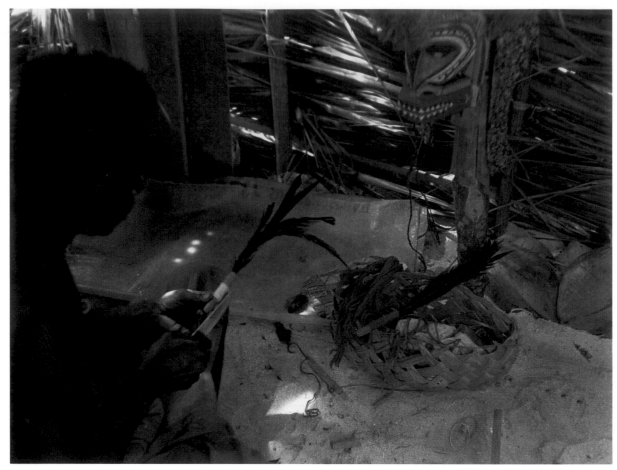

Fig. 27. Preparing feathers for *tatanua* mask, Pinikindu, 1979 (Photograph by R. B. Clay).

heads are not taboo to females and are often stored in family hamlet houses.

Tatanua dancers today wear palm-frond skirts and shirts. Some villages prefer coordinated shirt colors, usually red, while others allow a mixture. In the Mandak area, dancers often wear shell arm bands and shell pendants. Opinion varies about the traditional attire of former days: some maintain that dancers wore nothing, others that they wore leaf skirts and painted their upper torsos red.

Not only are the dancers the center of attention in the *tatanua* performance, but the complex precipitates a degree of village-wide male cooperation, in contrast with the predominating divisiveness of daily social interactions. The success of a *tatanua* dance is the concern not only of men who perform under the power-laden masks, but also of men organizing the clan mortuary observances. Music for the dance is provided by a chorus formed by all interested village males over about age four. The performance is a vil-lage rather than hamlet or clan endeavor. Such solidarity is enhanced by the expectation that spectators from other villages may test a dancer by speaking negative magic inaudibly during the performance. The success of the dance is regarded as a village feat, against outsiders. In day-to-day living, the village is fragmented into many small networks of interacting men and women, with social life centered around the scattered hamlets.

Perhaps the best way to convey the style and atmosphere of a *tatanua* performance is to describe one, such as the dance I witnessed in Pinikindu Village in 1979. Here the line consisted of eight men, representing a number of hamlets and clans in the village. In age the dancers ranged from twenty to fifty. Three of the performers, men in their early twenties, were dancing for the first time. Six of the masks were rented from a Southern Mandak village seventy miles away, and two, from a Notsi carver, were owned by a Pinikindu man. Some six weeks before the dance, in

the middle of the night, men from Pinikindu took a truck to transport the masks to their village, out of sight of the women. As the truck began its journey back to the village, the men sang *emburo* songs whose intent is to announce the arrival of a malagan.

The masks were placed in a small temporary enclosure attached to the *tatanua* sponsor's men's house. Here, in the weeks before the performance, men gathered to attach new "hair" to some of the masks (fig. no. 28). A respectful attitude was expected of anyone working on the masks, and those who violated this injunction were fined one pig, to be presented to the men's house and cooked over a fire rather than being baked under hot rocks in the usual manner. Such a pig was eaten only by men within the enclosure.

Early on the day before the performance, the dancers went inland to secure the plant materials for their attire. At dawn the following day, each mask was bespelled with a drop of seawater and held over the sea to catch the first rays of sunlight, so that the masks would shed any untoward power and "heaviness," and become "new as the day is new" (fig. no. 29). Men gathered in the men's enclosure to help the dancers prepare for the performance. Spells were performed for each dancer as protection against power within the masks and possible negative spells from the spectators. Once a mask has been lowered over a man's head, he must not utter a sound, for he has "gone inside a malagan." Should he speak or cry out, someone in his clan (or himself) will die. The dancers prepared to be led the short distance from the men's enclosure to the hamlet hosting the mortuary observances. The chorus proceeded first, entering the dance plaza singing *emburo* songs and seating themselves on the ground at the edge of the clearing (fig. no. 30). The *eanis lamlam*, the lead dancer, made the first dramatic entrance through a spray of lime dust (a final protective spell) into the clearing. His solo dance involved slow turns with bent knees as he rhythmically shook a clutch of olive shells held in his right hand, a cordyline branch in his left, the sign of a malagan. When the lead dancer had completed his solo, he knelt, and a female clan member, perhaps a sister or mother, presented him with a strand of shell valuables. Others, men and women, followed with small amounts of money. These payments are in recognition of and a protection against the presence of power in the *tatanua*. The woman's exchange is said to emphasize that now the women can *see* the malagan that was taboo to them. The lead dancer then "pulled" the line of dancers one by one into the clearing, as each danced a duet with him and received exchanges from a female clan member and spectators. When the entire

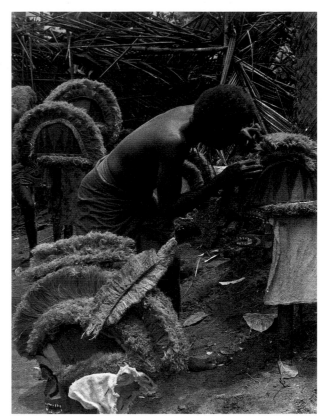

Fig. 28. Working on "hair" of *tatanua* masks, Pinikindu, 1979 (Photograph by R. B. Clay).

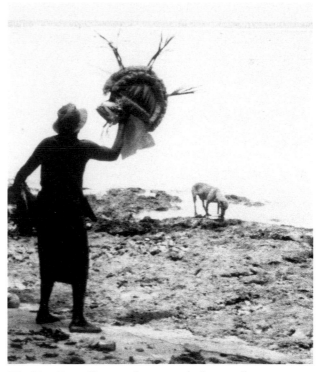

Fig. 29. Bespelling mask over sea before performance, Pinikindu, 1979 (Photograph by R. B. Clay).

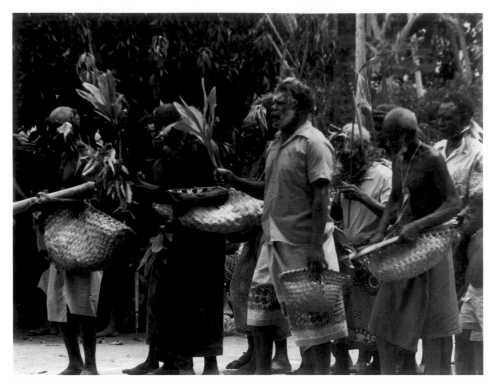

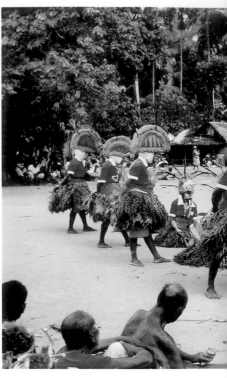

Fig. 30. Entrance of male *tatanua* chorus, Pinikindu, 1979 (Photograph by the author).

Fig. 31. *Tatanua* performance: Pinikindu, graph by R. B. Clay).

tatanua line was present, they danced together, parts of the dance being choreographed to mime incidents in the songs (fig. nos. 31, 32, 33).

Mandak *tatanua* songs, usually composed in three unrelated segments, are often concerned with the composer's or a close relative's experiences with death, illness, or sorcery. They do not memorialize the deceased, but refer instead to moments of individual sorrow and difficulty in the composer's life.[8]

The performance unfolds in an atmosphere alive with tensions. Each dancer is tested with the power in his own mask. If he has been lax in the required abstinence, the mask will eat into his head, an occurrence said to be not uncommon. During the 1979 performance, an additional man was stationed among the dancers. As a man reputed to possess strong forms of magic, his presence was a deterrent against potential ill will from spectators. He was also on hand to assist a dancer should he falter, or to lead a man back to the men's enclosure if the mask constricted his head, for the masks cannot be removed outside the men's enclosure. Another man was placed inconspicuously among the guests with the task of inaudibly murmuring spells throughout the performance in order to quiet angry emotions in the spectators.

When the performance was finished, the dancers returned to the men's house to remove their masks. The masks have at this point lost their power, and though they should be kept respectfully within a men's enclosure, there is no longer any need to protect the masks from female contagion.

The *tatanua* dance, in its preparations as well as in the actual performance, may be said to control the dancer as an active, expressive individual, subjecting him to its own power-laden requirements. In the preparatory stages, dancers leave their separate hamlets, put aside their daily diet, and avoid outspoken conflicts while in the men's enclosure. During the performance, the dancer's public face is that of the mask, imposing its power so that he cannot use his own voice. The *tatanua's* voice is that of the supporting male chorus. The feathers adorning his headdress speak of the individual dancers, yet link him through his shared set to other men. The *tatanua* figure presents a dynamic image of a cultural vision of male personhood. In daily social interactions the autonomous individual is often the focus of divisive rumor, conflict, and intrigue. Village life abounds with gossip and speculation about the intentions and unseen actions of men and women, about ruined gardens, drought, rain, and

70

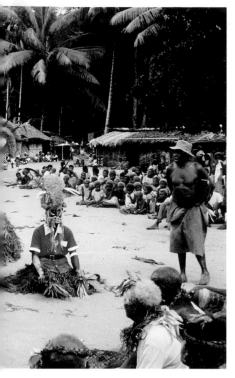

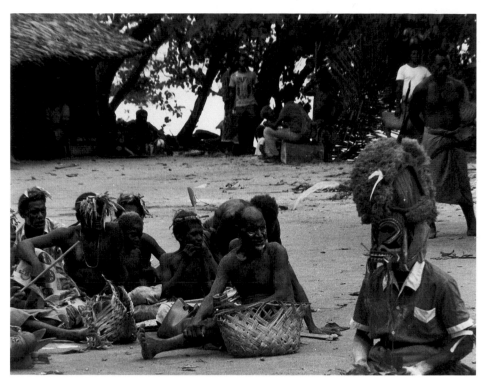

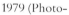
1979 (Photo-

Fig. 32. *Tatanua* dancers and male chorus, Pinikindu, 1979 (Photograph by R. B. Clay).

illness and death brought about by individual malice. Much of the perceived force behind human difficulties resides in suspicions about individual manipulations of power in magic spells. In the performance, the personal name, voice, and face of each dancer are covered and silenced in the presentation of a potent image of male capability and "strength," juxtaposed with power. The success of the performance is a shared village experience.

It is appropriate that the *tatanua* complex centers on the dancer's head, with massive masks and their power close to and potentially a source of danger to the dancer's head. The male head receives special attention among the Mandak, where numerous taboos emphasize its significance as the source of the male capacity to activate malagans, rituals, feasts, and other events. Here, however, the dancer's head is subject to power within the *tatanua* "head," an experience that simultaneously threatens and enhances the marked status of the male head.

As part of a mortuary celebration hosted by a clan "over" their dead, the Mandak *tatanua* speaks not of ancestral spirits but of the continued capabilities of the living. Since death here is so often perceived to be the result of sorcery, of human uses of power against others, the presentation evokes a sense of male bravado in its associations with the "dark" side of power manipulations, for the colors are said to recall warfare, strong forms of magic, sorcery, and the spirits of those who have died from violence. The *tatanua* presents to others a vision of the host village as one of ongoing, replenished vitality and male strength.

Yet the *tatanua* image is more complex than a display of male capability. In effect, power here turns inward toward the dancer, rather than outward as in its use in magic spells. Power in the *tatanua* masks is separate from humans who attempt to demonstrate their male capabilities to withstand its potency. The dancers and, through their participation, all the village males, do not demonstrate the uses of power; they demonstrate an understanding of potency as separate from but juxtaposed to human intentions and manipulations. The *tatanua* performance in effect reverses daily usages of power in magic spells by subjecting men to its requirements and thereby revitalizing human perceptions of the efficacy of power in their lives and the capabilities of men to realize and evoke a potent world.

The *tatanua* dance is one among many ceremo-

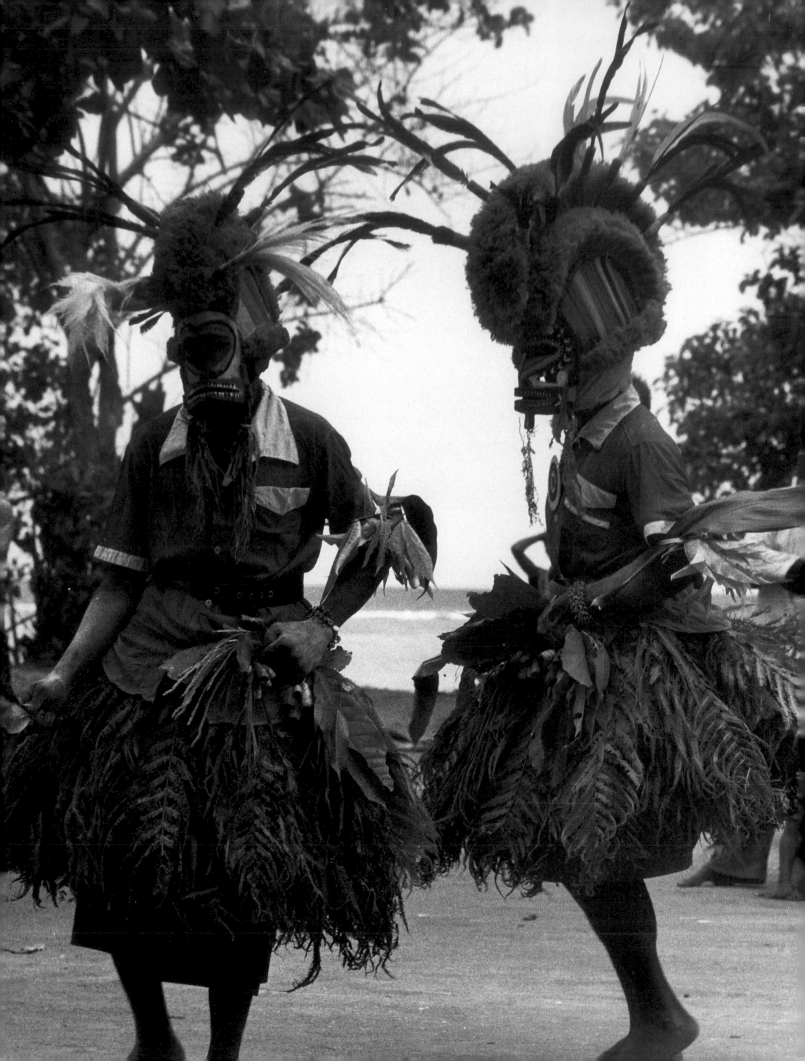

nial enactments executed within large-scale mortuary observances in New Ireland. All of these, including the now extinct *uli* complex of the Mandak region and the intricate malagan carvings in central and northern New Ireland, are dynamic presentations that express the vitality of the living, and of sponsoring males, clans, and villages. Certainly in the Mandak area mortuary expressions focus not on memorializing the deceased but on the strength of the living *in their relation to the deceased.*[9] Further, it is the action, the creative or re-creative fact of "getting up" a ritual enactment, that is stressed, and not the construction of a lasting memorial.[10] Having lost their potency, the *tatanua* masks are put away after the performance, and malagans are destroyed after their displays. The living have realized their capabilities to effect something impressive over their dead. Through the intri-

cacies of reciprocal interdependence and exchanges, another clan or group will act over their own dead in the future.

The transitory and socially intricate nature of these artistic mortuary traditions have made them vulnerable to disruption from outside forces, for their perpetuation depends on their continual re-creation. Knowledge of the ritual and artistic intricacies of the impressive *uli* complex have been lost, as too many decades of colonial disruption have blocked reenactment of these rites. Yet less elaborate mortuary displays and performances continue today in New Ireland, the *tatanua* among them, because the need to create impressive ritual expressions over the dead remains central to New Ireland social interactions and cultural perceptions.

NOTES

1. The author carried out anthropological research among the Northern Mandak in 1970–1971 and 1979–1980, supported by grants from the National Science Foundation; supplemented in 1970–1971 by financial assistance from Southern Illinois University, Carbondale, Illinois.

2. With independence in 1975, the national government of Papua New Guinea actively encouraged local regions to resume or continue many of their traditional ceremonies, some of which had been disrupted during the long period of colonial control. After 1975 in New Ireland, there was a small renaissance in reenacting various ritual forms that had lapsed in earlier decades. The *tatanua* is part of this renewal and thus may continue to spread in the central northern New Ireland villages.

3. The Mandak area was once known for the massive carved wood *uli* figures and their elaborate rites. Due to mission opposition and colonial disruptions in the first half of the twentieth century, the *uli* rites are no longer performed. *Malanggans*, the intricately carved and painted images and friezes associated with northern New Ireland, were

also a feature of mortuary observances in the Mandak area. Although some *malanggans* continue to be made in parts of the Mandak region, there are today very few *malanggans* displayed in Northern Mandak villages.

4. For discussion of the cultural dimensions of gender images among the Northern Mandak, see B. J. Clay, *Pinikindu: Maternal Nurture, Paternal Substance* (Chicago: University of Chicago Press, 1977); and ibid., *Mandak Realities: Person and Power in Central New Ireland* (New Brunswick: Rutgers University Press, 1986).

5. Phillip H. Lewis, "The Social Context of Art in Northern New Ireland," *Anthropology* 58 (Chicago: Field Museum, 1969), pp. 119–20; Gerhard Peekel, "Die Ahnenbilder von Nord-Neu-Mecklenburg. Eine kritische und positive Studie," *Anthropos* 22 (1927), pp. 33–34; Klaus Helfrich, *Malanggan 1: Bildwerke von Neuirland* (Berlin: Museum für Völkerkunde, 1973), pp. 22–23.

6. Helfrich, pp. 22–23.

7. Ibid., p. 21.

8. Helfrich, pp. 24–25. Earlier accounts of *tatanua* dances in northern New Ireland

mention mimes depicting humorous episodes in the love life of deceased individuals and courting, quarreling, and reconciliation between the sexes.

9. Though at the death of an influential "big man" the mortuary observances are larger than at the death of a man or woman of less social importance, the emphasis is still on the capacity of the living relatives of the deceased to execute elaborate mortuary observances. Furthermore, a big man may express his own capabilities by executing an elaborate mortuary feast at the death of his wife, brother, or other relative of less social significance. Thus, Northern Mandak mortuary celebrations are not simply reflections of the social importance of the deceased, but on the capabilities of the living.

10. Over the past several decades cement tombstones over graves have become common. Although these are more permanent memorials to the dead than the transitory dances and rites of mortuary observances, the "semels," as they are called, are treated very much as mortuary displays of the moment, in that they are constructed and presented publicly at the final mortuary observances for the deceased.

◁ *Fig. 33.* *Tatanua* performance, Pinikindu, 1979 (Photograph by the author).

The Transfer of Malagan Ownership on Tabar

Michael Gunn

INTRODUCTION

What we know of the artistic traditions of Tabar, a group of four small islands off the northern shore of New Ireland, is based primarily on the wooden or woven sculptures of the malagan tradition and on rock art. The antiquity of the rock art is not known, but evidence suggests that it is in part related to the better-known malagan art traditions.[1] Malagan sculptural forms derive from a rich vein of artistic ideas that were well developed as long ago as the mid-seventeenth century; the earliest reference to a malagan style of sculpture is a sketch of a New Ireland canoe prow drawn in April 1643 (fig. no. 7) by the Dutch explorer Abel Tasman or one of his artists.

When these remarkable artifacts were first collected by the outside world, little attention was paid to the imagery of malagan. The sculptures were viewed as bizarre, a confirmation of the unsavory reputation for cannibalism that the New Irelanders had at the time. Today the malagan tradition continues in a different world. The old images have changed into new ideas, the old metaphors have grown stale, poems of a forgotten glory. Today's art tradition within malagan is maintained primarily through the inheritance and transference of the rights to reproduce the traditional sculptural designs. When malagan ceremonies are operated and the old songs are sung, the brilliantly painted sculptures are fastened to the green fern leaf inside the malagan display house, and the people of Tabar pass to the next generation the rights to reproduce malagan sculpture that they inherited as individuals thirty or more years before.

Looking at the old malagan masterpieces, we now yearn to understand the complex iconographic system that so clearly organizes the elaborate combination of forms. Yet there is little written literature to help us understand this problem.[2] We may know that a white peaked helmet signifies the rain hat traditionally worn by New Ireland women, or that steeply sloping eyes denote a *ges* spirit that according to legend journeyed through Tabar villages, killing and taking the victim's liver in its mouth. But these scraps of knowledge are not enough. In wishing to understand malagan sculpture in our own terms as art, we want a satisfaction that must be denied us. The past has changed, and our ancestors did not have the foresight to question the New Irelanders about the imagery embedded in the wood and paint. They may have been afraid, they may not have been ready for this art, they may not have cared.

For the people on Tabar who still make and use malagan art traditions, however, the meaning of the sculptures is less opaque. There, in its own context, the understanding of the art is to be found in the transfer of ownership of rights to continue making malagan sculpture and organizing malagan ceremonies.

Tabar is often mentioned as the place of origin of the malagan, and indeed the islands are a strong reservoir of malagan ceremonial life. The rights to at least twenty-one major traditions are held by more than one hundred malagan-owning matrilineal kin groupings on Tabar.[3] The sculptural output in the past has been tremendous, particularly during the period between 1880 and 1920, when examples of Tabar malagan art reached major museum collections throughout the world. A far greater proportion of Tabar artworks must have remained on Tabar, for a large number of malagan items are burned after the ceremony to forestall their use in sorcery. Many more items were placed with the dead in caves above the sea, to rot mingling with the corpse.

To understand malagan traditions as they exist today on Tabar, we must examine the processes underlying the transfer of malagan from one generation to another, for it is only during transfer that the meaning of malagan is fully revealed. To begin, we will outline the function of malagan as understood by the people who use it.

USE AND FUNCTIONS OF MALAGAN ON TABAR

It should be emphasized that malagan is not only an art tradition, although the manufacture and display of sculpture within an appropriate structure is at the center of malagan. On Tabar, malagan has as its essential premise the tenet that a person must honor the dead of his or her spouse's kin group by displaying malagan sculpture or using malagan masks in ceremonial context. This obligation takes a number of forms:

1) participation in the burial rites of the spouse's clanspeople.

2) the operation of a series of commemorative ceremonies for a number of the dead from the spouse's clan.

3) the right to use malagan to validate land-use transactions. For example, if a man wants to continue to use a garden on land owned by his wife's clan beyond the initial two- or three-year period after marriage, he would make a malagan ceremony for some of his wife's dead ancestors.

4) the use of malagan masks to remove certain social prohibitions, such as to reactivate a graveyard to begin a men's house on old clan land.

5) establishment of a new subclan. On Tabar, if a child is born away from land owned by the mother's clan, then the mother and child start a new subclan named after the place the child was born. Shortly thereafter the leader of the mother's original clan must operate a malagan ceremony at the graveyard near the child's birthplace. This action connects the new subclan with the malagans of the old clan and ensures the continuation of the malagan traditions.

6) ratification of social contracts, for example the establishment of a truce to end fighting or argument between clans.

7) the responsibility of ensuring that his malagan inheritance passes on to the next generation.

Beyond these formal contexts of use, malagan has a number of other economic and social functions on Tabar.

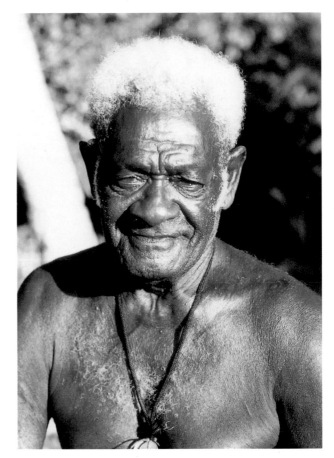

Fig. 34. Songis Lamot, noted shark-hunter and malagan carver (Photograph by the author).

The benefits of owning malagan are costly. It is one of the main roads to prestige and power on Tabar, but the fuel is very expensive: malagan runs on pigs. Even the smallest of malagan ceremonies demands at least one pig, and during some of the larger ceremonies up to twenty pigs might be strangled, singed, gutted, carved into sections, and given to the guests to carry home. For reasons of prestige a malagan operator has as many pigs as possible committed to a ceremony, for a large part of the power associated with a malagan ceremony comes from the operator and his colleagues gaining commitment from clanspeople, business partners, potential colleagues, and people indebted for various reasons to promise a pig for a coming malagan event. People use malagan ceremonies to pledge and strengthen contracts with one another, and the commitment of a pig initiates the pledge. The contract is further strengthened as the sequence of malagan ceremonies progresses, as the committed pig is cared for and grows in size and

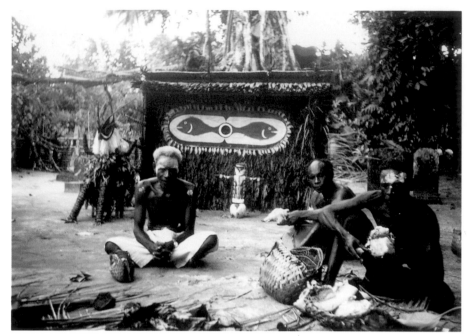

Fig. 35. A pause in the *cirep* malagan ceremony, the first of the commemorative series operated by Lusem Topu (left) and Sola Lokorova (center). Picia (right) acted as ritual leader for the entire series (Photograph by the author).

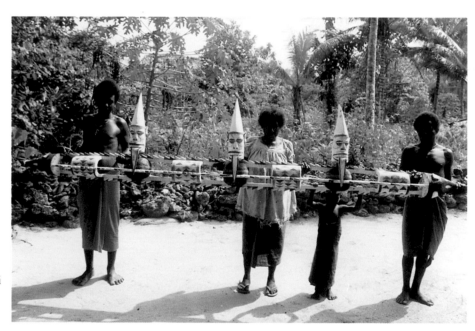

Fig. 36. The *kobokobor* horizontal malagan of the *mendis* malagan group, Poponoamb village, Simberi Island (Photograph by the author).

significance, and as the relationship between the parties to the contract develops. The pig is the living manifestation of a social bond and is central to the existence of malagan.

Malagan is influential at all crucial times of a person's life. It figures most prominently in the obligations that marriage brings to the spouse's kin. Marriage itself does not have a malagan ceremony, being a rela-

tively minor rite performed after the relationship has produced children. But marriage develops a connection between two kin groups, a connection that in the past brought an interdependence in land use and access, assistance in warfare, and the obligation to bury one another's dead. Malagan was intimately involved in this relationship of interdependence.

Marriages were always made between members

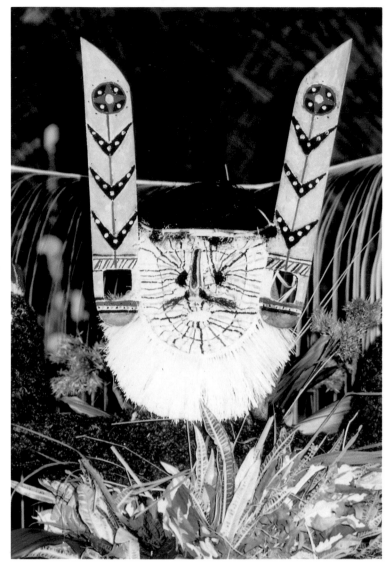

Fig. 37. Detail of the *wanis ngicamaget si mi varima*,
showing some of the innovations in materials (Photograph
by the author).

of the opposed moieties, or dual social groups, that
constituted the basic social structure of New Ireland
life. Children belonged to their mother's moiety and
clan. Soon after the marriage a malagan would cross
the clan boundary, generally from father to son. This
malagan would be destined to return to the original
clan in the next generation, when the son would pass
it to his own son. A tremendous tension between the
two clans could develop from this stake or commit-
ment to the future. If marriage failed to eventuate
between the two clans in the next generation, then
the clans would try other ways of resolving the
obligation.

It seems that the most typical relationship be-
tween two clans involved a bush clan living inland
and a saltwater clan on the shore. In times of stress
the saltwater people would need access to the moun-
tains, which their relationship with the bush people
offered; conversely, the bush people needed salt and
fish. Most malagan sculptures today are recognized
as having either a bush or a saltwater origin. This can
be seen in some of the horizontal *kobokobor* malagans
(see fig. no. 2: *kobokobor si mi mendis*. Poponoamb vil-
lage, Simberi). A malagan with pig heads at each end
is a malagan of bush or mountain ancestry; if the ends
are representations of fish heads, then the sculpture

derives from a saltwater clan. There are no fixed rules in this regard, however, for examples do exist of *kobokobor* with pigs at one end, fish at the other.

THE ACQUISITION OF MALAGANS

The first and most significant malagan in a person's life is the one received during childhood from the mother's brother. This malagan would be of the *kupkup si malangga* category, referred to as "fountain of water, clean and light" because it is a major prohibition-removing type of malagan. For example, the malagan sculpture *da* within the *mendis* malagan tradition is a *kupkup si malangga* representing a round black coco-

nut waterbottle, a potent symbol of growth. Later in life the initiate may acquire the rights to sculpture containing the image of a malaganized human figure (*marumarua*) standing on the top of the *da* waterbottle as if the figure were growing like a sprouting coconut. This portrayal of polysemic images is a common aspect of malagan and is particularly noticeable in malagan sculpture of the late eighteenth and early nineteenth centuries, when images of figures blended into one another and acted as ambiguous puns that often portrayed clan interrelationships. The actual image would depend upon the malagan tradition concerned and the rights inherited by the user. One example of a *kupkup si malangga* used on Tabar is derived from an

Fig. 38. Malagan display for the funerary ceremony *nambor* twelve days after the death of Pamas (Photograph by the author).

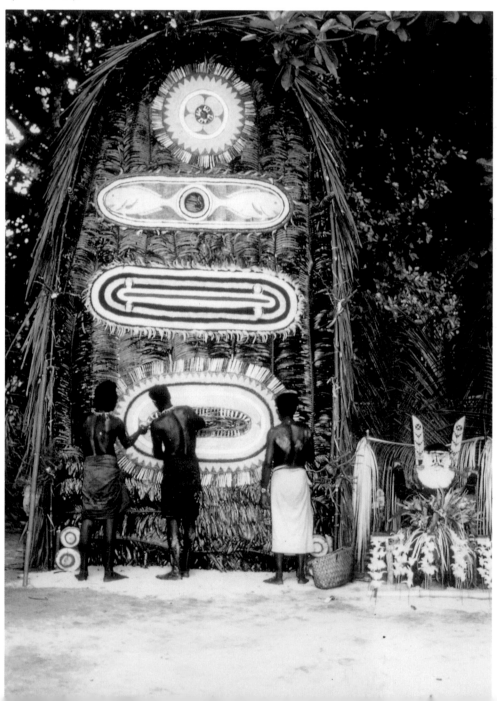

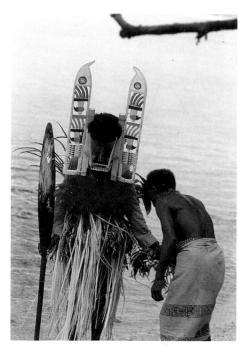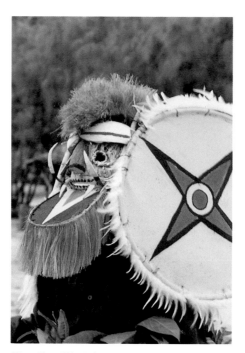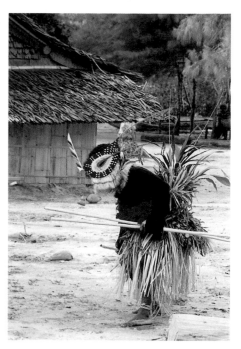

Fig. 39. Sola, a malagan operator, hands a shell rattle to Picia, who is wearing the *wanis wanariu si mi varima* mask (Photograph by the author).

Fig. 40. *Wanis beiyang si mi varima* moving through the village during *cukuavatir*, the second to last ceremony of the commemorative series (Photograph by the author).

Fig. 41. A *ges* threatening the photographer with a spear (Photograph by the author).

inverted palm tree with a face painted on the roots. More usually, however, this type of malagan has a woven body with a wooden head, or is a representation of two fish or two birds painted or carved onto an oval board with a central hole (see cat. no. 44).

People acquire the rights to display additional malagans for reasons of both necessity and prestige. The number and variety of malagan sculptures displayed often reflects the owner's need to transfer a malagan to the next generation, because the transaction must include public display of the sculptural form. The high point of a malagan owner's life comes when he operates a series of malagan ceremonies culminating in the display of the entire range of sculpture he and his clan own. Once a malagan has been displayed and transferred during a series of ceremonies, the original owner can no longer redisplay that malagan—he must use the rights to other malagans. If the person concerned is the first-born of the new generation of his subclan, then he would have inherited the rights to a large proportion of his subclan's malagans. If not, then there are at least four ways around the problem of not having rights to a sufficient number of sculptures. The first solution is to ask the leader of one's kin group to have a malagan transferred in exchange for a token payment during the coming ceremony. Should the kin group's stock of malagans be exhausted, or the senior man feel disinclined, then the next approach is to ask one's father or another close nonclan relative to sell one by *lak*. The third alternative is to invent a new malagan. The fourth is to reuse those malagans one already has.

When rights to use specific sculptures or masks at malagan ceremonies are transferred across the clan boundary, from father to son for example, or when a man desires a malagan owned by another kin group, then the malagan can be duplicated (*kapot*), and a copy of the sculpture is made. The usage rights to a single malagan sculpture are transferred, a process that can be completed during one malagan ceremony. In this process of transferring usage and reproductive rights the original owner is paid *lak* (a sum of traditional currency, today often supplemented with cash and tobacco), and the rights to operate the malagan duplicate are also transferred during a malagan ceremony. This type of acquisition was very popular in the old days, when malagan was the only road to high status and senior men would compete with one another for prestige. If a malagan changes hands through *lak*, the original owner can still use the rights in his own ceremonies. Only the less important parts of malagan can have usage and reproductive rights sold out of the clan, even though these less important parts may be some of the most spectacular looking sculptures, such

as the four-meter-high *eikwar* types.

New malagans can be dreamt up, displayed, and incorporated within a tradition belonging to the dreamer's clan. However, before they are completely subsumed within the tradition, carvings must receive the approval of all senior men of that tradition, particularly of those in other kin groups. A person inheriting malagan is responsible for its integrity and is obligated to police any infringements on the design rights of this malagan by others. Generally, new ideas are considered risky, for no one is entirely sure what the tradition as a whole contains; it takes a brave man to risk the accusation of breach of another clan's copyright. Few events seem to sober a malagan ceremony faster than the silent accusation of copyright violation made by slapping lime on the operator's back. New malagans are invented so rarely today that few people on Tabar recognize that innovation is acceptable within the tradition. However, change does occur in matters of practicality through the authorization of a senior owner. For example, the malagan man Pamas initiated a change in the backing materials on the horizontal *rarau* malagans found in the traditions *lunet* and *kulepmu*, switching from the increasingly expensive barkcloth made from the branches or trunk of the breadfruit tree to the more plentiful copra sack.

Should a man be brazen enough, and many are, he could try the fourth alternative, the reuse of a malagan. This method takes two forms: the use of reproductive rights to pay a carver to make another copy of the same malagan; or the reuse of the actual sculpture that one has carefully stored in the rafters of the men's house. If the owner is reusing the same piece of sculpture for a different ceremony, then the malagan must be washed down, cleaned, covered in lime, and repainted. Fresh paint is important, for the paints are made of bush materials that retain their lustre for only a few days. The most striking malagans are those painted in the early morning and displayed within a few hours in a fresh, bright green malagan house. Some people reuse malagans, but it is not considered good form to do so. The first showing of a malagan sculpture is generally greeted with discreet acclaim. The second showing is more likely to elicit a stifled yawn. The third may well touch off a downward trend of the owner's reputation. An exception

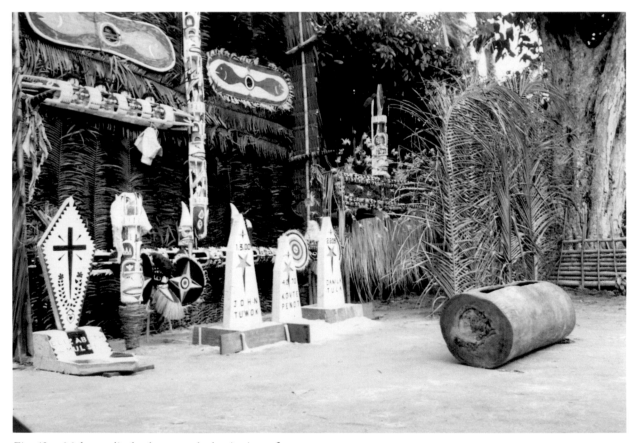

Fig. 42. Malagan display house at the beginning of *aruaru*, the final malagan ceremony of the series (Photograph by the author).

is made for some of the sculpture belonging to the rainmaking malagan called *marada*. In *marada*, wooden heads (*koabat*) are made of the heavy, fine-grained wood of *pindik* (*Cordia sp.*) that can withstand the rain the malagan brings. In the old days the heads were washed after use, oiled, and stored in the men's house or buried in a swamp until needed again.

STRUCTURE AND TRANSFER OF MALAGAN

The sculptural malagan traditions on Tabar are held and transferred by the subclans. Traditions such as *kulepmu, lunet (lonuat), malanggatsak, marada, mendis (mandas), varima (verim), walik,* and *wawara (vavara)* are comparatively widespread, with "strings" of subtraditions owned by a number of different clans in different locations. These malagans are transferred during a public malagan ceremony for which the audience can consist of very knowledgeable men guarding the copyright to inherited traditions. For these widely held traditions the acceptable variation of sculptural design can be as little as two or three centimeters on the length of wooden feathers found on the head of a *malanggatsak* figure. For the less widespread malagan traditions such as *dengenas, longobu, songsong, takapa, tangala, totobo, turu, vovali (vuvil),* and the disputed malagan group *arumi,* or the nearly extinct *curwunawunga (watirewong), karavas, sisabua (lasisi),* and *tomut* groups, the controls on the transmission of inherited rights are less rigid. In these traditions examples of a style of malagan may only be exhibited once in the lifetime of the audience, and if no one is in the position of having to defend copyright held by another subclan, variations on the design can pass unnoticed or unremarked.

A "string" subtradition (called *mi tumtum* in the Northern Tatau dialect, or *mi tabataba* in the Mapua–Big Tabar region) is defined through the process of transferral. The "string" is not of fixed length, for it can be broken if the owner dies before passing on all the malagans to the next generation. Some "strings" may have only five malagans, though others may be ten or thirteen long. Each sculptural item in the string is passed individually to the next generation, and a full series of malagan ceremonies is required to complete the transfer of each sculpture or mask in the "string." As a consequence, the full "string" may take a lifetime to transfer from one generation to the next, with the most correct and approved route being that from mother's brother to sister's son. Malagans may be transferred from father to son across the clan boundary, but in this type of transferral the *ciribor* ("bone of pig") ownership rights are retained by the

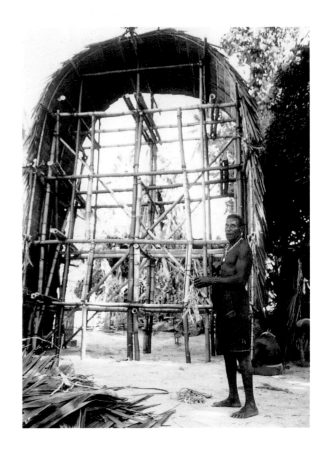

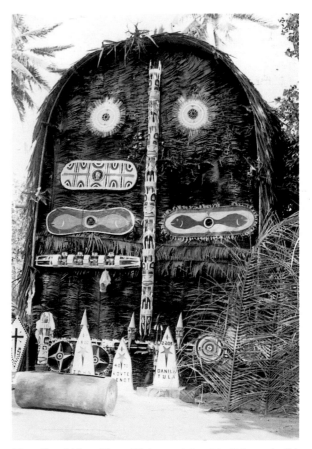

Figs. 43 and 44. Above, Picia proclaims his rights to build the malagan display at an early stage of the ceremonies. *Below,* the malagan display house several weeks later, at the beginning of *aruaru,* the final malagan ceremony of the series. (Photographs by the author).

81

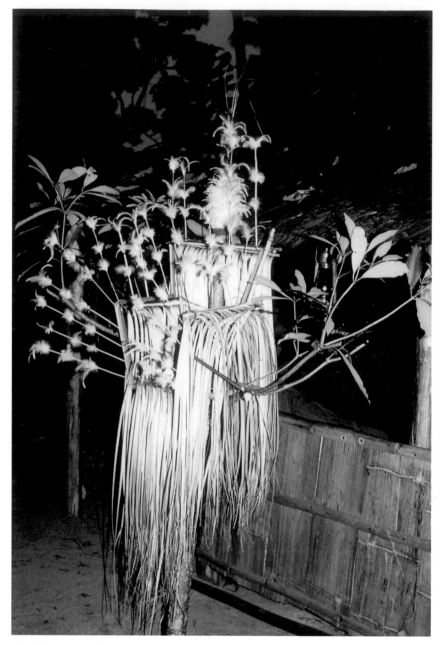

Fig. 45. Bo death chair, displayed outside of the men's
house to honor Pamas, of Tatau village, on the day of
his death. (Photograph by the author.)

original clan, and only reproduction and usage rights
are transferred. The complete transfer of each indi-
vidual malagan sculpture with *ciribor* may take up to
the full set of twelve or more commemorative cere-
monies, although the number of ceremonies can vary
considerably, depending upon the status of the per-
son or people commemorated, the size of the pig pop-
ulation, or the wealth and power of the person or
clan operating the ceremonies.

If a malagan changes hands with *ciribor*, all rights
are transferred as well, and the original owner can no
longer operate it. This process involves not only the
usual owner and recipient, the mother's brother–sister's
son pair, but also the carver (*tunumar*), because part of
the correct transferral of the *ciribor* of malagan involves
work with the carver to demonstrate how the carving
is to look. In the old days the carver would be paid
well for his services as *tunumar*. For example, a nine-

stage transferral of the rights to a sculpture would have started with *cirep*, the malagan ceremony in which a suitable log was identified, chopped down, and brought into the malagan enclosure. This act for the carver was called *cikciker*, and for this he would have been paid one-third of a length of traditional shell money (*rea*). The next seven stages in the carving of the malagan were also part of the handing over of the *ciribor*, and each occasion was marked by payments to the carver at a pig feast during which he was honored. The final payment marked the completion of the final stage of the transferral of the *ciribor*.

Ciribor is the key symbol in malagan, because the most important aspect of malagan is the knowledge of who has the correct rights of ownership to its parts, and ownership is *ciribor*. The term literally means "bone of pig," but its connotation is "skeleton of malagan." Hence, on one level of interpretation, malagan=human=pig. One aspect of this equation can be understood by noting that when a man operates a malagan with *ciribor*, he must obtain a pig from his parents or his mother's brother. They will have fed the pig, so the "bone" of this group of malagan ceremonies will have come up within the clan lines. To be formally recognized on Tabar as a person who owns malagan, this person or his matrilineal subclan would have publicly received at a malagan ceremony the rights to operate a ceremony within the rules and modes of behavior of a malagan subtradition.

The passing of a "string" to the next generation may begin with the use of a malagan of the *kupkup si malangga* category during a commemorative series of malagan ceremonies. During a later series the new owner may receive the rights to dance in masks such as *ges* and *pi*. These could be followed during a fur-

ther series by the rights to display frieze-type malagans (*kobokobor*) that hang horizontally on the wall of the display house; vertical pieces (*eikwar*) that resemble totem poles; wooden heads (*kovkov*) that are placed on raised platforms or made to fit on a body made of banana trunk; wooden, anthropomorphic figures (*marumarua*); or other diverse shapes. The final grouping in a "string" consists of the heavy and elaborate dance masks used for removing major prohibitions, such as those lifted from the men's house enclosure and graveyard at the last of the commemorative series of malagan ceremonies. The masks (*malanginivis*) have their own separate display house built in the men's house enclosure.

Although this process of transference is subject to public inspection for breaches of copyright, it is not possible for the traditions to be fixed absolutely. Most of the songs and many of the dances are in effect public property, for they are sung at funerals and other public malagan occasions.

CONCLUSION

The search for a satisfactory interpretation of old malagan artworks often seems to elude us in the late twentieth century. Yet the people of Tabar do not find this a problem. For them the meaning of malagan lies in its use. From memory, and often from oral descriptions, they produce new versions of the master artworks first carved centuries ago. The context of production has changed, as have the details and the referents of the sculptures and masks. But the tradition continues, linking malagan with clanspeople, binding people to one another with sculpture given now and returned in the next generation.

NOTES

1. Michael Gunn, "Rock Art on Tabar, New Ireland Province, Papua New Guinea," *Anthropos* 81 (1986).

2. W. Foy, "Tanzobjekte von Bismarck Archipel, Nissan und Buka," *Publikationen der königlichen ethnographischen Museum, Dresden* 13 (1900), pl. xiii; Dieter Heintze,

"Ikonographische Studien zur Malanggan Kunst Neuirlands," Ph.D. diss., Eberhard-Karls-Universität, Tübingen, 1969.

3. Derived in the main from H. Nevermann and E. Walden, "Totenfeiern und Malagane von Nord-Neumecklenburg," *Zeitschrift für Ethnologie* (Berlin) 72 (1940); Phillip H. Lewis, "The Social Context of

Art in New Ireland," *Anthropology* 58 (Chicago: Field Museum, 1969); G. N. Wilkinson, "Carving a Social Message: The Malanggans of Tabar," in *Art in Society*, eds. Michael Greenhalgh and Vincent Megaw (New York: St. Martin's Press, 1978); and my own fieldnotes from Tabar, 1982 and 1983–84.

Cat. no. 9, detail ▷

CATALOGUE
OF THE
EXHIBITION

1.

Canoe prow ornament

Northern New Ireland
Wood and pigment; 30″ × 12″ × 6¼″ (76.5 × 30 × 16 cm)
Provenance: collected by J. Hammond and W. H. Pease
The Peabody Museum of Salem, 1867

This exceptionally early malagan carving was collected by a captain
with the East India Marine Society during the period of intense
whaling and trade by American ships in the South Seas and before
the expansion of German interest in the area. It is remarkable also
for its degree of abstraction. The upper portion presents the kind
of zigzag foliage in use on bird friezes, but the wood is not cut
through. Below this are combined a human face and a complex
arrangement of several birds. The jaws of the face stand alone,
clenching a branch of betel nut, while above a bird suggests the
eyes and nose. Another bird's body supports the teeth.

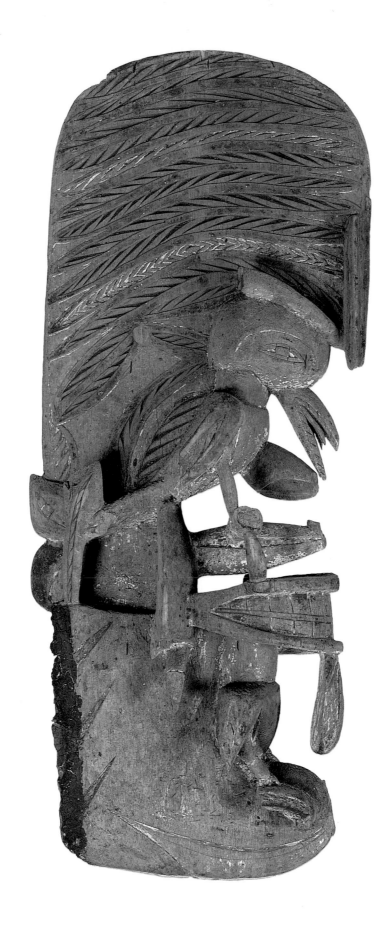

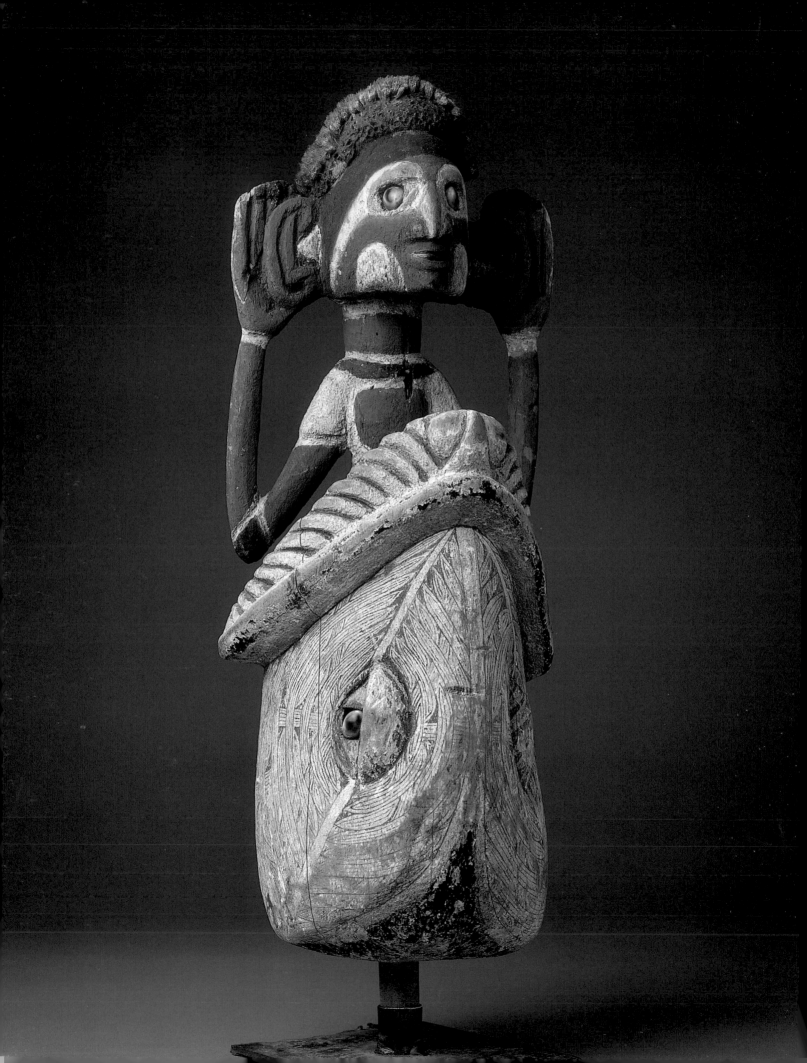

2.

Boat prow ornament

New Ireland
Wood (*alstonia*), parinarium fruit paste, vegetable fiber, *Turbo petholatus* opercula, and pigment; 21⅝″ (55 cm) high
Literature: Krämer, plate 43; *Führer durch die Sammlungen, Hamburgisches Museum für Völkerkunde*, p. 248.
Provenance: Museum Godeffroy
Museum für Völkerkunde, Hamburg, 1886

Small, pegged figures like this one were probably set into the block of wood left at the prow of dugout canoes, and may have been used on a so-called soul boat, a large-scale model of a canoe filled with human figures and made for display at memorial ceremonies (the best example known to survive is now in Stuttgart). If so, the depiction of a man in a shark's mouth, his hands cocking his ears, may be related to magical practices in shark-catching, and to New Ireland ideas about the transposition of souls of the deceased to sharks. It is certainly an exceptionally early example of New Ireland sculpture; the Museum Godeffroy ceased to function after the trading firm of Godeffroy and Sons went bankrupt in 1879, and the piece probably predates this by some years.

◁ 2

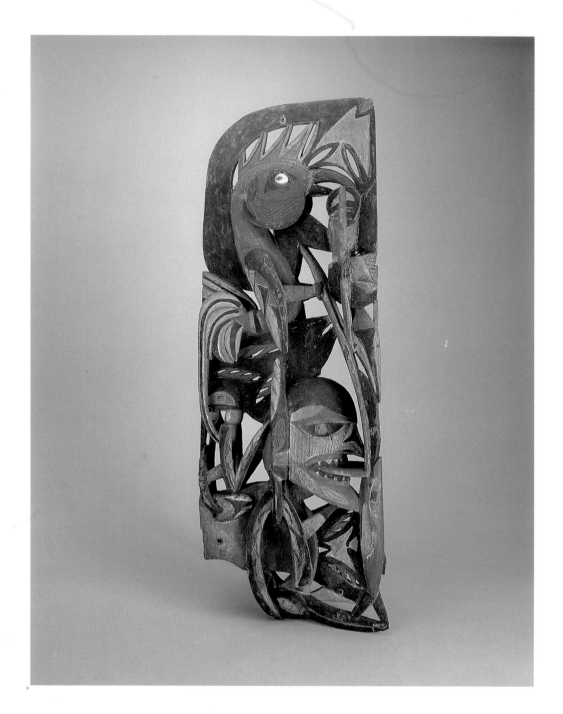

3.

Canoe Prow

Northern New Ireland
Wood, *Turbo petholatus* opercula, and pigment; 26¾″ × 3¾″ × 9″
 (68 × 9.5 × 22.8 cm)
Provenance: J. F. G. Umlauff
The Field Museum of Natural History, 1905

Canoe prows are the earliest documented type of New Ireland sculp-
ture, appearing in Tasman's well-known drawing of 1643

(fig. 7), yet surviving examples are few. The lower half of this work shows a human head; the tongue is folded upward and is transmuted into a small, inverted human torso and head, which is held in the beak of the large rooster behind it. There are secondary representations of fish, birds, and snakes. Present-day New Irelanders suggest that the ornaments were used in pairs, at the prow and stern of boats.

4.

Wall panel

New Ireland, Barok area
Bamboo, wood, bark, and pigment; 55½″ × 121″ × 1¼″ (141 × 308 × 3 cm)
Literature: Eckhart von Sydow, *Die Kunst der Naturvölker und der Vorzeit* (Berlin: Propyläen Verlag, 1932), no. 284 (illus.), p. 556; p. 56. Cf. Krämer, 1925, plate 35
Provenance: collected by the Deutsche Marine-Expedition (Walden), 1908
Museum für Völkerkunde, Abt. Südsee, Staatliche Museen Preussischer Kulturbesitz, West Berlin

Although the exact place where this wall panel was collected is unknown, it almost certainly was made for exhibition in the manner of a malagan within the mortuary festivals of one of the matrilineal peoples of central or southern New Ireland, for it depicts the debutante-like public display of young women, who are called *dawan* in Barok and Patpatar languages and *davar* in Mandak.

To become *dawan*, young girls underwent months or even more than a year of seclusion within a tiny hut. There the girls were fed rich foods and prohibited from sunshine or exercise, so that they would assume the ideal appearance of a *dawan*: rotund and with a very light "red" skin color. Each *dawan* was cared for by an older woman of the moiety opposite her own, who instructed her in the songs and dances to be performed publicly at the final festival.

On the wall panel, one half of each *dawan*'s face is painted red —the color New Irelanders consider most powerful, "hottest," and most beautiful—as are their swollen abdomens and prominent vulvas. Red is the color of blood and the best shell money, both symbolic of matrilineal relationship. The other sides of their faces are painted black or white, the colors of shame or mourning; they are also painted those colors used to distinguish the complementary roles of each moiety during mortuary rites.

Hanging from their necks the *dawans* wear numerous strings of shell money, each of which is bound near the ends. Suspended from these is an oval leaf purse (*kolot*) of the sort in which the shell money of ritually allied matricans is usually kept. The operculum of a *Turbo* shell decorates each purse, representing the red eye of a

91

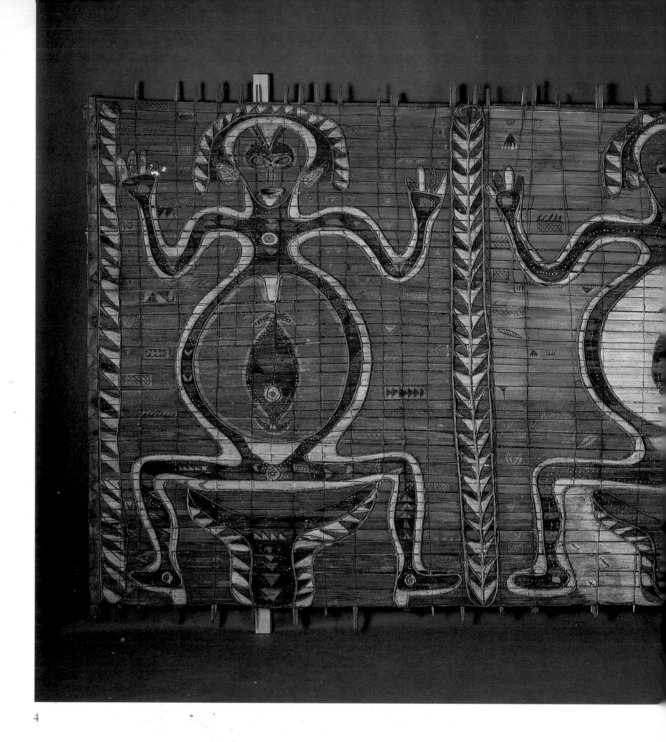

4

bird or the embryo of an egg, the symbol of such allied clans,
which "tie together the ends of their shell money" to produce such
major rituals.

Marriageable men attend the mortuary rituals and watch the *dawan*
as they dance and sit in ritual self-display on the distinctive forked
chairs (known as *ngonara* among the Barok), which are clearly de-
picted in these panels. A year or two after the festival, the male
relative responsible for each *dawan* will consider offers of shell money
in exchange for her.

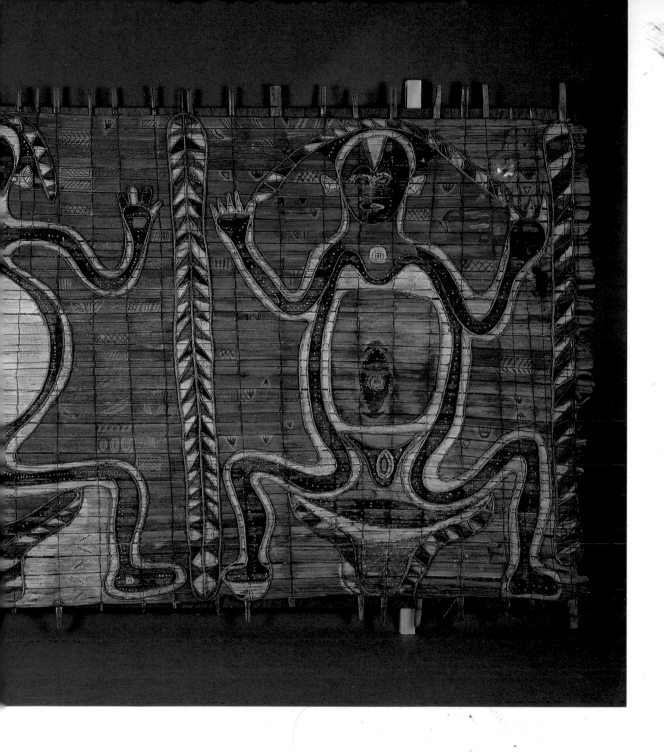

The meaning of the *dawan* image is essentially different from that of the images associated with males. The images created by and for male initiates are artificial and technological products of various disciplines of magical or hidden power. *Dawan* are girls who have matured into women; ready to realize their innately creative feminine capacity for production of new clan members and wealth, they are regarded as self-sufficient symbols of this capacity.

—Marianne George

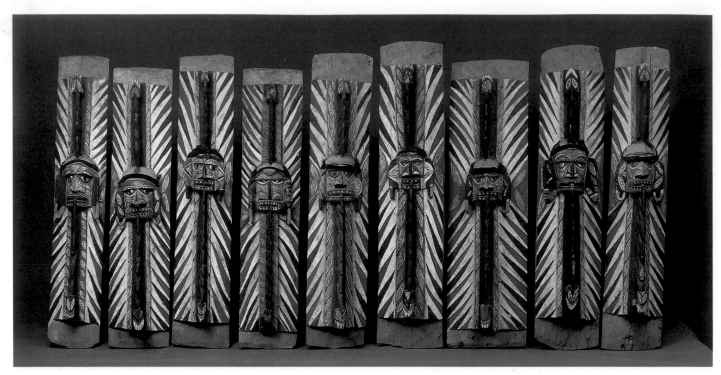

5

5.

Set of nine architectural panels

Northern New Ireland
Wood *(alstonia)*, vegetable fiber, *Turbo petholatus* opercula, and
 pigment, each approximately 33⁷⁄₁₆″ × 7³⁄₈″ × 4″ (85 × 20 × 10 cm)
Provenance: collected by the Deutsche Marine-Expedition (Walden),
 1907–09
Museum für Völkerkunde, Abt. Südsee, Staatliche Museen
 Preussischer Kulturbesitz, West Berlin

In a photograph taken by Bühler in 1948, panels like these can be
seen attached to the inner side walls of a malagan enclosure. Another
set is held at the Field Museum, Chicago. The motif of the rippling
snakes above and below the heads, possibly representing clan ani-
mals, is dramatically reinforced by the zigzag painted background.

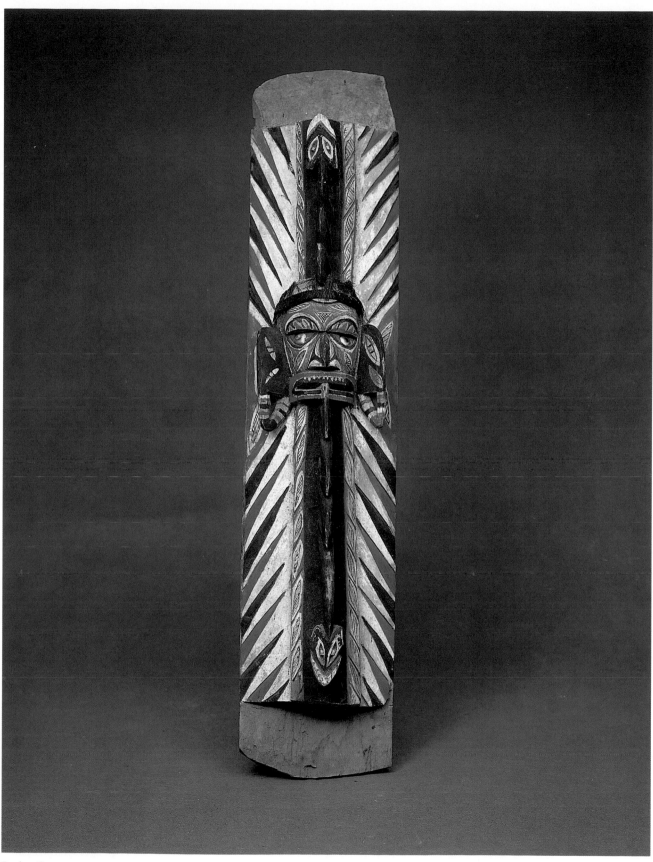

5, detail

6.

Set of two architectural panels

Northern New Ireland
Wood (*alstonia*), *Turbo petholatus* opercula, and pigment; each
 approximately 39″ × 11⅞″ (100 × 30 cm)
Provenance: H. Robertson
Museum für Völkerkunde, Hamburg, 1900

These panels probably comprised a portion of a larger set made to
be displayed on the inner walls of a malagan enclosure (see cat. no.
5). They are closely related in style to a horizontal panel at Hamburg
as well as to a more elaborate example at Frankfurt (Krämer, plate
100). The profile heads show a traditional men's hairstyle, the same
coiffure displayed on many *tatanua* masks.

6

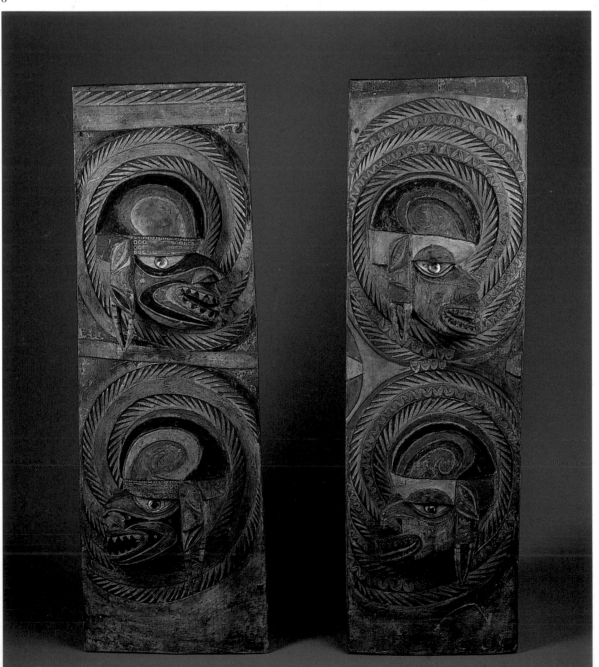

7 ▷

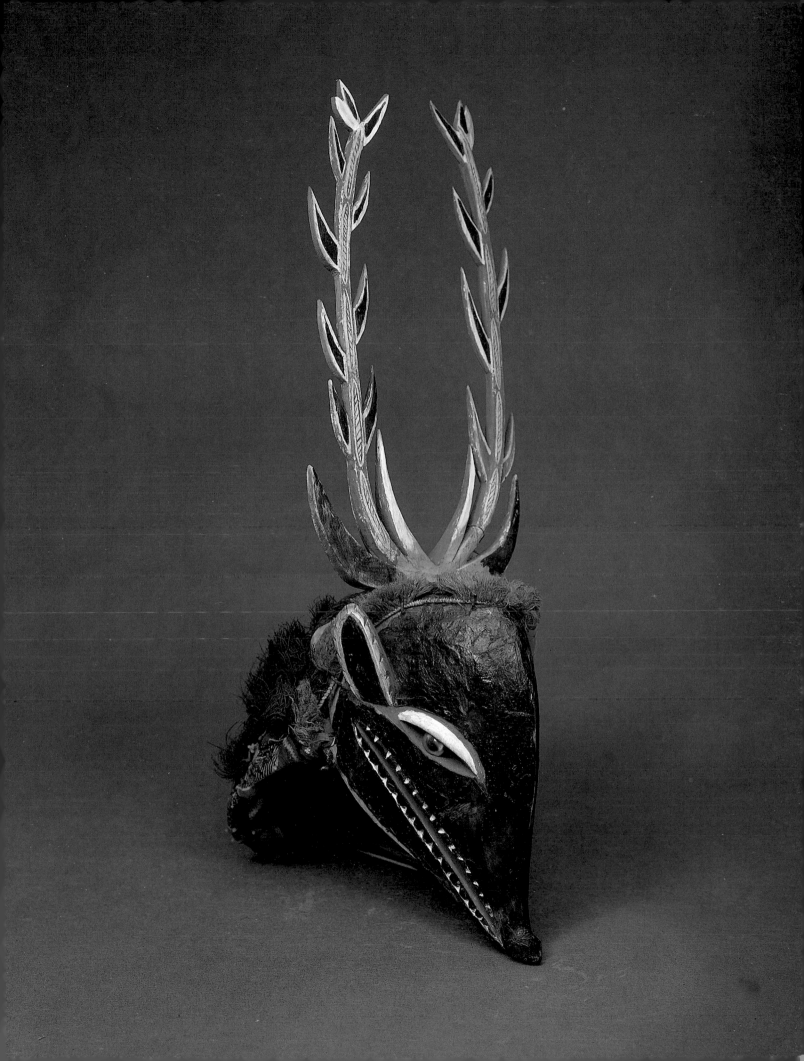

7.

Mask

Northern New Ireland
Wood (*alstonia*), vegetable fibers, parinarium fruit paste, *Turbo petholatus* opercula, trade cloth, beeswax?, and pigment;
27½" × 8¼" × 13⅜" (70 × 21 × 34 cm)
Literature: Helfrich, 1973, p. 126, cat. no. 108.
Provenance: collected by Hellwig in Kapsu before 1903
Museum für Völkerkunde, Abt. Südsee, Staatliche Museen Preussischer Kulturbesitz, West Berlin

This mask is highly unusual in form. The head itself bears a general resemblance to examples of pig head masks, but the wax-coated surface is generally seen on human representations. Most anomalous are the feathery branches, resembling antlers, that protrude from the top of the head. These have led to the suggestion that the mask actually represents a deer. Species of European deer are known to have been introduced in New Guinea during the period of the German Protectorate, but it seems unlikely that they would have been known on New Ireland, either on the hoof or from pictures, at an early date. It is possible that deer were seen by New Irelanders who were carrying out labor contracts in New Guinea or Queensland, but it seems more probable that this mask represents a decorated pig head.

8.

Pig mask

Northern New Ireland, southwest coast
Wood (*alstonia*), parinarium fruit paste, vegetable fibers, coral, *Turbo petholatus* opercula, and pigment; 11½" × 10⁷⁄₁₆" × 37⅜" (29 × 26.5 × 95 cm)
Literature: Helfrich, 1973, p. 126, cat. no. 107.
Provenance: collected by the Deutsche Marine-Expedition (Walden), 1907–09.
Museum für Völkerkunde, Abt. Südsee, Staatliche Museen Preussischer Kulturbesitz, West Berlin

Boars are at times represented in New Ireland dances, and there are a number of surviving examples of pig masks. This one is a rare form and is of particular interest for its correspondence to certain types of anthropomorphic masks, especially in the treatment of the top of the head as hair (represented by palm-leaf ribs), and the surrounding "corona" of feathery rods. The side pieces, now missing, are another reference to human masks; this application of human mask traits to an animal subject may well represent a conscious allusion or shading of meaning between the two categories.

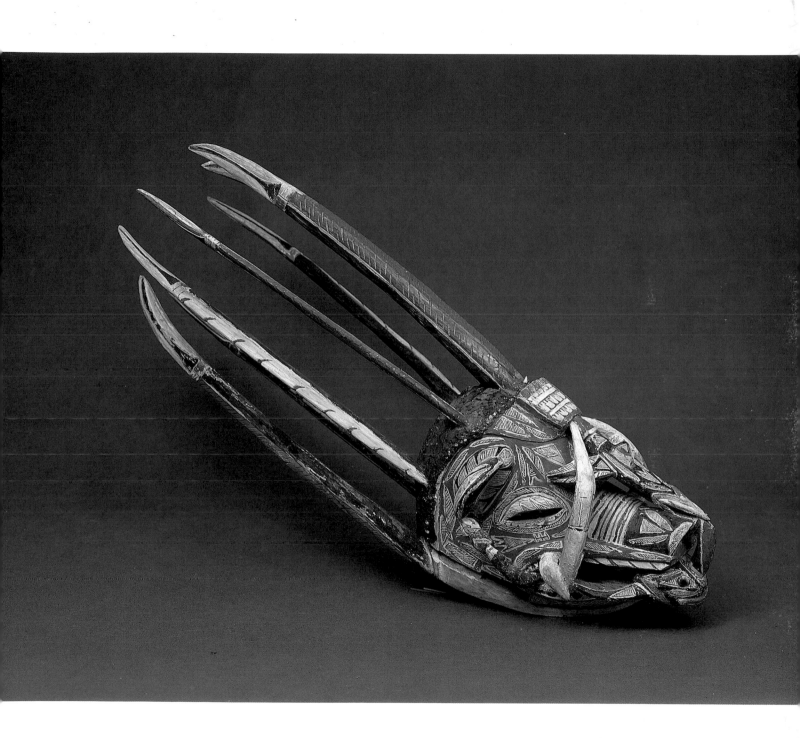

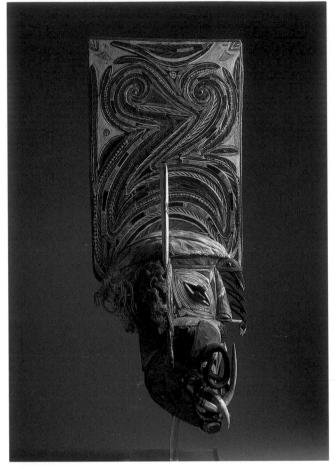

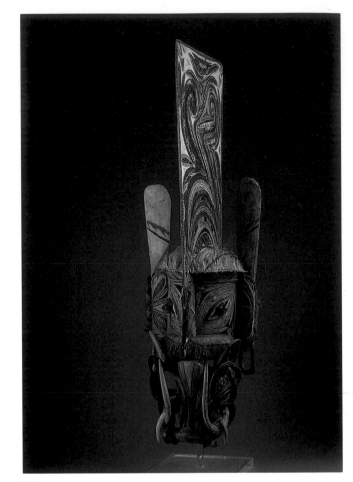

9, side 9, front

9.

Mask, *ges*

Northern New Ireland
Wood (*alstonia*), *Turbo petholatus* opercula, woolen yarn, and
 pigment; 43¹¹⁄₁₆″ × 13⅜″ × 22¹³⁄₁₆″ (111 × 34 × 58 cm)
References: Krämer, *Die Malanggane von Tombara*, plate 86
Provenance unknown
Übersee-Museum, Bremen

This large and spectacular mask represents a *ges* spirit, an individual's
alternate and usually invisible spiritual double which dwells in the
bush, as indicated by the slanting eyes. The large crest, with its
pattern of openwork whorls, is stylistically close to the type of
bird frieze Krämer refers to as *selagot*. The anthropomorphic upper
face, its nose in the form of a combined snake and bird design,
dissolves into the jaws of a pig, with multiple curving tusks. The
date of its accession in the Bremen collections is lost, but must
predate Krämer's publication of the work in 1925.

10.

Mask, *wanis*

Northern New Ireland
Wood (*alstonia*), sea sponge, bast, *Turbo petholatus* opercula, and
 pigment; 20⅞″ × 21⅝″ × 16⅞″ (53 × 55 × 43 cm)
Literature: Krämer, plate 89
Provenance: E. J. Robertson
Museum für Völkerkunde, Hamburg, 1884

Masks of this type represent *wanis*, or bush spirits. The earpieces
follow a complicated pattern of zigzagging snakes and small heads
of birds or fish. Two more snakes curve forward from the side of
the face and connect to the tusks that protrude from the mouth. The
facial decoration is an excellent example of the looping, asymmetri-
cal eye paint seen on many anthropomorphic New Ireland masks.

11.

Mask

Northern New Ireland, between Lemakot and Limba
Wood (*alstonia*), *Turbo petholatus* opercula, parinarium fruit paste,
 coral, vegetable fiber, and pigment; 23¹³⁄₁₆″ × 8¼″ × 7½″ (60.5 ×
 21 × 19 cm)
Literature: Helfrich, *Malanggan 1*, no. 51 (illus.), p. 103.
Provenance: An employee of Hernsheim and Co., 1879–80
Museum für Völkerkunde, Abt. Südsee, Staatliche Museen
 Preussischer Kulturbesitz, West Berlin

This unusually early and complex mask contains numerous animal
representations. The large earpieces have parrot heads at top and
bottom, while the space in between is filled with a pattern of small
fish heads. The sides of the head are supported by elaborately painted
snakes; a small animal, possibly a crustacean, is held in the mouth
of the mask and is connected to the large fish above the top of the
head by two intricately twined snakes painted in contrasting fashion.
Helfrich groups this mask under the large category of *nit*; it is of a
type still in use in Tabar, known there as *wanis si mi varima*, of the
malanginivis type, appearing in dances and performances. The proper
right earpiece has been restored, and in an old drawing of the piece
there appears a decorative band around the head, possibly of feathers,
and perhaps a peaked cap. The beard is rendered by fragmentary
vegetable fibers.

Overleaf: 10, 11 ▷

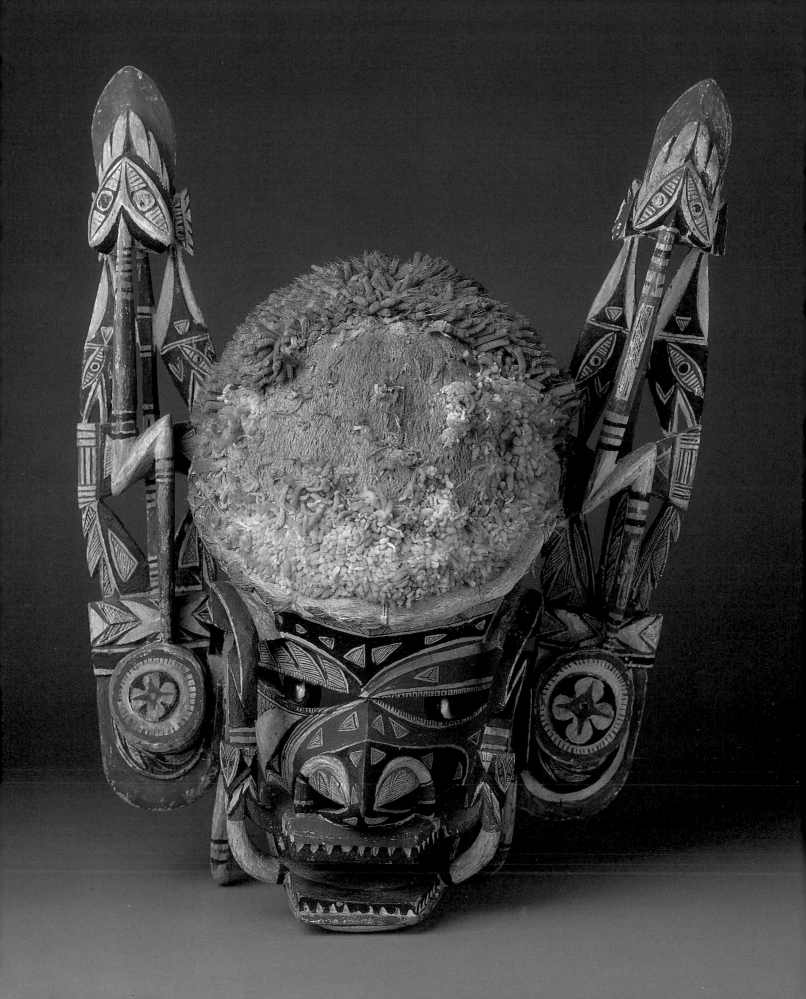

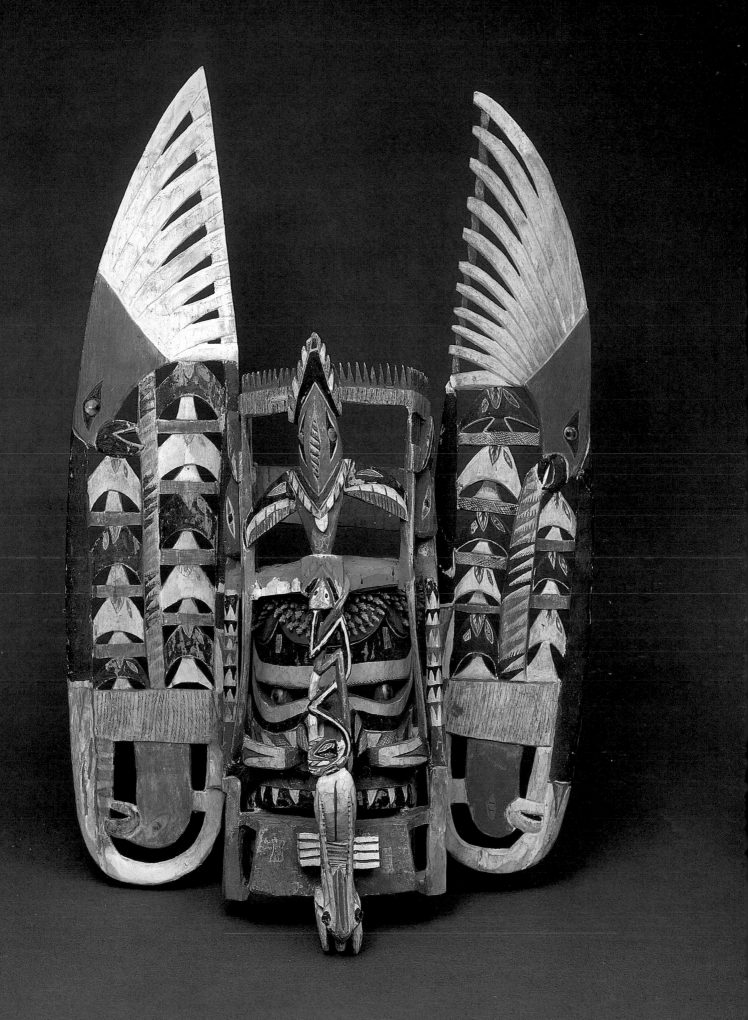

12.

Mask

Wood, *Turbo petholatus* opercula, and pigment; 21⅝″ × 4⁵⁄₁₆″ × 3⁹⁄₁₆″
 (55 × 11 × 9 cm)
Provenance: American Board of Commissioners for Foreign
 Missions
The Peabody Museum of Salem, 1946

Very little is known of the history of this unusual mask, presumably
collected by Congregationalist missionaries in the Pacific. It is
unmistakably malagan in form, and the use of snail opercula to
represent eyes further links it to New Ireland; but it lacks the
characteristic surface decoration and instead has strikingly simple
linear patterns. It may be of extremely early date. There are no
holes for attachment of a cap or headdress to secure to a dancer's
head; in the lower half of the mask interior there is a small block of
wood that probably served as a bit for the wearer to hold the mask
in his mouth.

12

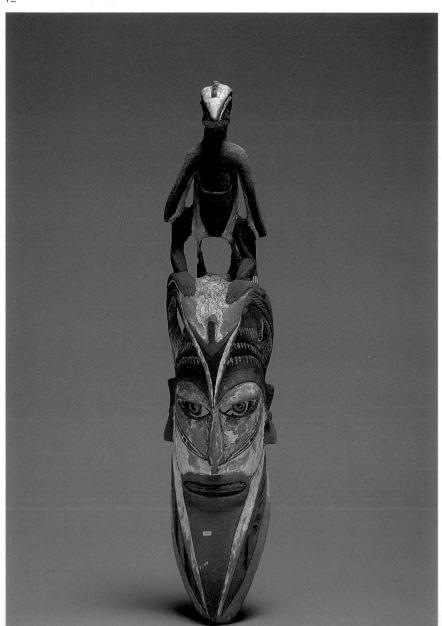

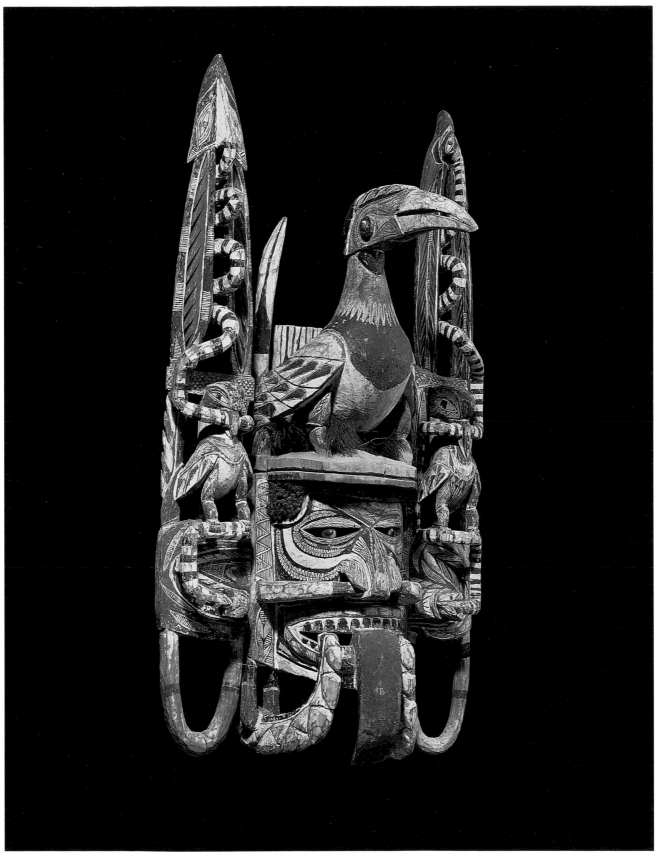

13

13.

Mask (*wanis*)

Northern New Ireland
Wood (*alstonia*), *Turbo petholatus* opercula, and pigment;
 37″ × 20⅞″ × 19″ (94 × 53 × 48 cm)
Provenance unknown
UCLA Museum of Cultural History, Museum Purchase

This unusually large and elaborate *wanis* mask is of a type used in ceremonies to remove major prohibitions. A large hornbill figure is placed on top of the head, and the tongue protrudes from the mouth, flanked by what are probably representations of plant garlands. In the center of the earpieces are chickens holding snakes in their claws and beaks.

14.

Mask

Northern New Ireland
Wood (*alstonia*), vegetable fiber, *Turbo petholatus* opercula, and
 pigment; 24″ × 11½″ × 19″ (61 × 9.2 × 48.5 cm)
Literature: Tibor Bodrogi, *Oceanic Art* (1959); plate 89
Provenance: collected by the crew of the ship *Panther*, of the Austro-
 Hungarian Navy, before 1900
 The Ethnological Museum, Budapest
The Brooklyn Museum, 1984
 Gift of Mr. and Mrs. Milton F. Rosenthal

This extraordinarily powerful mask probably represents a *ges* spirit, a powerful and in this case perhaps destructive force. Many myths refer to these spirit doubles of the living, who sometimes attacked humans who inadvertently saw them. Here the protrusion from the mouth may depict the liver of a *ges* victim. The nosepiece is a subtle and highly abstract version of the theme of bird and snake in struggle.

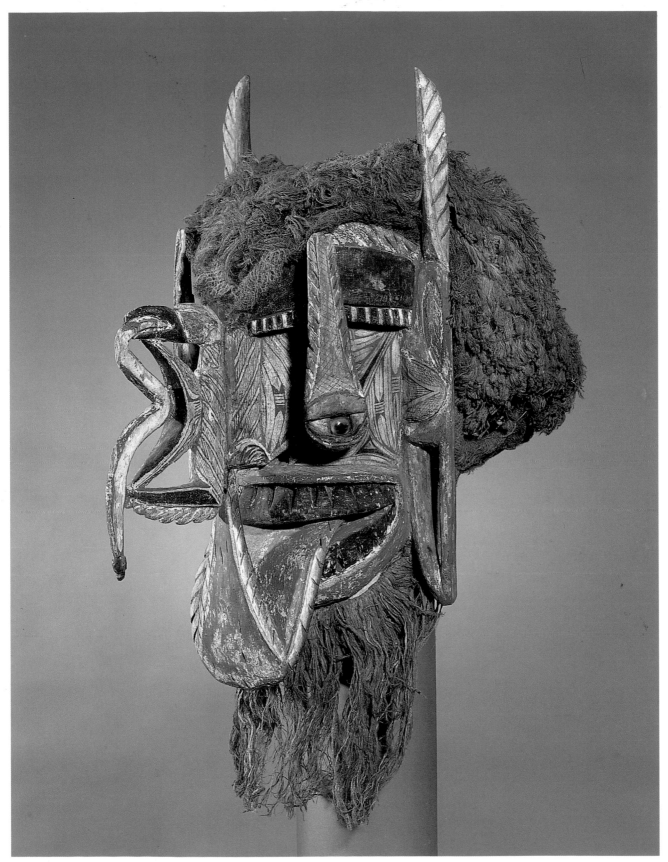

14

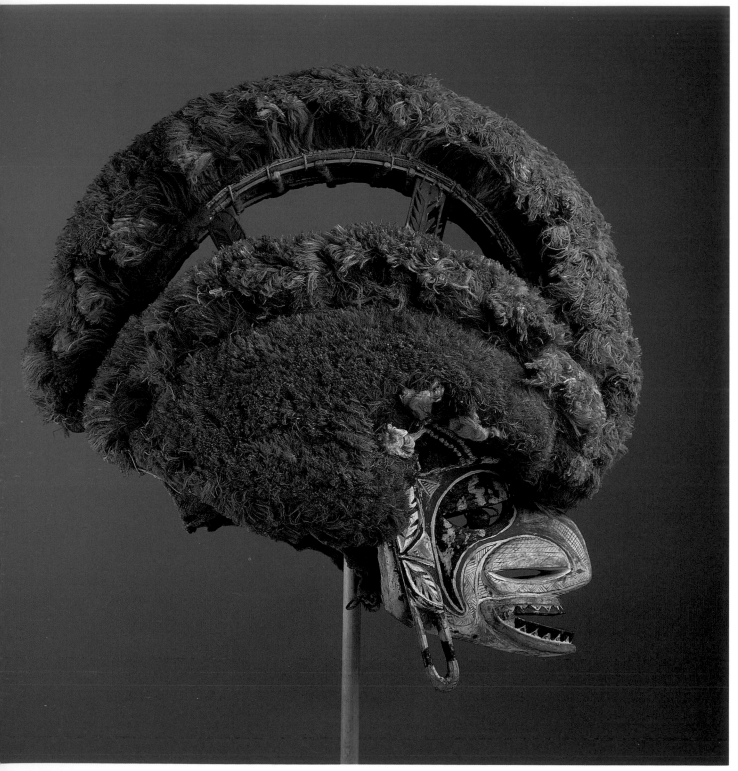

15.

Mask, *tatanua*

Northern New Ireland
Wood (*alstonia*), vegetable fibers, *Turbo petholatus* opercula, and
 pigment; 20⅞″ × 10⁷/₁₆″ × 22⁷/₁₆″ (53 × 26.5 × 57 cm)
Literature: Krämer, *Die Malanggane von Tombara*, plate 74
Provenance: Museum Umlauff, Hamburg, 1895.
Übersee-Museum, Bremen

Although this mask conforms to the stylistic conventions of *tatanua*,
the crest is exceptionally large, and the two tiers with an open
space between them highly unusual. An old label under the chin
reads "J.F.G. Umlauff, Museum, Hamburg, Spielbudenplatz 8,
N 40 anga . . . " (unreadable). It may be the piece referred
to in old museum records as having been purchased in May 1895.
In any case, it had entered the museum's collections by 1925, when
it was published in Krämer.

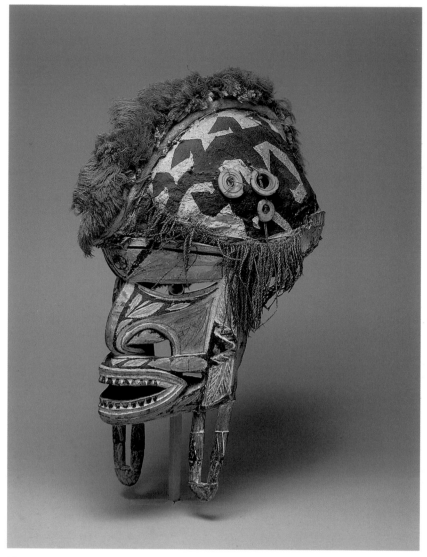

16

16.

Mask

Northern New Ireland
Wood (*alstonia*), vegetable fiber, parinarium fruit paste, lime, *Turbo petholatus* opercula, and pigment; 17″ × 7½″ × 12½″
 (43.2 × 19 × 32 cm)
Provenance unknown
The Fine Arts Museums of San Francisco, California Midwinter
 International Exposition, 1895

This classic example of a *tatanua* mask shows one of the most striking characteristics of these dance headdresses: the differentiation of the two sides of the headpiece. In dance, *tatanua* masks are seen perhaps most advantageously from the side: because of the differences between the sides of the mask, the appearance of the dance line is altered when the dancers turn around.

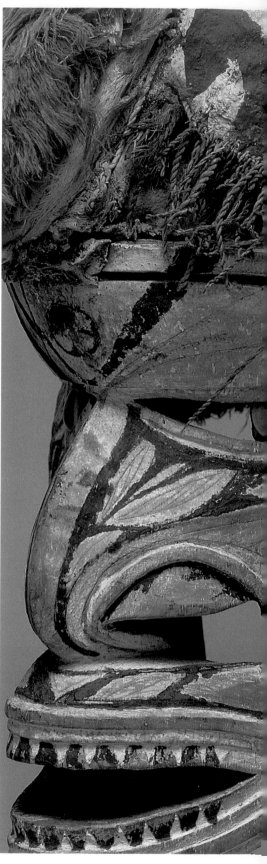

16, detail

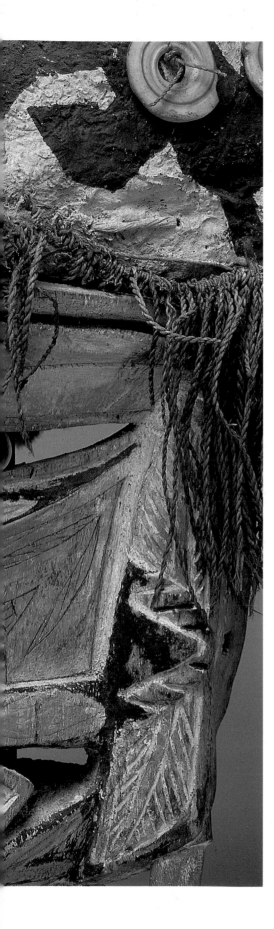

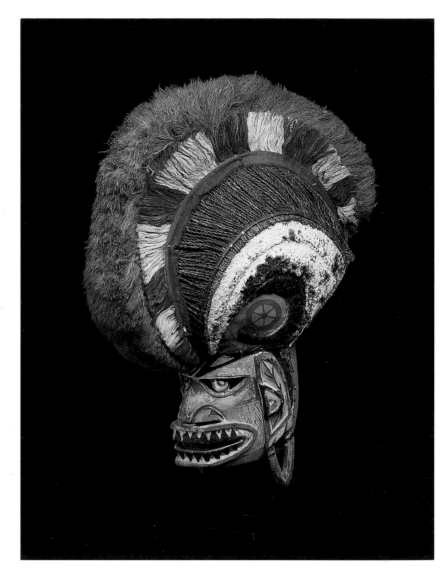

17

17.

Mask, *tatanua*

Northern New Ireland
Wood (*alstonia*), lime, vegetable fibers, trade cloth, *Turbo petholatus*
 opercula, and pigment; 17″ × 7¼″. × 13¼″ (43.5 × 19 × 33.5 cm)
Provenance unknown
Dr. and Mrs. Jack Wallinga, Minneapolis

A good example of the prototypical *tatanua* design, this mask is
distinguished by the ingenious use of printed trade cloth. The
maskmaker placed the spoked-wheel pattern of the fabric at the
center of the concentric arcs of the headdress, as a variant of the
mataling, or eye of fire, motif. The crest design is unusually elaborate.

18.

Mask, *tatanua*

Ungalubu village, New Hanover
Wood (*alstonia*), vegetable fiber, trade cloth, glass beads, metal,
 and pigment; 17¾" × 7½" × 22" (45 × 19 × 56 cm)
Provenance: collected by Dr. Lau on New Hanover
 Museum voor Volkenkunde, Rotterdam
Loed and Mia van Bussel, Amsterdam, 1965

This superb example of the *tatanua* style bears an elaborate dance
ornament in the mouth showing a quadruped topped by a small
"eye of fire" motif. The crest is made in multiple bands of coconut
fiber, and its center is black sennit on one side and red trade cloth
on the other. Snakes coil across the nose and mouth on both sides
of the cheeks.

18

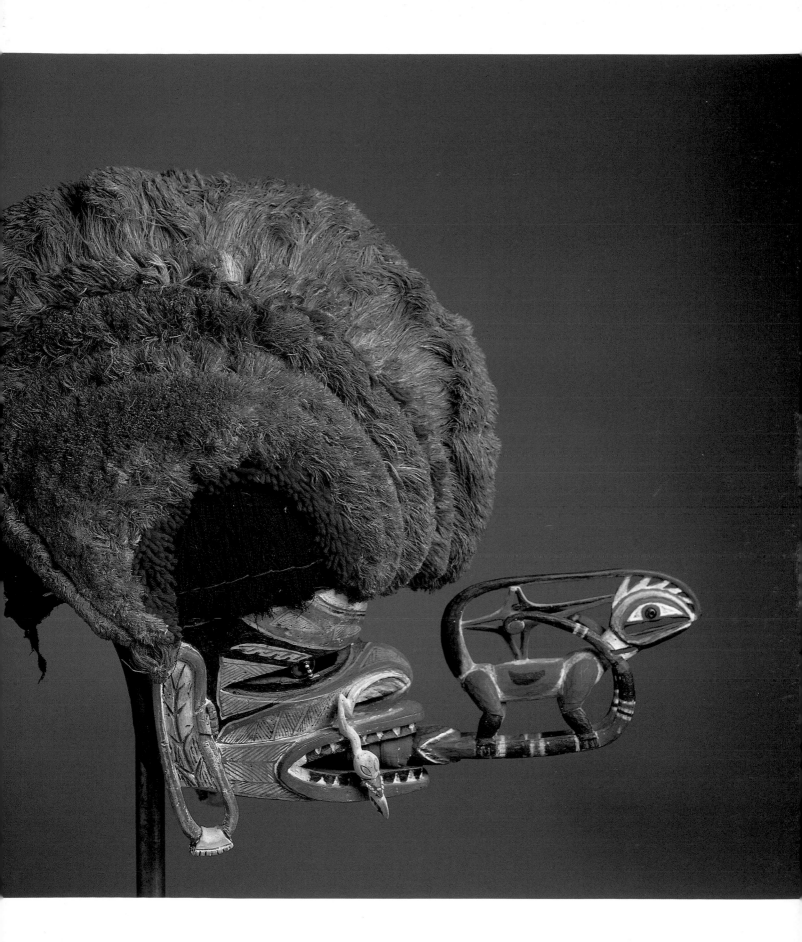

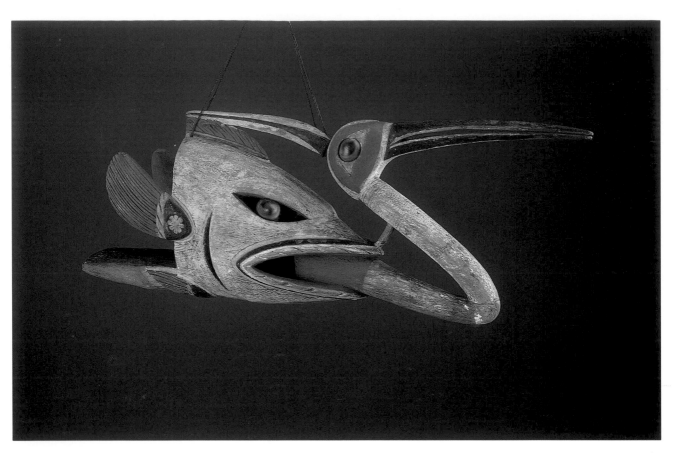

19

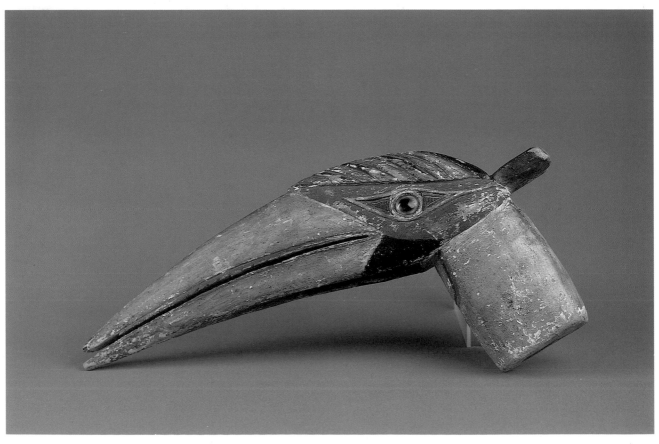

20

19.

Dance ornament

Northern New Ireland
Wood (*alstonia*), *Turbo petholatus* opercula, and pigment;
 5¹¹⁄₁₆″ 16⅛″ × 2¹³⁄₁₆″ (14.5 × 41 × 7.2 cm)
Provenance: Carl Nauer
Übersee-Museum, Bremen, 1911

This highly unusual mouth ornament depicts a shark swallowing a bird; far more common are the simple hornbill-head ornaments, like catalogue no. 20. The small flat bit behind the shark head would have been held between the dancer's teeth. The piece was acquired from Carl Nauer, captain of the steamship *Sumatra*, which made regular voyages throughout German New Guinea. A related example is to be found in Berlin (Krämer, plate 72).

20.

Dance ornament

Northern New Ireland
Wood (*alstonia*), *Turbo petholatus* opercula, and pigment;
 7½″ × 14⅜″ × 1⁹⁄₁₆″ (19×36.5×4 cm)
Provenance unknown
The Übersee-Museum, Bremen

Wooden hornbill heads are by far the most common form of dance ornament in New Ireland. The dancer would have held the small wooden bit in his teeth and danced in imitation of the movements of the bird. The skin and beaks of actual hornbills were also used as dance ornaments, mounted on small wooden cores and held in the same way. A frieze from Bremen, catalogue no. 43, shows men wearing hornbill ornaments.

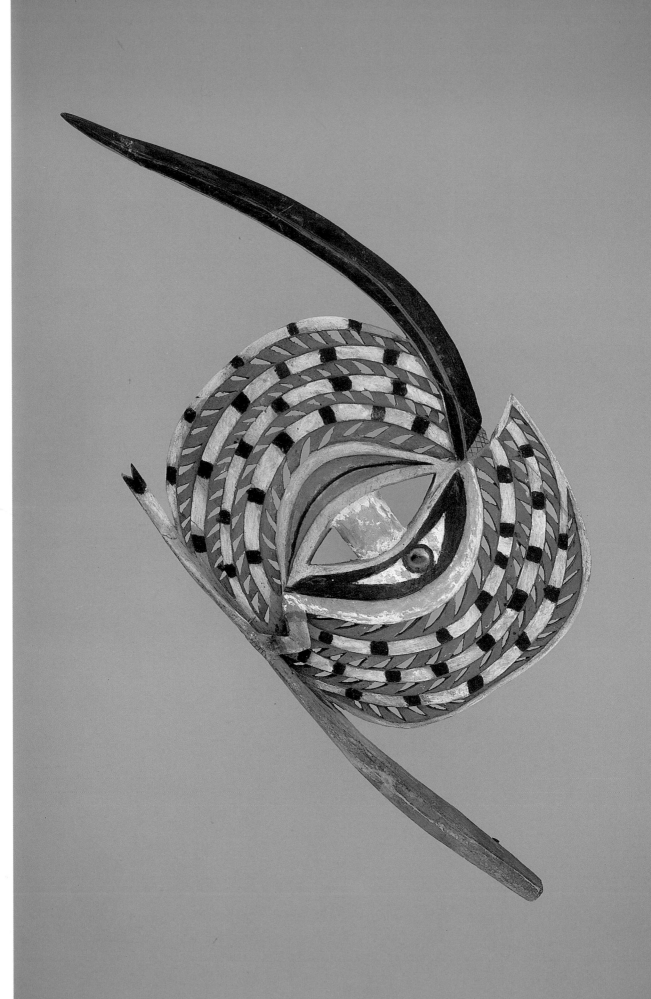

21.

Dance ornament

Northern New Ireland
Wood (*alstonia*), *Turbo petholatus* opercula, and pigment;
 $19^{11}/_{16}''$ × $7^{7}/_{8}''$ × 2" (50 × 20 × 5 cm)
Provenance: Harold M. Sewall
The Peabody Museum of Salem, 1925

Of more abstract design than the more conventional hornbill-head
dance ornaments, this example nevertheless refers to birds as well.
In the center a bird-eye design bears a snail operculum, and a long,
curving beak extends over the openwork disc to protrude from the
middle of the dancer's face.

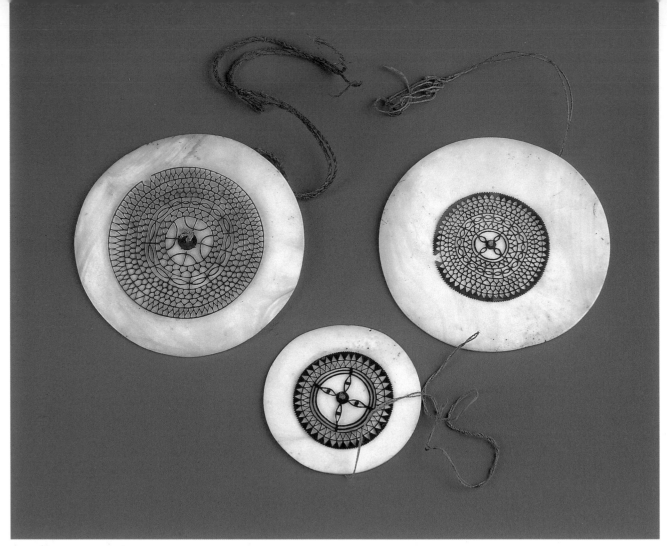

22

22.

Kapkap ornaments

New Ireland
Tridacna shell and tortoiseshell; diameters 3″, 4½″, and 4⅝″
 (7.5, 11.4, and 11.7 cm)
Provenance unknown
The Übersee-Museum, Bremen

Tridacna and tortoiseshell neck ornaments, known as *kapkaps* in
Neo-Melanesian, were widely distributed throughout the Bismarck
Archipelago. They are thought to have originated on New Ireland
and the surrounding offshore islands and to have been dispersed
through indigenous trade routes. In some regions their use was
restricted to men in positions of leadership. The tortoiseshell disc
is often divided into quadrants, and this design seems to be related
to the *mataling,* or eye of fire, found on malagan sculpture.

23.

Friction block

Northern New Ireland
Wood; 8¼″ × 20″ × 7½″ (21 × 50.8 × 19.1 cm)
Provenance: A. B. Lewis, 1909–13
The Field Museum of National History, 1913

Musical instruments of this type are unique to New Ireland.
The player rubs the three protruding wedges, cut to different
sizes, with a damp hand; this action produces an undulating
series of notes. Such drums were used in malagan ceremonies
and men's rituals, and are known as *lonuat* in the Notsi language
area, after a bird whose cry they supposedly mimic, and *livika*
in the Mandak region. They are nearly always decorated with
incised carving and inset opercula to suggest an animal form.
The shells are missing in this example.

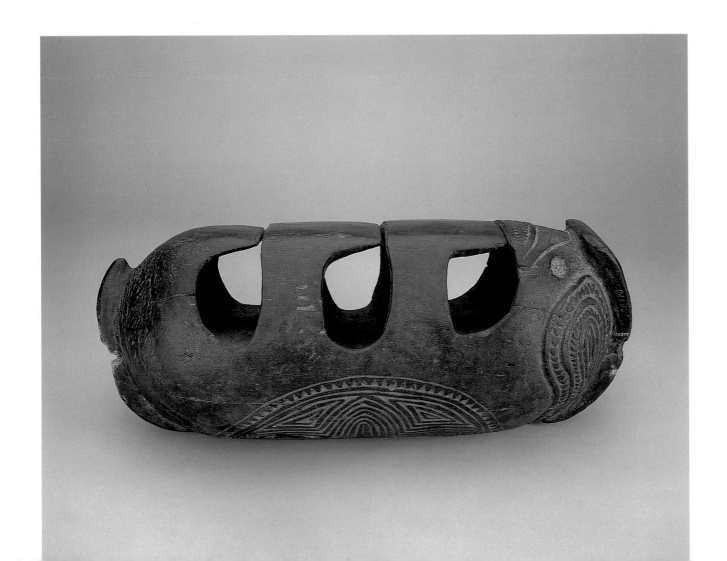

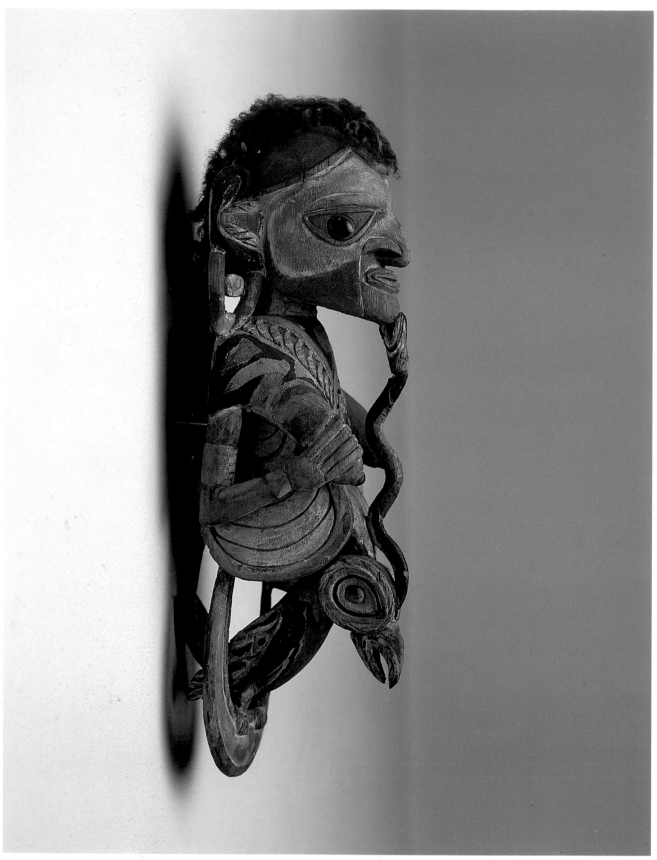

24

24.

Female figure

Wang village, Great Tabar Island
Wood, (*alstonia*) human hair, *Turbo petholatus* opercula, and
 pigment; 14½″ × 4⅝″ × 5¼″ (37 × 11 × 13 cm)
Provenance: collected by a German named Meyer on Great Tabar
 in 1914
 L. Brettschneider, Munich
Loed and Mia van Bussel, Amsterdam, 1972

This softly carved figure is anomalous in its small scale, in its use
of human hair, and in its representation of a female. Figures that
terminate at the ribcage are referred to on Tabar as *eibongamas*. Here,
a crescent-like support below the ribs holds a large bird, probably
a parrot. A rippling snake that begins at the bird's head bites the
figure's chin with jaws that resemble the conventionalized malagan
treatment of fish or shark jaws. In her left hand the woman holds a
food pounder, and she wears plant garlands across her shoulders.
The surface seems to show some traces of charring, and there is a
small lug at the back of the head, presumably for suspension.

25.

Standing figure

Northern New Ireland
Wood (*alstonia*), *Turbo petholatus* opercula, parinarium fruit paste,
 and pigment; 69³⁄₁₆″ × 11³⁄₁₆″ × 9³⁄₁₆″ (176 × 30 × 25 cm)
Provenance: Eduard Hernsheim, 1879
Museum für Völkerkunde, Abt. Südsee, Staatliche Museen
 Preussischer Kulturbesitz, West Berlin

Regretably little is known about this early and extremely interesting
work. It seems to resemble in form later examples of standing
figures in which the torso terminates at the ribcage, but here the
large bird held in the figure's hands supplants the flaring ribs. The
small quadruped painted on the nose is unusual. The lower portion
of the figure is rendered as a panel carved and painted in a radiating
foliate design, which New Ireland informants associated to a coco-
nut-palm frond, and bordered by a row of small bird heads. Two
large snakes are intertwined up the center. Michael Gunn has sug-
gested that it resembles the *eibongamas* figures of Tabar, with snakes
consuming the entrails.

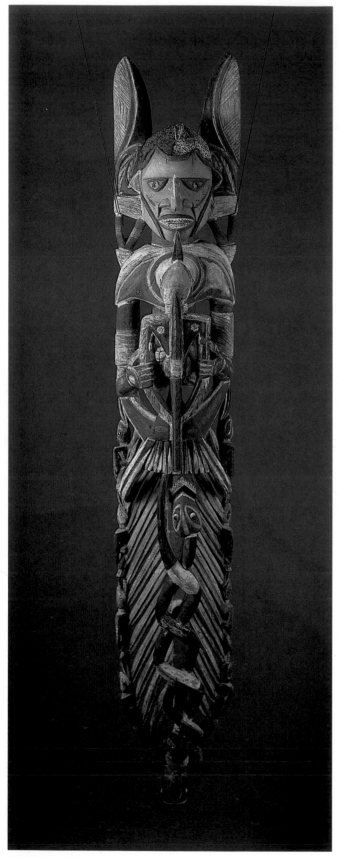

25

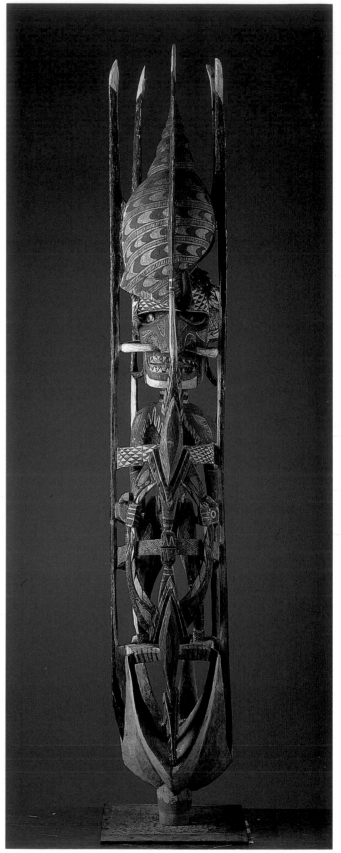

26

122

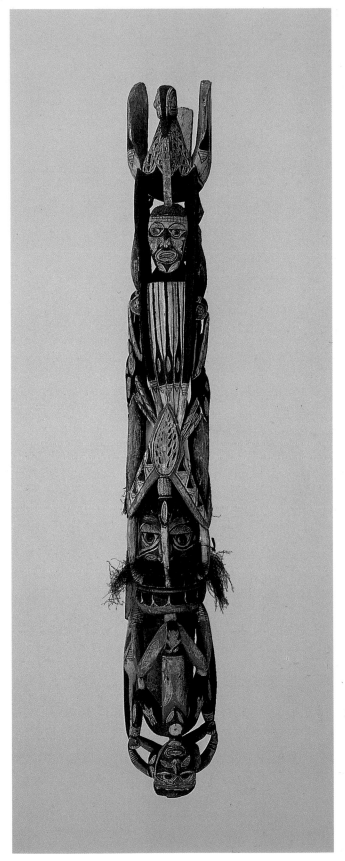

27

26.

Standing figure

Northern New Ireland
Wood, *Turbo petholatus* opercula, and pigment;
 51³/₁₆″ × 7⅞″ (130 × 20 cm)
Museum für Völkerkunde, Hamburg

This small figure is shown standing on a pronged form that, according to Biró, represents the calyx of a flower. A triton shell carved in wood is set atop the head, enclosed in the feathery struts of a *malanggatsak* figure. New Ireland informants suggested that the figure may have been made for a deceased woman, probably someone belonging to a shore clan. Triton shells were used as trumpets and may sometimes have been attached to the crests of *tatanua* masks.

27.

Standing figure

Tatau Island
Wood (*alstonia scholaris*), lime, *Turbo petholatus* opercula, vegetable
 fibers, and pigment; 41⅜″ × 5¼″ × 5¼″ (105 × 13 × 13 cm)
Literature: Spiegel 1973, 203; Gunn, "Tabar malagan," 1982,
 appendix 2
Provenance: Captain Farrell
Australian Museum, Sydney, 1887

One of a group of five similar figures held at the Australian Museum, this complex pole is a *kobokobor*, or foundation piece, of the *kulepmu* malagan tradition. It is an excellent example of the virtuoso carving style of the early contact period. Vertical figures like this are known as *eikwar*.

28.

Standing figure

New Ireland
Wood (*alstonia*), *Turbo petholatus* opercula, shells, and pigment;
 78″ × 13½″ × 12″ (198 × 34.3 × 30.5 cm)
Literature: *The Art of Collecting* (Minneapolis: The Minneapolis
 Institute of Arts, 1986), p. 12
Provenance: Museum für Völkerkunde, Dresden
The Minneapolis Institute of Arts, 1985
 Gift of Myron Kunin

Music is an important part of New Ireland ceremonial life, and one of the principal instruments is a set of bamboo pipes, constructed like the panpipes of ancient Greece. This large-scale figure of a piper wears a conical headdress representing a *karuka*, a woman's

28 ▷

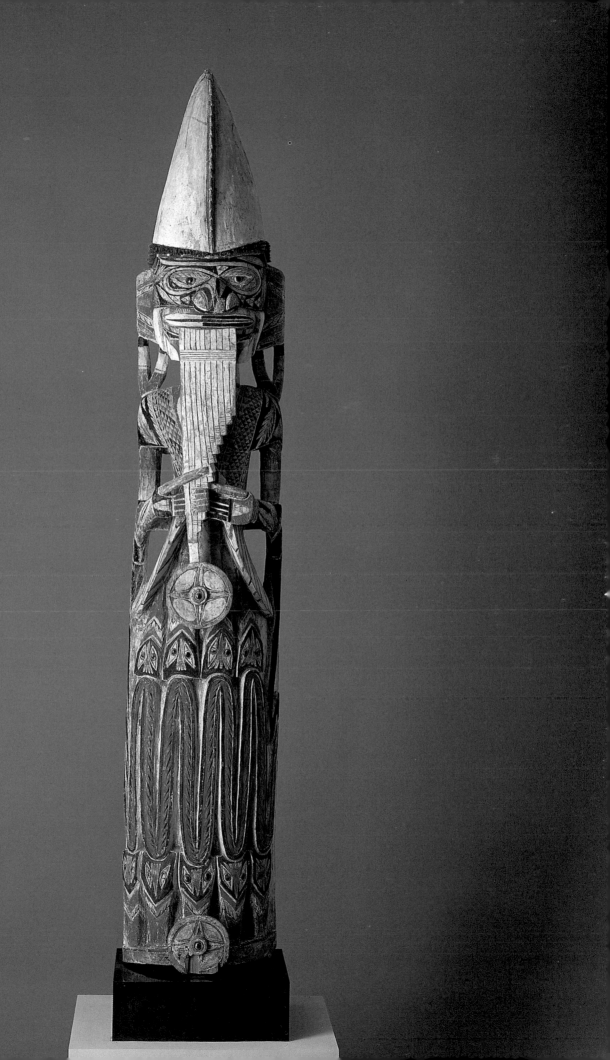

pandanus-leaf hat (see fig. 3), and is thus presumably female; New Ireland informants disagreed about whether women were permitted to play the pipes. The hair is rendered by tiny shells. Other panpipe players, of significantly smaller size are in collections at Stuttgart, Salem, and elsewhere. Another similar figure is in the collection at Dresden.

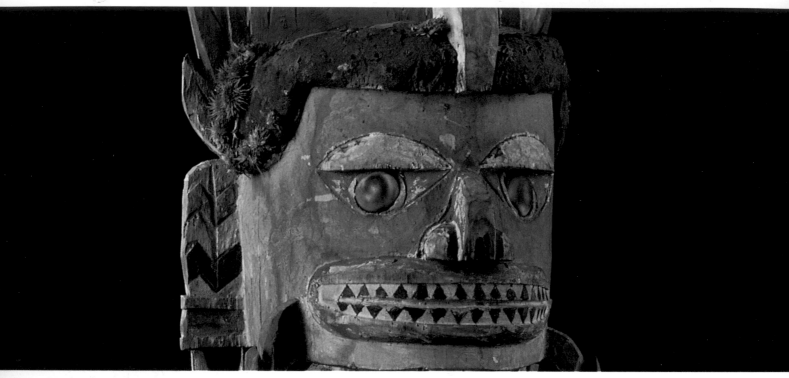

29, detail

29.

Standing figure

Northern New Ireland
Wood (*alstonia*), *Turbo petholatus* opercula, and pigment;
 63½" × 6" × 6¾" (161.2 × 15.2 × 17.1 cm)
Literature: *Masterpieces from the Sir Henry Wellcome Collection at
 UCLA* (Los Angeles, 1966) no. 384, pp. 143 (illus.), 157.
Provenance unknown; collected in New Ireland before 1933
 The Wellcome Medical Trust
UCLA Museum of Cultural History, Gift of the Wellcome Trust

An elaborate openwork crest rises from the head of a figure standing in the mouth of a large fish, possibly a shark. The figure is of the type known as *malanggatsak*, a powerful image that can inflict harm. The meaning of these virtuoso pieces is unknown, but they were probably made to lean against the inner wall of the malagan en-closure. The relationship of sharks and humans is a subject of great interest in New Ireland sculpture.

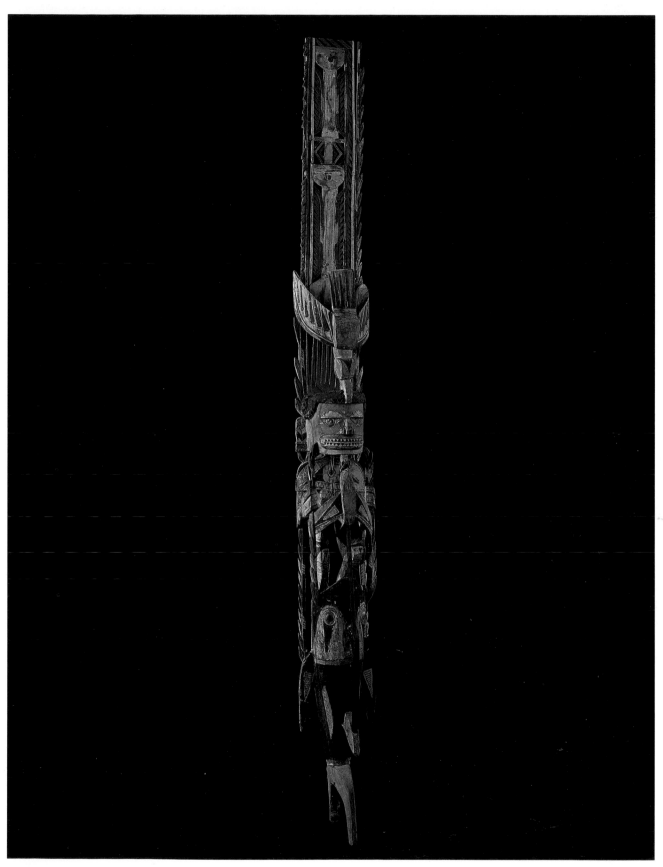

29

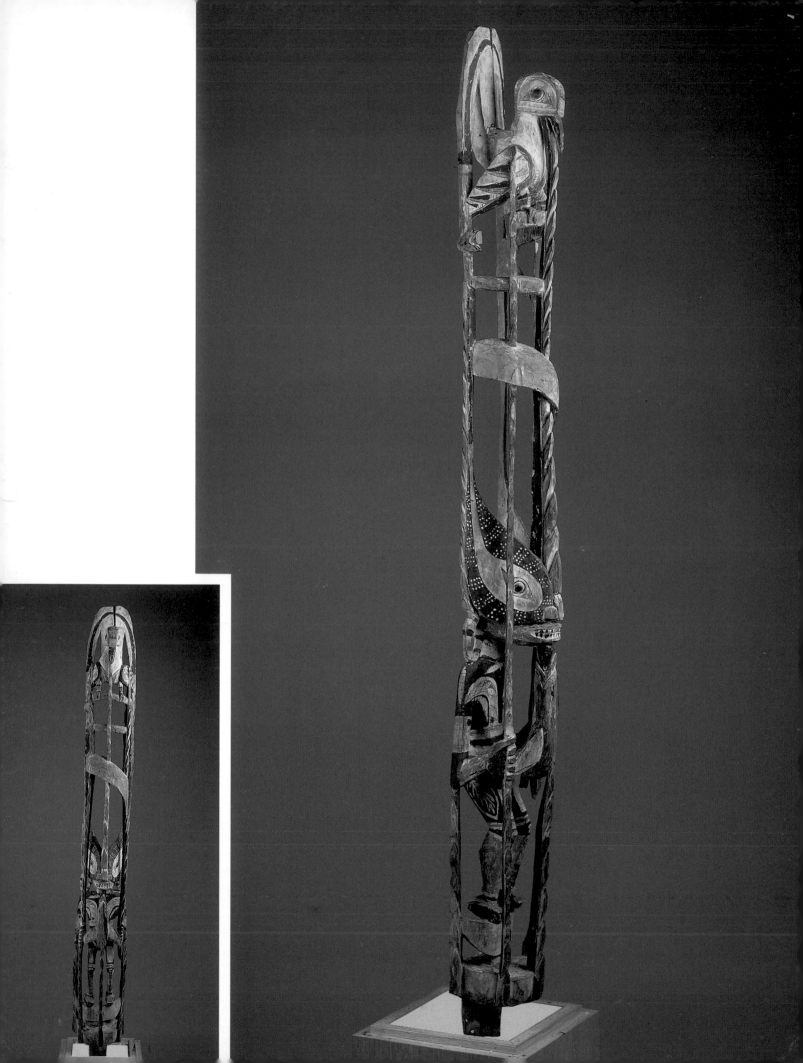

30.

Standing figure, *ges*

Northern New Ireland
Wood (*alstonia*), *Turbo petholatus* opercula, and pigment;
 56¹¹⁄₁₆″ × 6⁵⁄₁₆″ × 5½″ (144 × 16 × 14 cm)
Provenance: Collected by Rohrmann, probably before 1913
Übersee-Museum, Bremen, 1939

The figure is represented wearing a mask usually made of bast and representing a bird (Krämer, no. 80), or more likely a *ges* spirit (Helfrich, nos. 116, 118–119, p. 38–9; Bühler 1933:252). The spiral band enclosing the tall struts is unusual and imparts a rare sense of motion to the piece. The bird at the top is a chicken. The sculpture was part of a gift to the museum by the widow of an official of the Norddeutscher Lloyd shipping firm who made several tours through German New Guinea between 1907 and 1912.

◁ 30

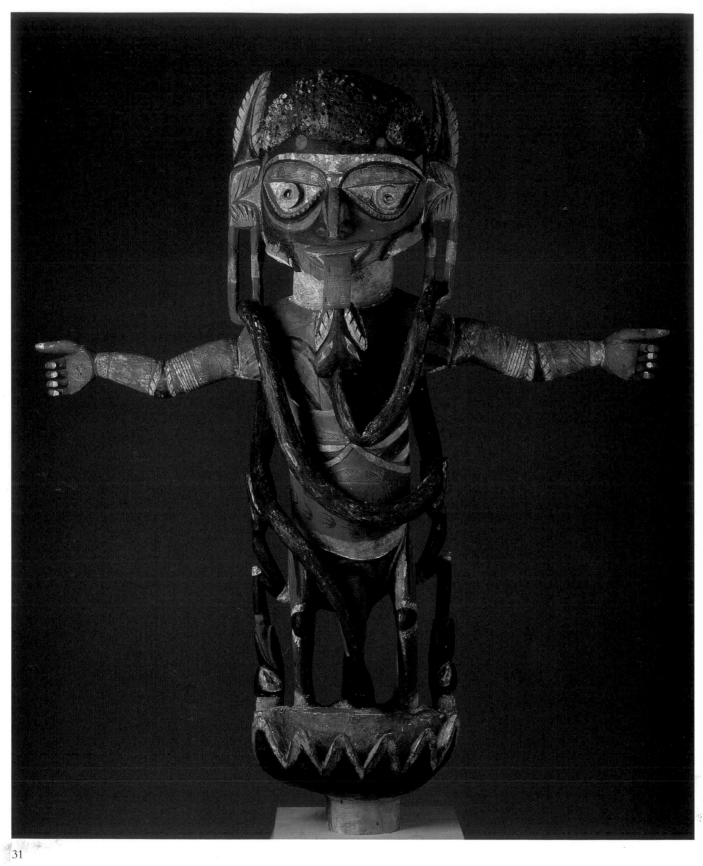

31

31.

Standing figure with snakes

New Ireland
Wood (*alstonia*), parinarium fruit paste, *Turbo petholatus* opercula,
 and pigment; 53⅛″ × 41⅜″ (135 × 105 cm)
Museum für Völkerkunde, Hamburg

The figure, of the type known in Tabar as *marumarua*, is used in magical practices to control rain. It stands on a base with an undulating edge, usually interpreted as a Tridacna shell; such figures were kept with seashells in a secluded bush area. The feet are entirely absent. The proximity of the large snake to the phallus of the figure may imply a reference to various Melanesian myths that assign phallic significance to snakes, of which there are several variants specific to New Ireland (Powdermaker 1933a, 273–74). The outstretched arms are separately made and attached to the figure.

32.

Standing figure

New Ireland
Wood (*Cordia sp.?*), parinarium fruit paste, shells, *Turbo petholatus*
 opercula, and pigment; 107″ × 23¼″ × 13″ (273 × 59 × 33 cm)
Literature: *Ferne Völker*, p. 176, no. B 39; Krämer, 1925, plate 53
Provenance: Governor Albert Hahl
Linden-Museum, Stuttgart, 1907

Ritual experts in New Ireland maintained elaborate traditions of
practices to control weather for crops and for ceremonial life.
Large hardwood figures, known in Tabar as *marumarua* of the *marada*
malagan tradition, stood in designated groves in the bush and
provided an activating force for producing rain or fair weather.
So-called rainmaker figures were often posed with one or both
arms extended, made separately and pegged in. Informants in the
Notsi area stated that a right hand extended was related to rain, the
left to sun. The pieces lack the decorative painting characteristic of
much northern New Ireland sculpture and have massive, distinctively
shaped heads. This example stands on a base with a fluted edge,
probably a *Tridacna* shell. He wears a *kapkap* ornament, and his
shoulders are crisscrossed with snakes. When the piece entered the
Linden-Museum, its place of collection was given as Kapsu, but
this was subsequently changed to Pores for unknown reasons.
Krämer gives the place of origin as Bol.

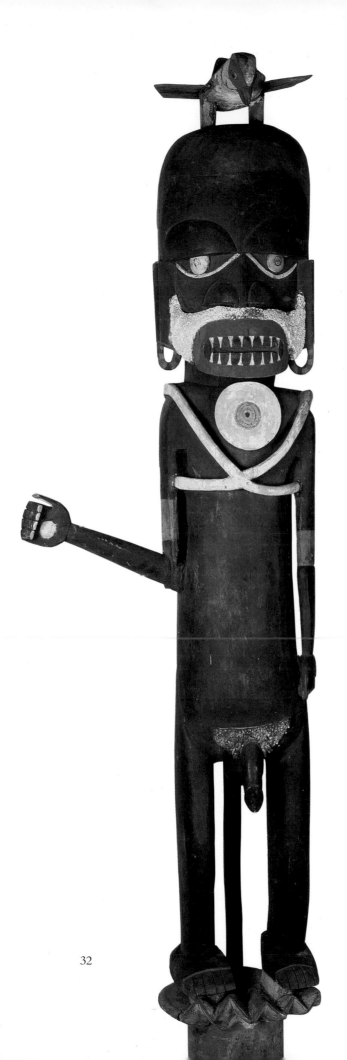

32

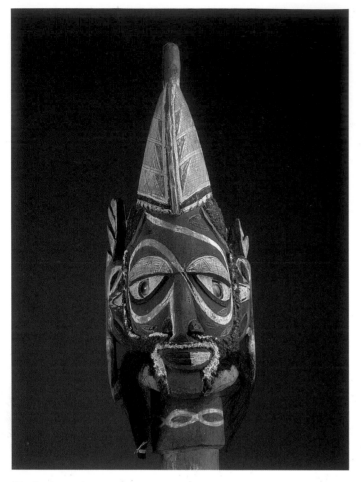

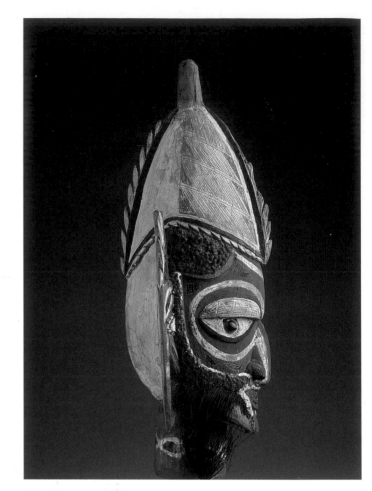

33, front

33, side

33.

Head from horizontal frieze

Northern New Ireland
Wood (*alstonia*), *Turbo petholatus* opercula, vegetable fiber,
 parinarium fruit paste, and pigment; 20¹¹⁄₁₆″ × 5⅞″ × 6⅛″ (52.5 ×
 15 × 15.5 cm)
Provenance unknown
Übersee-Museum, Bremen

This head from a horizontal board represents a female, because it is
wearing the peaked rain hat actually made of pandanus leaves and
worn only by women (Tabar *karuka*). That depiction notwith-
standing, it also sports a beard, which may allude to men taking
the roles of women in certain dances or may represent the kind of
ambiguity and transformation that appears so often in malagan
sculpture.

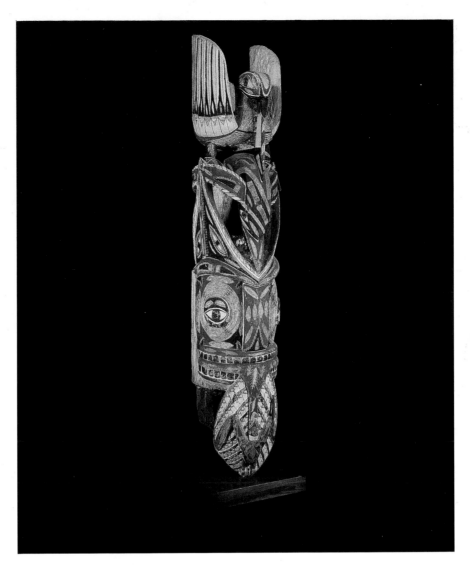

34

34.

Head

Northern New Ireland
Wood, *Turbo petholatus* opercula, and pigment; 64½″ × 15¾″ ×
 14⅛″ (164 × 40 × 36 cm)
Literature: McCarthy, 1945, p. 402; Spiegel, 1973, p. 141.
Provenance: Mrs. Farrell
The Australian Museum, 1892

The central image of this sculpture is a colossal anthropomorphic
head, holding in its mouth a highly stylized branch of betel nut.
Above the head a flying fish with a bird beak is bent into an arc and
surmounted by a large bird, probably a chicken. The head may
represent a *ges* spirit of the *malanggatsak* type. It was probably made
to be attached to a body formed from vines and other vegetable
material.

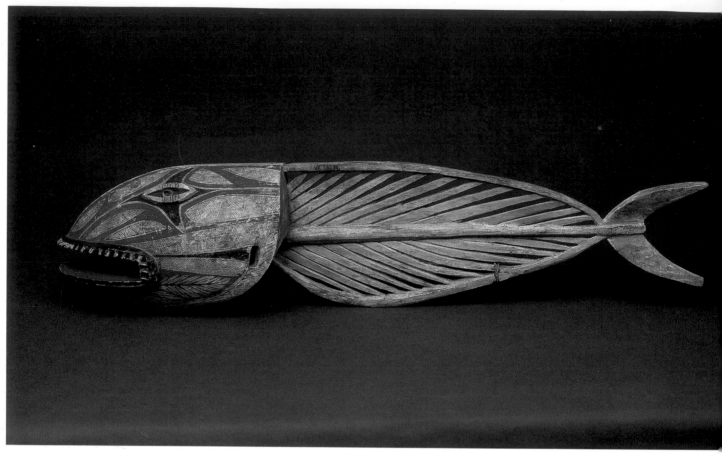

35

35.

Fish

Northern New Ireland
Wood (*alstonia*), *Turbo petholatus* opercula, and pigment;
 39⅜″ × 9″ × 6¹¹/₁₆″ (100 × 23 × 17 cm)
Provenance: collected by Friederici, 1909
Museum für Völkerkunde, Abt. Südsee, Staatliche Museen
 Preussischer Kulturbesitz, West Berlin

Although large fish sculptures exist in various collections, this
representation of a filleted fish may be unique. The carver has
disregarded anatomical accuracy in order to render the bones as a
radiating pattern (resembling the lower panel of cat. no. 25), which
a Nalik-area informant identified as a coconut-palm frond. The
large open mouth may have originally held a small human figure,
as does the well-known example in Stuttgart. The piece does not
exhibit a socket to be set on a pole and thus may have been carried
horizontally in a dance, as in Powdermaker's photo (*Life in Lesu*,
p. 120). Small slits on either side probably held tenoned fins, now
missing.

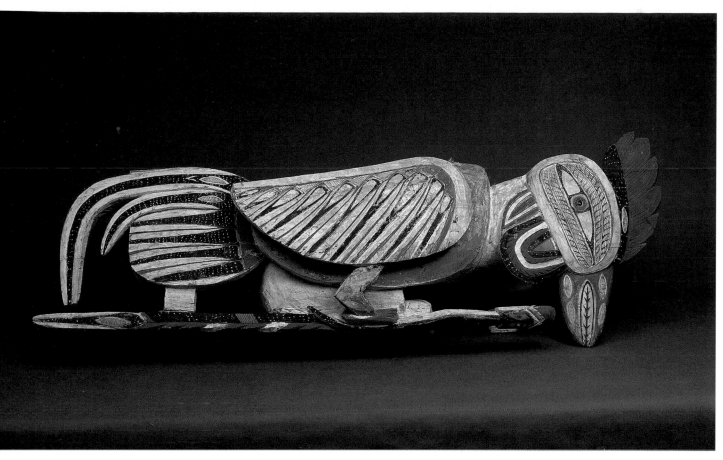

36

36.

Rooster frieze

Tabar Island, Feripats
Wood (*alstonia*), *Turbo petholatus* opercula, pigment, and remnants
 of chicken feathers; 48¾″ × 13″ × 16½″ (124 × 33 × 42 cm)
Provenance: collected by the Deutsche Marine-Expedition (Walden),
 1907–09
Museum für Völkerkunde, Abt. Südsee, Staatliche Museen
 Preussischer Kulturbesitz, West Berlin

This highly unusual rendering of a struggle between a rooster (Tabar
mi toa) and a snake may have been displayed on a pole as part of a
malagan ensemble, or it may have served as a head crest for a large,
standing figure. The undecorated parts of the body were formerly
covered with white chicken feathers. Bühler (1948, p. 20) notes the
importance of chickens in religious iconography and the use of
chicken feathers as highly significant decorative material.

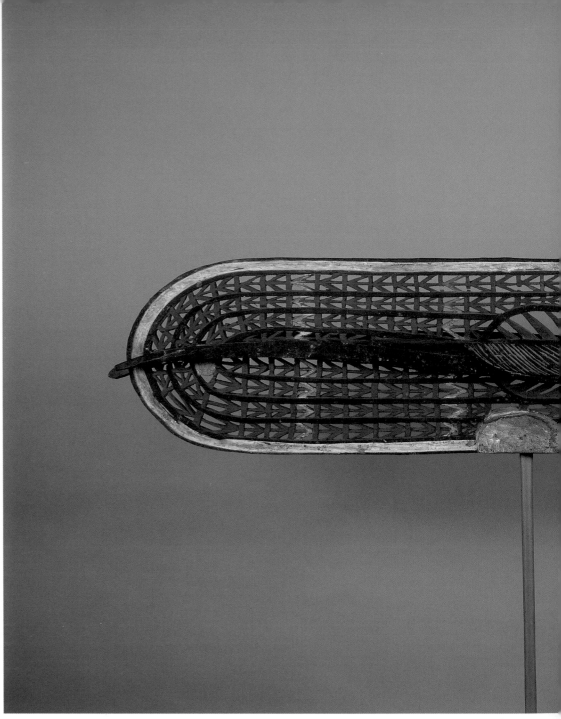

37

37.

Horizontal bird frieze

Northern New Ireland
Wood, glass bead, *Turbo petholatus* operculum, and pigment;
 36⅝″ × 7½″ × 4⅝″ (93 × 19 × 11 cm)
Literature: McCarthy, 1945: 400 (illus.)
Provenance: Captain Farrell
Australian Museum, Sydney, 1887

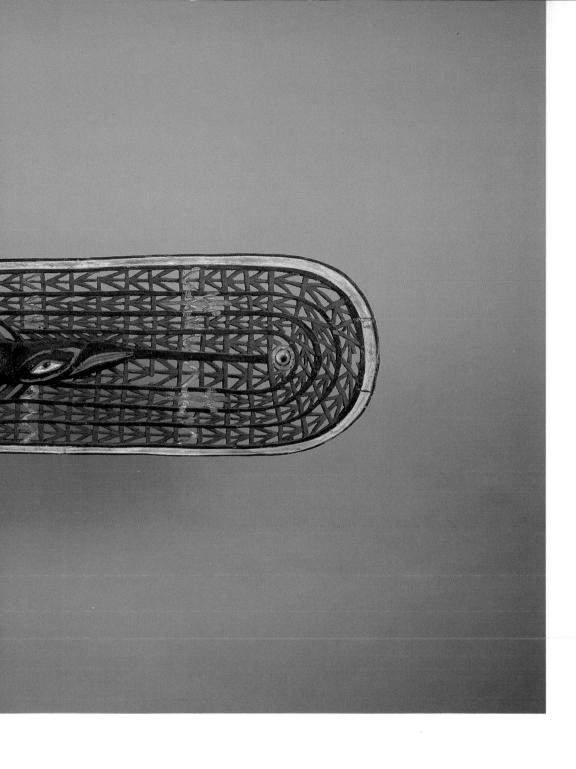

This rather unusual horizontal frieze would have been placed on a pole for display or pegged to the top of a standing figure. The subordination of the frigate bird figure to the openwork pattern, and the regularity of that pattern, are distinctive. Two small figures of birds or lizards are picked out of the latticework in white lime. Brouwer suggests that it may have originated in the Mandak language area, where such pieces are known as *wavarapeve*.

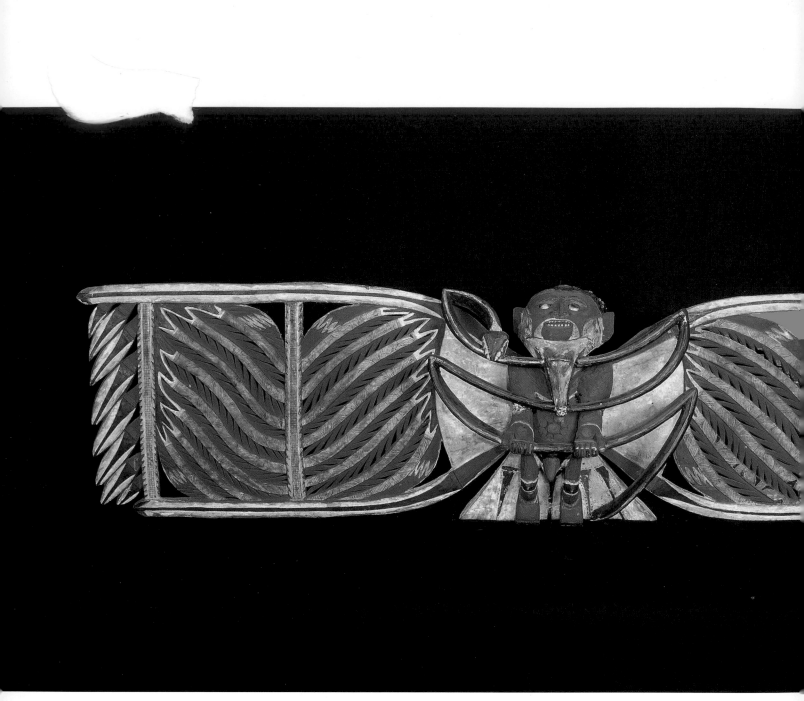

38.

Horizontal frieze

Northern New Ireland
Wood (*alstonia*), *Turbo petholatus* opercula, resin, and pigment;
　12⅝″ × 50″ × 4¾″ (32 × 127 × 12 cm)
Literature: *Ferne Völker*, p. 159, no. B 29
Provenance: Admiral Merten, 1904–07
Linden-Museum, Stuttgart

This panel bears an extremely close resemblance in carving and decoration to an example in Hamburg (see fig. 1) and may even be the work of the same hand. But a comparison of the two points up the importance of transformation motifs in malagan sculpture. Here the central figure has evolved from bird to human, the beak now a beard, the eyes now cheeks. He grasps the snake with his hands, his feet resting on the vestigial tailfeathers. As in the Hamburg example, the snake bites its own body, but certain details of the carving are different, and the small black birds atop the wings are missing.

39.

Horizontal frieze

Northern New Ireland
Wood (*alstonia*), *Turbo petholatus* opercula, and pigment; 9½″ ×
 30½″ × 6¼″ (24.1 × 77.5 × 15.9 cm)
Provenance: J. F. G. Umlauff
The Field Museum of Natural History, 1905

This piece has usually been interpreted as a bird and snake in struggle,
but may, like catalogue no. 38, represent instead a bat and snake. It
differs from the more commonly seen type in the sinuous rather
than angular treatment of the snake, and in the echoing curves of
the wings. The heavy line of black, a color associated with rain
and peace, enclosing the openwork portion of the wings is said to
contain the danger associated with the color red.

39

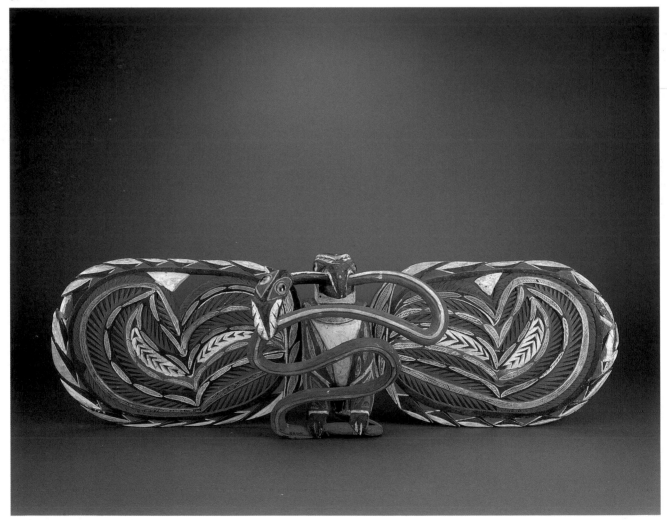

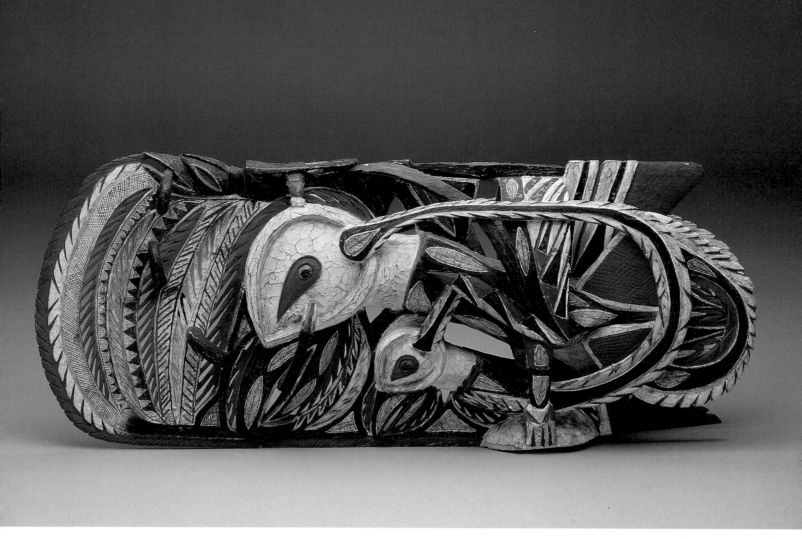

40

40.

Horizontal frieze

Northern New Ireland
Wood (*alstonia*), *Turbo petholatus* opercula, and pigment;
 39¼″ × 16″ × 5½″ (99.7 × 40.6 × 14 cm)
The Minneapolis Institute of Arts, 1985
 Gift of Bruce B. Dayton

A classic rendering of the New Ireland theme of birds and snakes
in struggle, this frieze depicts two chickens and a smaller frigate
bird (or *drongo*) compressed at the top edge, holding the tail of a
snake that undulates through the stylized foliage. The struggle
between birds and snakes is a common feature of sculpture and
dance performances; the snakes may be associated to *masalai*
animals, but the prevalence of the theme suggests that broader issues are
being addressed: the opposition of spheres of the cosmos, air and
earth, in a cosmic struggle. A similar piece is held in the collections
at Otago.

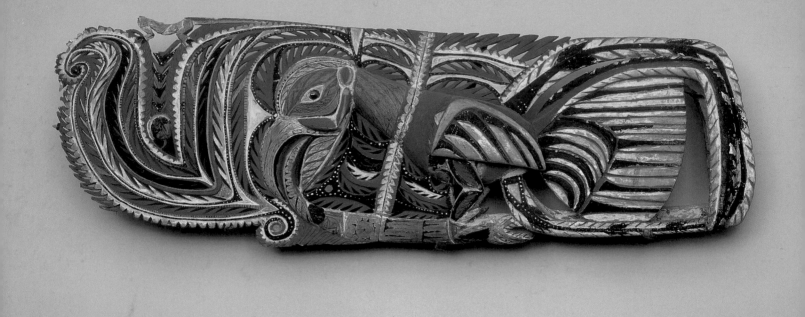

41

41.

Horizontal bird frieze

Northern New Ireland
Wood (*alstonia*), *Turbo petholatus* opercula, and pigment;
 40¼″ × 14″ × 3″ (102.2 × 35.6 × 7.6 cm)
Literature: Dwyer and Dwyer, *Traditional Art of Africa, Oceania,*
 and the Americas. The Fine Arts Museums of San Francisco, 1973.
Provenance unknown
The Fine Arts Museums of San Francisco, California Midwinter
 International Exposition, 1895

Horizontal bird friezes of this type frequently depict roosters, al-
though in this example the bird may be a parrot. The bird holds a
short, thick snake in its beak and claws. A small human figure, the
head now missing, appears at the upper edge of the front. The
piece appears to have been sawn and reattached in the field, with
the crack through the middle turned into a painted decorative band.
It is carved and painted on both sides, and was probably displayed
on a pole standing free.

41, detail ▷

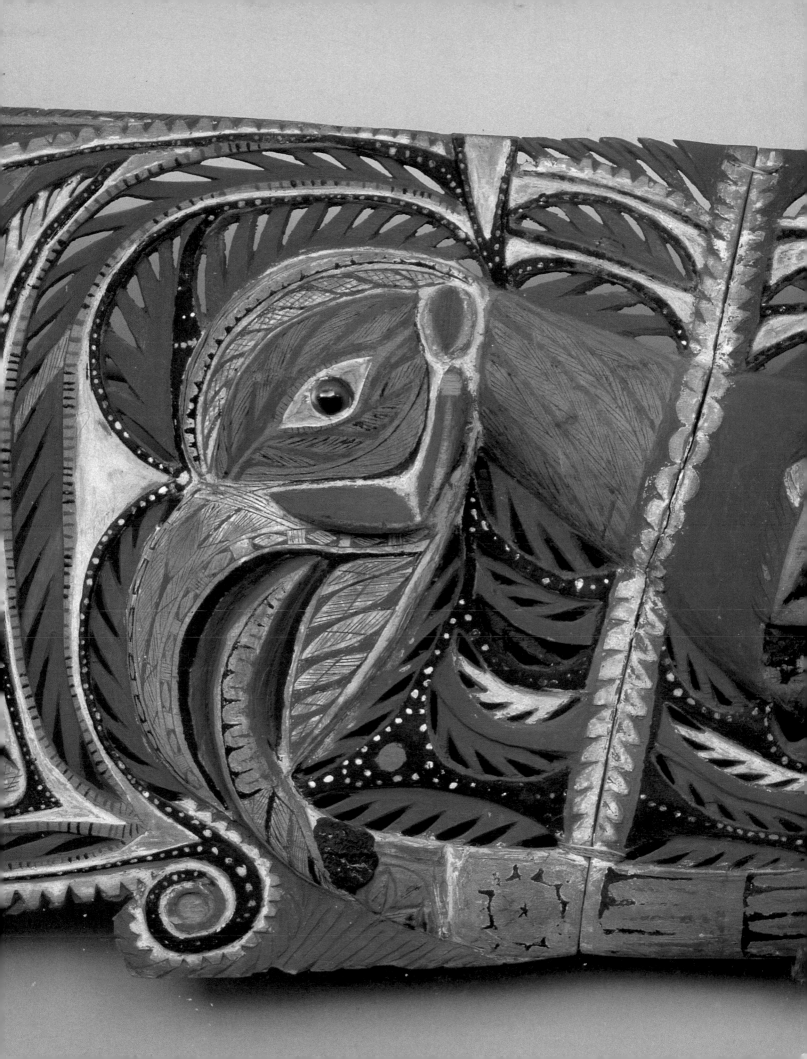

42.

Bird frieze

Northern New Ireland
Wood, *Turbo petholatus* opercula, and pigment;
 18½″ × 97″ × 9″ (47 × 246.4 × 22.8 cm)
Provenance: A. B. Lewis, 1909–13
The Field Museum of Natural History, 1913

Horizontal bird friezes of the type Krämer refers to as *selagot*
were frequently mounted on a pole and were intended to be
seen from any side; they were thus fully carved and painted.
This example is one of the largest versions of such friezes,
and there is an unusual degree of openwork in the rendering
of the tailfeathers. The bird represented is probably a chicken.

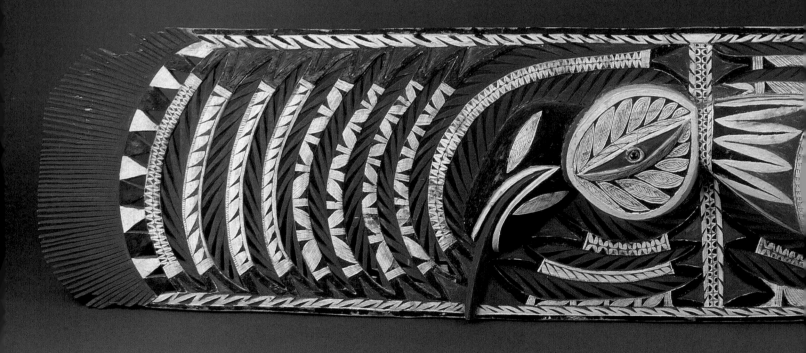

42

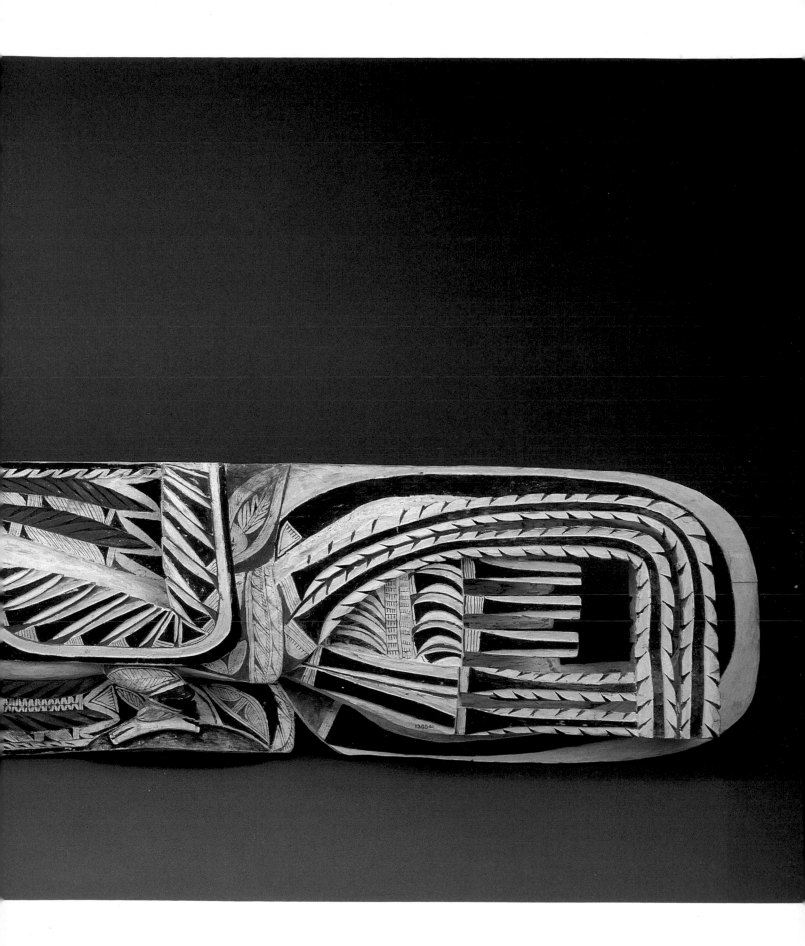

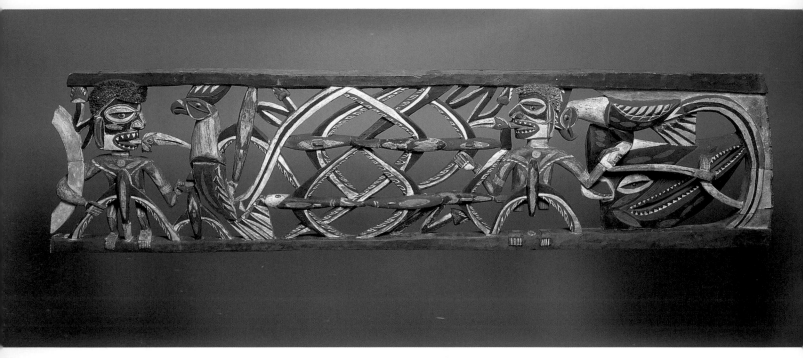

43

43.

Horizontal frieze fragment (possibly *kulepmu*)

Northern New Ireland
Wood (*alstonia*), parinarium fruit paste, *Turbo petholatus* opercula,
 and pigment; 21⅝″ × 86⅝″ × 3⅜″ (55 × 220 × 8.5 cm)
Provenance: Dr. Ludwig Cohn, about 1912
Übersee-Museum, Bremen

This fragment is probably slightly less than half of an unusually
large horizontal frieze, likely of the type with a large opening in
the middle (*kulepmu*). New Ireland informants believe that it predates
the colonial period. It is unusual also in its degree of openwork
and for its dramatic interlacing pattern. The end shows a boar head
surmounted by a rooster; the small human figures hold a hornbill
dance ornament in their mouths. The interlace is composed of
multiple figures of birds or flying fish, and the pattern they form
may also be intended to represent a fishnet held between the two
men. Groves provides extensive information about the symbolic
content of fishnets and about the religio-magical practices attached
to them. The corners of the net are filled by zigzagging snakes.
The piece was collected by Ludwig Cohn, a zoologist on the staff
of the Übersee-Museum, on a trip in the Bismarck Archipelago in
1912, possibly aboard the ship *Sumatra*. He may have acquired this
work in the port of Kavieng, or he may have purchased it from
Carl Nauer, captain of the *Sumatra*.

44.

Horizontal frieze

Northern New Ireland
Wood, *Turbo petholatus* opercula, and pigment; 66½″ × 14¼″ ×
 5½″ (168.9 × 36.2 × 14 cm)
Provenance: J. F. G. Umlauff
The Field Museum of Natural History, 1905

There are various descriptions in the literature of the use of friezes
with center openings. Some state that men and initiated boys would
thrust their heads through the hole during a ceremony, thus forming
a "living" malagan tableau. Others say that spears were thrown
through the opening. Informants in New Ireland uniformly in-
terpreted the scene on this example as birds drinking from a puddle
in the crotch of a tree, and one, seeing in this motif a theme of
harmony, suggested that such friezes were carried over the head
and supported on the shoulders of a man who walked between
warring factions, urging them to peace. The ends represent fish
heads, probably an allusion to ownership by a shore clan, but the
tailfeathers of the birds are lapped over the fish mouths in the same
way that boar tusks are usually represented, most likely as a
conscious allusion to another frequent image.

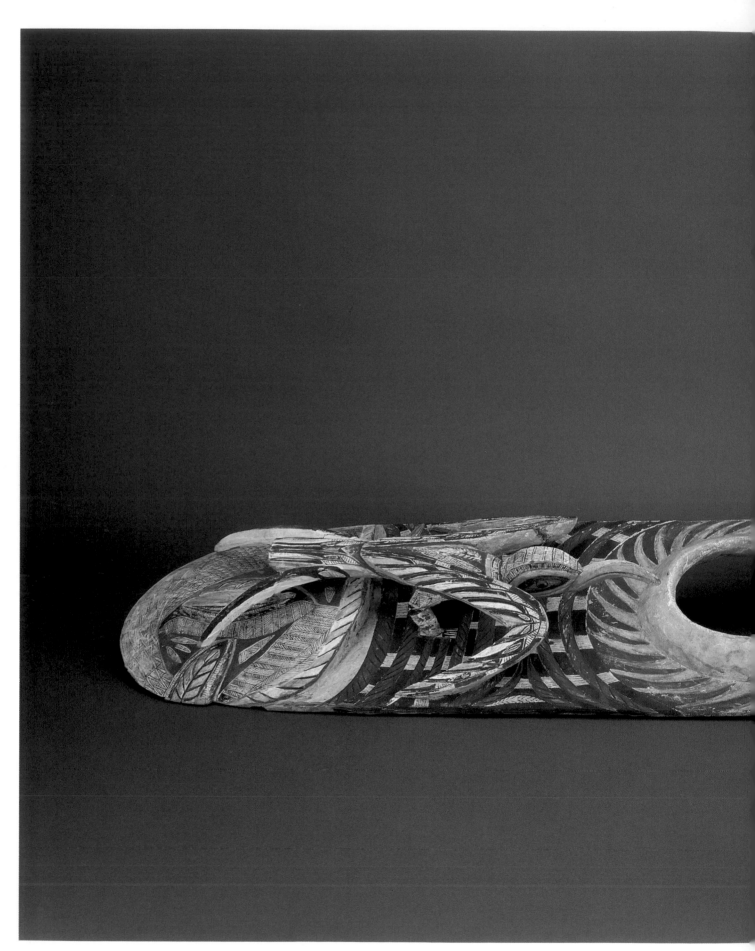

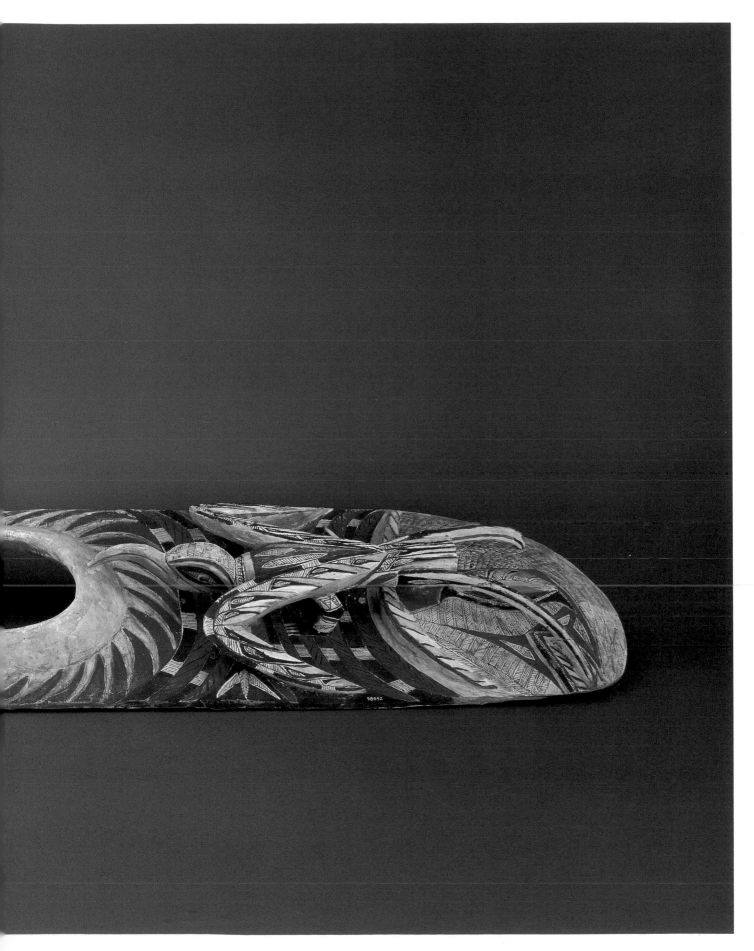

98592

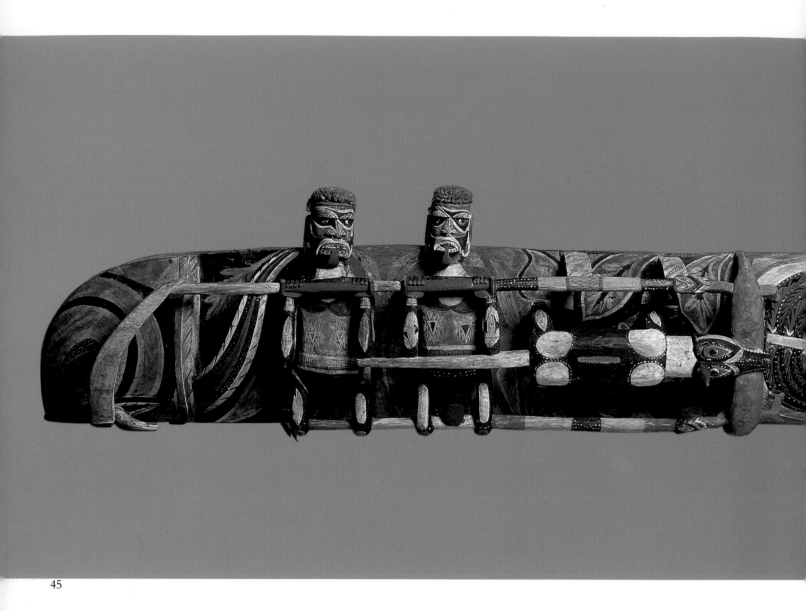

45

45.

Horizontal frieze, *walik*

Northern New Ireland.
Wood (*alstonia*), parinarium fruit paste, vegetable fibers, *Turbo
 petholatus* opercula, glass beads, and beeswax (?); 14⅜″ × 125³⁄₁₆″
 × 7⁵⁄₁₆″ (36.5 × 318 × 18.5 cm)
Provenance unknown
Übersee-Museum, Bremen

An excellent example of the *walik* type of malagan, with a complex
mataling (eye of fire) motif at the center, this pole shows fish heads
at the ends and thus presumably originated in a coastal clan. Paired
male and female figures, their heads made separately and attached,
rest their hands and feet on struts in the form of snakes, and two
long-tailed quadrupeds (possibly dogs or crocodiles) are opposed
at the center. From data gathered on Tabar, Gunn (personal com-
munication) designates this type of sculpture as *kobokobor si mi walik*.

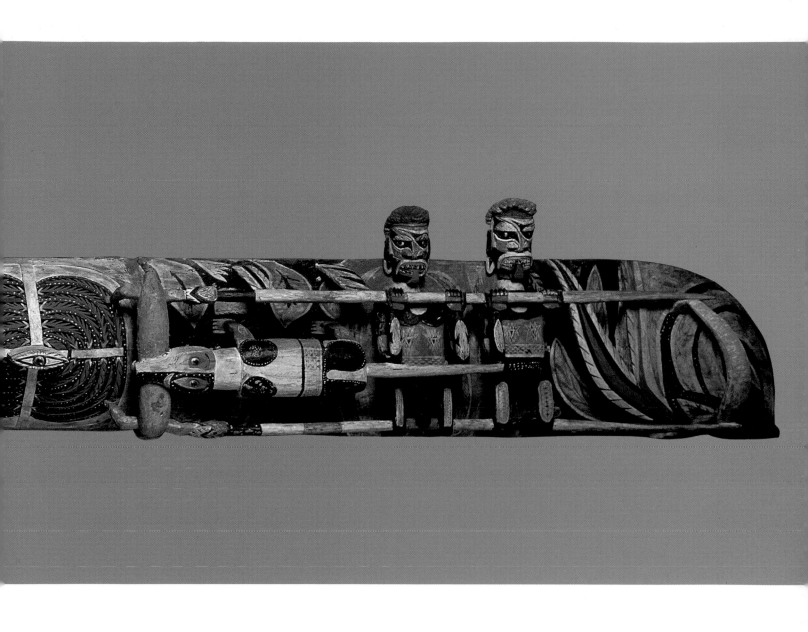

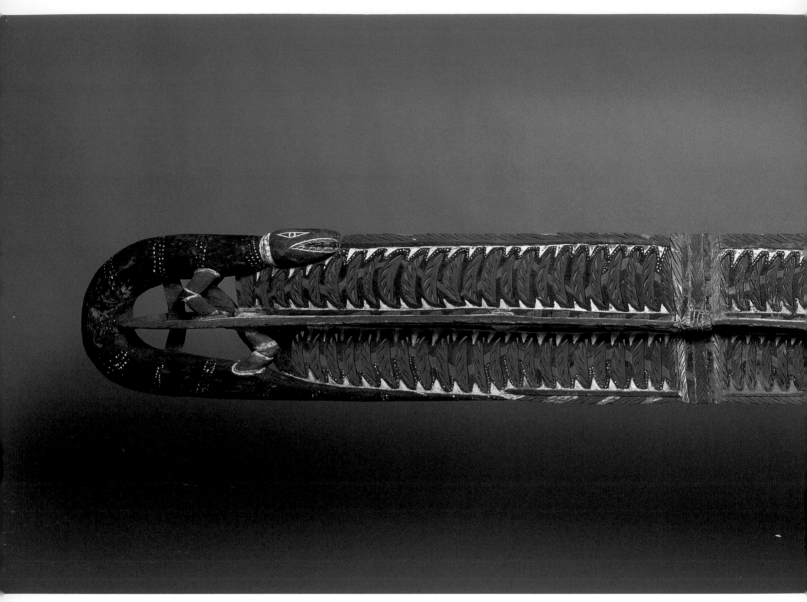

46

46.

Horizontal frieze

New Ireland
Wood (*alstonia*), *Turbo petholatus* opercula, and pigment;
 23⅝″ × 94⅛″ × 5¼″ (60 × 239 × 13 cm)
Provenance unknown
Übersee-Museum, Bremen

An unusual variant of the openwork board, this work terminates
at one end in a rooster with a separately made and attached head.

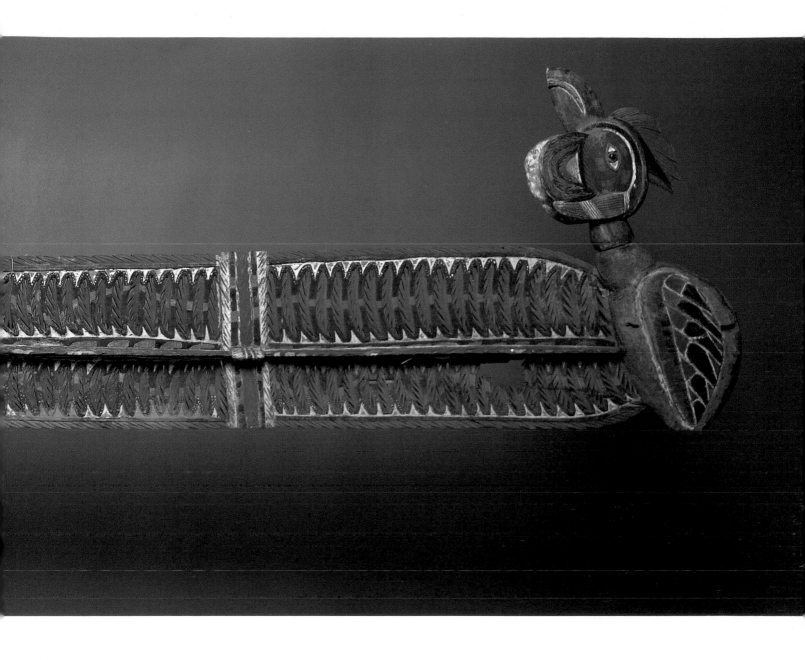

The animal at the other end resembles a lizard. Although lizards
appear on recent and contemporary malagan sculptures, they are
extremely rare on older examples. Informants in New Ireland
suggested that the animal was instead a *masalai* snake, its feet an
indication of its special liminal status. The composition may thus
be a variation of the more common types of bird-and-snake design.
The undulating painted pattern in the foliage is especially notable.

47.

Figure of a fish with vertical plank

Northern New Ireland
Wood (*alstonia*), *Turbo petholatus* opercula, and pigment;
 138⅜″ × 7½″ × 7⅛″ (352 × 19 × 18 cm)
Provenance unknown
Übersee-Museum, Bremen

This virtuoso piece combines large scale with exceptionally delicate
carving and decoration. The large fish, which Notsi-area informants
identified as a river species, *kusila*, holds in its mouth a board with
a pattern of eyes and comb-like devices in elaborate openwork.
The topmost portion is missing, but the pole probably terminated
in another animal, perhaps a bird. The overall conception may be
comparable to that of cat. no. 29.

47, detail

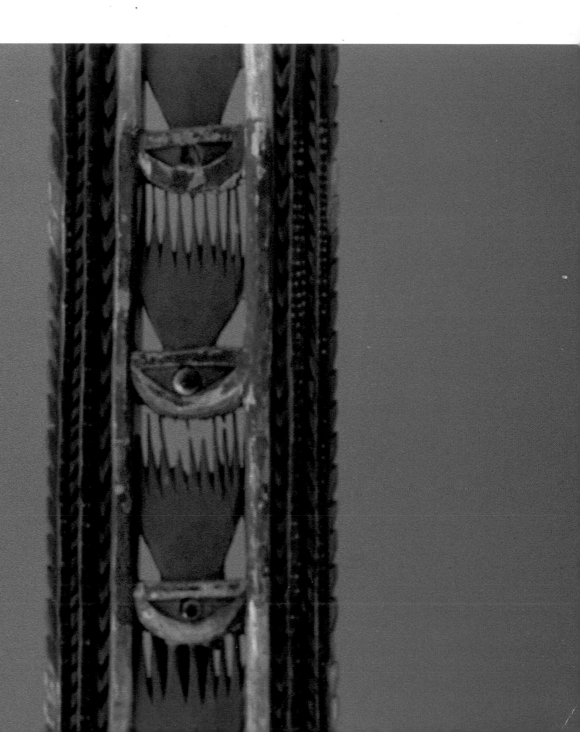

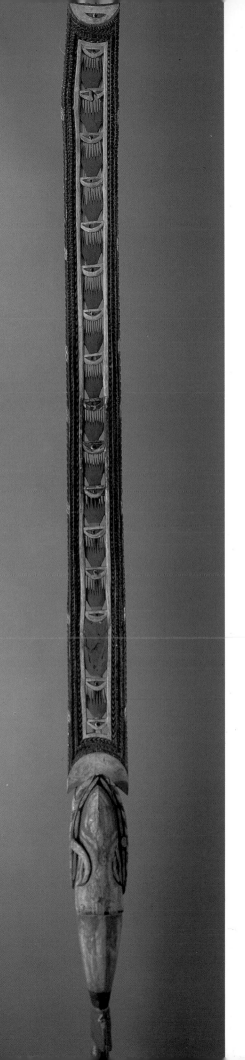

47

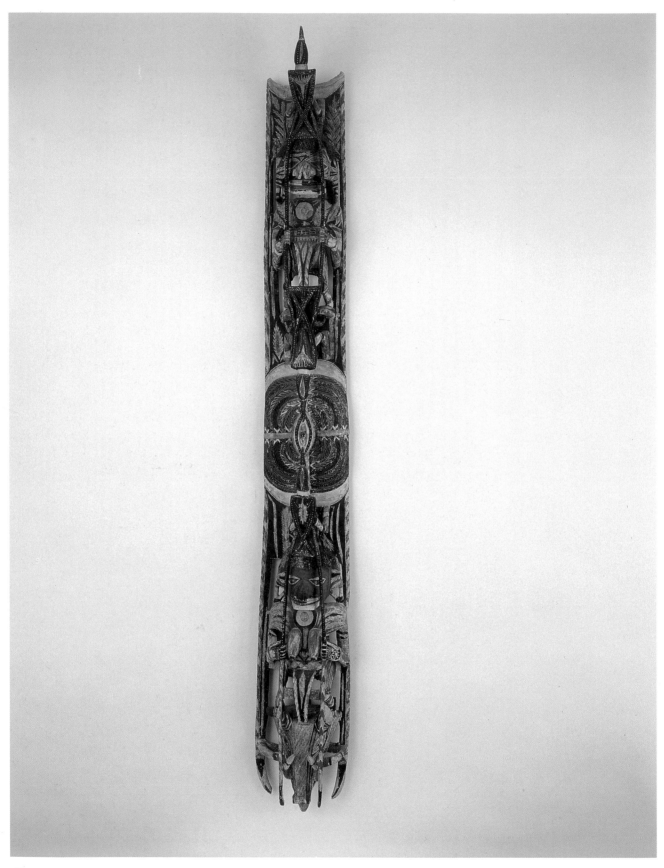

48

48.

Vertical pole

Northern New Ireland, possibly Tabar
Wood (*alstonia*), vegetable material, *Turbo petholatus* opercula, and
 pigment; 101″ × 10⅝″ × 7½″ (257 × 27 × 19 cm)
Literature: *Oceanic and African Art from the Heinrich Collection* (New
 York: Parke-Bernet Galleries, 21 October 1967), cat. no. 76; *Art
 at Auction: The Year at Sotheby's and Parke-Bernet* (New York,
 1967–68), p. 231; *Art Quarterly* (Autumn 1968), p. 313; *The
 Minneapolis Institute of Arts Bulletin* 57 (1968): 63, 78 (illus.);
 Schmitz, 1969, p. 246, pl. 179, color pl. 35; Lincoln, "Oceanic
 Art in the Collections of the Minneapolis Institute of Arts,"
 PAN (Pacific Arts Newsletter) 18: 11–12.
Provenance: Collected by S.M.S. *Seeadler*, 1912
 The Heinrich Collection, Stuttgart
 Parke-Bernet Galleries, New York
 J.J. Klejman, New York
 The Minneapolis Institute of Arts, 1967
 Gift of the Morse Foundation

This large *eikwar si mi walik* (Tabar) pole features a pair of figures,
male and female, and a large eye of fire (*mataling*) in the center.
The female figure stands on a pig head, which may connect the
piece to bush clans. Two frigate birds are counterposed over the
eye of fire, and their tail feathers, together with those of a third
bird at the top, form the enclosing struts typical of such openwork
poles. There is a small break at the top; the piece may originally
have extended beyond its present length. Traces of evanescent yellow
pigment can be seen in the crescents surrounding the eye of fire.
The decorative paint is exceptionally delicate and fine.

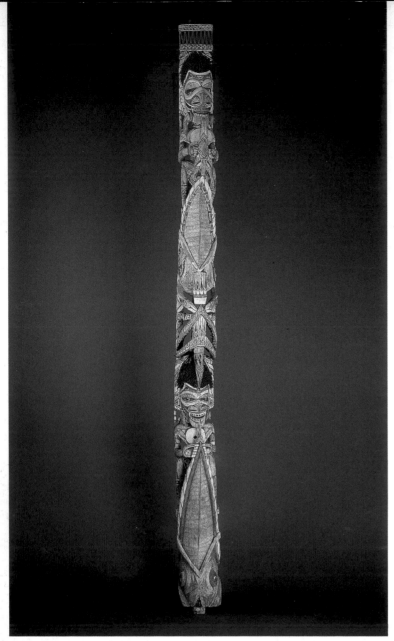

49

49.

Vertical pole

Northern New Ireland
Wood (*alstonia*), vegetable material, parinarium fruit paste, *Turbo
 petholatus* opercula, and pigment; 76¾″ × 5⅝″ × 5½″ (195 ×
 14.3 × 14 cm)
Provenance: J. F. G. Umlauff
The Field Museum of Natural History, 1905

This *eikwar* pole bears the repeating motif of the human figure
standing in a fish mouth. Unlike figures on some poles, these two
are not differentiated sexually. Both wear *kapkap* ornaments. Phillip
Lewis has suggested that the "muttonchop" whiskers sometimes
seen on malagan figures derive from the facial hairstyles of Germans
in the region in the late nineteenth century.

39, detail ▷

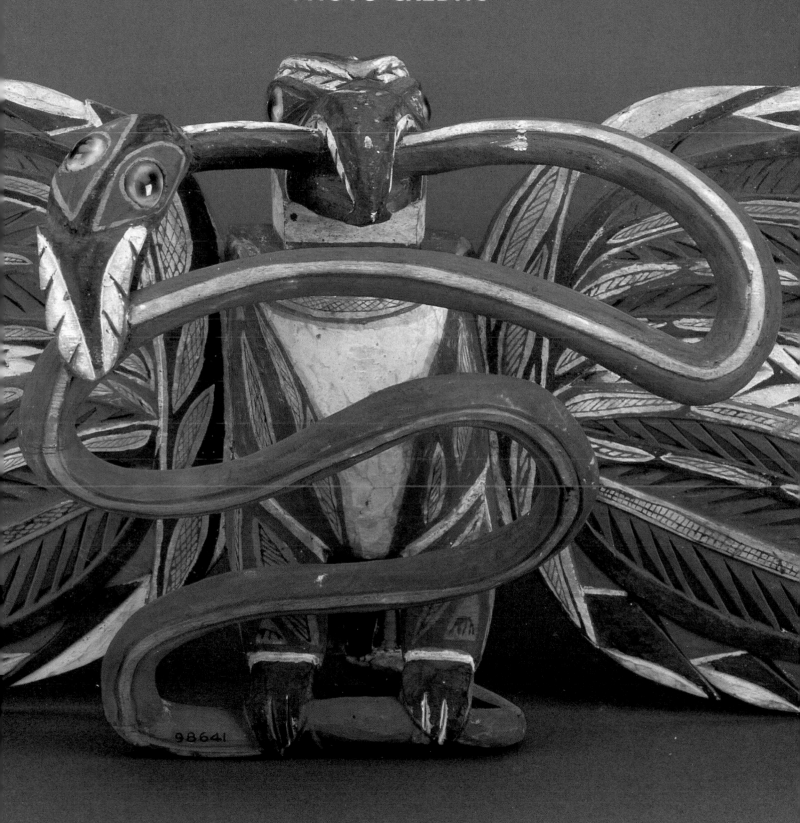

Bibliography

Albert, Steven M. "'Completely by Accident I Discovered its Meaning:' The Iconography of New Ireland Malagan." *Journal of the Polynesian Society* 95 (1986): 239–52.

Antze, Gustav. "Ahnenfiguren aus Kreide von Neu Mecklenburg." *Jahrbuch des städtischen Museums für Völkerkunde zu Leipzig* 4 (1910): 37–42.

Bell, F. L. S. "Courtship and Marriage Among the Tanga." *Mankind* 1, no. 12: 20.

———. "The Industrial Arts in Tanga." *Oceania* 19, no. 3 (1949): 206–33.

———. "Land Tenure in Tanga." *Oceania* 24: 28–57.

———. "Male and Female in Tanga." *Mankind* 5, no. 4 (1957): 137–48.

———. "The Place of Food in the Social Life of Tanga." *Oceania* 17: 139–72, 310–26.

———. "Report on Fieldwork in Tanga." *Oceania* 4: 290–309.

———. "Tattooing and Scarification in Tanga." *Man* 49 (1949): 29–31.

———. "Warfare Among the Tanga." *Oceania* 5: 253–79.

Billings, Dorothy. "Styles of Culture: New Ireland and New Hanover." Ph.D. diss., University of Sydney, 1972.

Billings, Dorothy, and Nicolas Peterson. "Malanggan and Memai in New Ireland." *Oceania* 38 (1967): 24–32.

———. "A Note on Two Archaeological Sites in New Ireland." *Mankind* 6, no. 6 (1965): 254–57.

Biskup, Peter, ed. *The New Guinea Memoirs of Jean Baptiste Octave Mouton.* Canberra: Australian National University Press, 1974.

Bodrogi, Tibor. *Art in North-East New Guinea.* Budapest: Hungarian Academy of Sciences, 1961.

———. "Kapkap in Melanesien." *Beiträge zur Völkerforschung.* Leipzig, 1961, pp. 50–65.

———. "Malangans in North New Ireland." *Acta Ethnographica Academiae Scientiarum Hungaricae* (Budapest) 16, nos. 1,2 (1967): 61–77.

———. *Oceanian Art.* Budapest: Corvina, 1959.

———. "The Religious Significance of the Malangan Rites in North New Ireland." *Muvelt Hagyomany* 13, no. 14: 127–40.

Braunholtz, H. J. "An Ancestral Figure from New Ireland." *Man* 27 (1927): 217–19.

Brouwer, Elizabeth. Review of *Malanggan I: Bildwerke von Neuirland,* by Klaus Helfrich. *Tribus* (1979): 205–6.

———. "A Malagan to Cover the Grave: Funerary Ceremonies in Mandak." Ph.D. diss., University of Queensland, 1980.

Brown, G. *George Brown, D. D. Pioneer, Missionary and Explorer—an Autobiography.* London: Hodder and Stoughton, 1908.

———. "A Journey Along the Coasts of New Ireland and Neighbouring Islands." *Proceedings of the Royal Geographical Society, London* 3 (1881): 213–320.

———. "Notes on the Duke of York Group, New Britain and New Ireland." *Proceedings of the Royal Geographical Society, London* 47 (1877): 137–50.

Bühler, A., T. Barrow, and C. P. Mountford. *The Art of the South Seas.* New York: Crown Publishers, 1962.

Bühler, Alfred. *Neuirland und Nachbarinseln.* Führer durch das Museum für Völkerkunde Basel; Basel, 1948.

———. *Oceania and Australia: The Art of the South Seas.* London: Methuen, 1962.

———. "Totenfeste in Nord Neuirland," *Verhandlungen der Schweizerischen Naturforschenden Gesellschaft* (Aarau) 114 (1933): 243–70.

Capell, A. "A Lost Tribe in New Ireland." *Mankind* 6, no. 10 (1967): 499–509.

Cayley, Webster H. *Through New Guinea and the Cannibal Countries.* N.p., 1898.

Chinnery, E. W. P. "Namatanai District." *Anthropological Report, Territory of New Guinea* 1 (1925): 60–63.

———. "Studies of the Native Population of the East Coast of New Ireland." *Anthropological Reports, Territory of New Guinea* 6 (1931).

Christiansen, S. "Tambu Stories of New Ireland." *Folk* (Dansk Etnografisk Tidsskrift) 6, no.2: 27–30.

Clay, Brenda. *Pinikindu: Maternal Nurture, Paternal Substance.* Chicago and London: University of Chicago Press, 1977.

———. *Mandak Realities: Person and Power in Central New Ireland.* New Brunswick: Rutgers University Press, 1986.

Clay, R. Berle. "The Persistence of Traditional Settlement Patterns: An Example from New Ireland." *Oceania* 43, no. 1 (1972): 40–53.

———. "Reconnaissance in Central New Ireland." *Archaeology and Physical Anthropology in Oceania* 9, no. 1 (1974): 1–17.

Coulter, J. *Adventures on the Western Coast of South America and the Interior of California, Including a Narrative of Incidents at the Kingsmill Island, New Ireland, New Guinea, and Other Islands of the Pacific.* London, 1847.

Cox, W. H. "New Ireland (New Mecklenburg) Myths." *Man* 13, no. 12 (1913): 195–99.

Dodge, Ernest S. *Islands and Empires: Western Impact on the Pacific and East Asia.* Minneapolis: University of Minnesota Press, 1976.

Duffield, A. J. "On the Natives of New Ireland." *Journal of the Royal Anthropological Institute of Great Britain and Ireland* 15 (1885): 114–21.

Edge-Partington, James. *An Album of Weapons, Tools, Ornaments, Articles of Dress of the Natives of the Pacific Islands.* 1880–1898. Reprint. London: Holland Press, (2 vols.), 1969.

Ferne Völker—Frühe Zeiten. Stuttgart: Linden-Museum, n.d.

Finsch, Otto. "Anthropologische Ergebnisse einer Reise in der Südsee." N.d.

———. *Etnologische Erfahrungen und Belegstücke aus der Südsee.* Vienna, 1893.

———. *Südseearbeiten.* Hamburg: L. Friedrichsen, 1914.

———. "Über die Ethnologischen," *Abteilungen der königlichen Museen zu Berlin* (1885–1886): 57–70.

Firth, Stewart. *New Guinea under the Germans.* Melbourne: Melbourne University Press, 1982.

Fischer, Hans. *Studien über Seelenvorstellungen in Ozeanien.* Munich, 1965.

Foy, W. "Schnitzereien von Neumecklenburg." *Etnologica Leipzig* 2, no. 1: 125–31.

———. "Tanzobjekte von Bismarck Archipel, Nissan und Buka." *Publikationen der königlichen ethnographischen Museum, Dresden* 13 (1900).

Führer durch die Sammlungen. Hamburg: Hamburgisches Museum für Völkerkunde, 1984.

Gifford, Philip C. "The Iconology of the Uli Figure of Central New Ireland." Ph.D. diss., Columbia University, 1974.

Giglioli, H. "Notes on a Remarkable and Very Beautiful Ceremonial Stone Adze from Kapsu, New Ireland." *International Archiv für Ethnographie* (Leiden) 3 (1890): 181–86.

Girard, M. "L'Importance Sociale et Religieuse des Cérémonies Exécutées pour les Malanggan Sculptés de Nouvelle-Irlande." *L'Anthropologie* 58: 241–67.

Godin, Patrice. "Note sur la Production des Malanggan en Nouvelle-Irlande de 1870 à 1914." *Journal de la Société des Oceanistes* 35, no. 65 (1979): 283–85.

Groves, W. C. "Fishing Rites at Tabar." *Oceania* 4: 432–57.

———. "Report on Fieldwork in New Ireland." *Oceania* 3: 325–61.

———. "Report on Fieldwork in the Territory of New Guinea from May 1933–August 1934." *Oceania* 5 (1934): 218–23.

———. "Secret Beliefs and Practices in New Ireland." *Oceania* 7, no. 2 (1936-1937): 220–45.

———. "Settlement of Disputes in Tabar." *Oceania* 4 (1933–1934): 501–19.

———. "Sharkfishing in New Ireland." *Mankind* 2 (1936): 2–6.

———. "Tabar Today: A Study of a Melanesian Community in Contact with Alien Non-Primitive Cultural Forces,"*Oceania* 5, no. 2 (1934–1935): 224–40; 5, no. 3: 346–60; 6: 147–57.

Gunn, Michael. "Rock Art on Tabar, New Ireland Province, Papua New Guinea," *Anthropos* 81 (1986).

———. "Tabar Malagan." *Bulletin of the COMA* 12 (1983): 30–32.

———. "Tabar Malagan—An Outline of the Emic Taxonomy." In *Development of the Arts in the Pacific*, edited by Philip Dark. Wellington: Pacific Arts Association, 1984.

Hahl, Albert. *Gouverneursjahre in Neu Guinea*. Berlin: Frundsberg Verlag, 1937.

Hall, H. U. "Malagan of New Ireland." *University of Pennsylvania Museum Journal* 5, no. 4 (1935): 2–11.

———. "New Ireland Masks." *University of Pennsylvania Museum Journal* 10, no. 4 (1919).

Hartwig, Werner. "Anfänge der Warenproduktion im Südöstlichen Bismarck-Archipel in den Letzten Jahrzehnten des 19. Jahrhunderts." Vol. 2, *Veröffentlichungen des Museums für Völkerkunde zu Leipzig*. Berlin: Akademie-Verlag, 1961.

Heintze, Dieter. *Ikonographische Studien zur Malanggan Kunst Neuirlands*. Ph.D. diss., Eberhard-Karls-Universität, Tübingen, 1969.

Helfrich, Klaus. *Malanggan 1: Bildwerke von Neuirland*. Berlin: Museum für Völkerkunde, 1973.

Hempenstall, Peter J. *Pacific Islanders under German Rule: A Study in the Meaning of Colonial Resistance*. Canberra: Australian National University Press, 1978.

Hernsheim, Eduard. *South Sea Merchant*. Edited and translated by Peter Sack and Daphne Clark. Boroko: Institute of Papua New Guinea Studies, 1983.

———. *Südsee Erinnerungen*. Berlin: 1883.

Hesse, Irene. *Die Darstellung der menschlichen Gestalt in Rundskulpturen Neumecklenburgs*. Cologne: 1933.

Jessep, Owen. "Land and Spirits in a New Ireland Village." *Mankind* 12, no. 4 (1980): 300–310.

———. "Land Tenure in Barok, New Ireland." Ph.D. diss., Australian National University, 1977.

Kerchache, J. *Iles Tabar*. Paris, 1971.

Krämer-Bannow, Elisabeth. *Bei Kunstsinnigen Kannibalen der Südsee. Wanderungen auf Neu-Mecklenburg 1908–1909*. Berlin: Verlag Dietrich Reimer, 1916.

Krämer, Augustin. *Die Malanggane von Tombara*. Munich: Georg Müller, 1925.

———. "Tombaresisches, Altes und Neues." *Anthropos* 22 (1927): 803–10.

Kuechler, Susanne. "The Malangan of Nombowai." *Oral History* 11, no. 2 (1983): 65–98.

Lacey, Rod. "Our Young Men Snatched Away: Labourers in Papua New Guinea's Colonial Economy, 1884–1942." University of Papua New Guinea, Occasional Papers in Economic History, No. 3.

Laufer, Carl M. S. C. *Missionar und Ethnologe auf Neu Guinea: eine Gedenkschrift*. Freiburg: 1975.

Leach, Edmund R. "The Artist in New Ireland Society: A Second Comment." In *The Artist in Tribal Society*, edited by Marian W. Smith. New York: Free Press of Glencoe, 1961.

Lewis, Phillip H. "Art in Changing New Ireland." In *Exploring the Visual Art of Oceania: Australia, Melanesia, Micronesia, and Polynesia*, edited by Sidney M. Mead. Honolulu: University Press of Hawaii, 1979.

———. "The Artist in New Ireland Society: A Second Comment." In *The Artist in Tribal Society*, edited by Marian W. Smith. New York: Free Press of Glencoe, 1961.

———. "Changing Memorial Ceremonies in Northern New Ireland." *Journal of the Polynesian Society* 82, no. 2 (1973): 141–53.

———. "New Ireland: Coming and Going, 1970." *Field Museum of Natural History Bulletin* (Chicago) 42, no. 8 (1971).

———. "A Note on a Friction Drum from Ambwa, New Ireland." *Abhandlungen und Berichte des Staatlichen Museum für Völkerkunde* 34 (1975): 581–92.

———. "A Sculptured Figure With a Modelled Skull from New Ireland." *Man* 64, no. 176 (1964): 133–36.

———. "The Social Context of Art in Northern New Ireland." *Anthropology* 58 (1969), Chicago: Field Museum of Natural History.

Ligvaet, A. "An Interesting Musical Instrument from New Ireland." *Antiquity and Survival* (the Hague) 1 (1955): 299–302.

Linton, R., and P. S. Wingert. *Arts of the South Seas*. New York: Museum of Modern Art, 1946.

Lithgow, D., and O. Claessen. *Languages of the New Ireland District*. Port Moresby: Dept. of Information and Extension Services, 1968.

Lomas, P. W. "Malanggans and Manipulators: Land and Politics in Northern New Ireland." *Oceania* 50, no. 1 (1979): 53–65.

———. "The Early Contact Years in Northern New Ireland: From Wild Frontier to Plantation Economy. *Ethnohistory* 28, no. 1(1981): 1–21.

McCarthy, F.O. "The Art of Malanggan in New Ireland." *Australian Museum Magazine* 8 (1945): 396–405.

———. "The Malangan Masks of New Ireland." *Australian Museum Magazine* 9 (1946): 50–56.

———. "Melanesian Kapkaps." *Australian Museum Magazine* 9 (1946): 81–86.

Meier, J. "Der Totemismus im Bismarck-Archipel Melanesia Südsee." *Anthropos* 14–15 (1919–1920): 532–42.

Messner, Florian. "Sind die auf Neu-Irland verwendeten Zeichen und Symbole Ideogramme?" *Wiener Völkerkundliche Mitteilungen* 21–22 (1979–1980): 49–52.

Meyer, A. B. "Masken von Neu Guinea und dem Bismarck Archipel Zoologisches und Anthropologischen Ethnographisches Museum." *Publikationen aus dem königlichen ethnographischen Museum zu Dresden* 7 (1889): 1–14.

Neuhaus, P. K. "Beiträge zur Ethnographie der Palau, Mittel-Neu Irland aus dem Nachlassbearbeitung von P. C. Laufer und Carl G. Schmitz." *Kölner ethnologische Mitteilungen* 2 (1962).

Neuhauss, R. *Deutsch Neu-Guinea.* Berlin: 1911.

Nevermann, Hans. "Tiergeschichten und mythische Stammbäume aus Neumecklenburg aus dem Nachlass Augustin Krämers." *Zeitschrift für Ethnologie* 81 (1956): 180–87.

———. "Totenfeiern und Malagane von Nord-Neumecklenburg. Nach Aufzeichnungen von E. Walden." *Zeitschrift für Ethnologie* 72 (1940): 11–38.

Panoff, Michel. "Travailleurs, recruteurs et planteurs dans l'Archipel Bismarck de 1885 à 1914." *Journal de la Société des Oceanistes* 35, no. 64 (1979): 159–73.

Parkinson, Richard. *Dreissig Jahre in der Südsee. Land und Leute, Sitten und Gebräuche im Bismarckarchipel und auf den Deutschen Salomoinseln.* Stuttgart: Strecker & Schröder, 1907.

———. "Über Tattowierung der Eingebornen in District Siarr auf der Ostkuste von Neu Mecklenburg." *Internationales Archiv für Ethnographie* (Leiden) 5 (1892): 76–78.

Parkinson, R. and A. B. Meyer. "Schnitzereien und Masken von Bismarck–Archipel und Neu–Guinea." *Zoologisches und Anthropologisch–Ethnographisches Museum, Dresden,* no. 10 (1985).

Peekel, Gerhard. "Die Ahnenbilder von Nord-Neu-Mecklenburg. Eine kritische und positive Studie." *Anthropos* 21 (1926): 806–24; 22 (1927): 16–44.

———. "Lang-Manu. Die Schlussfeier eines Malagan-(Ahnen-)festes auf Nord-Neu-Mecklenburg." In *Festschrift für P.W. Schmidt,* edited by W. Koppers (Vienna: 1928), 542–55.

———. *Religion und Zauberei auf dem Mittleren Neu-Mecklenburg, Bismarck-Archipel, Südsee.* Parts 1,2. Münster: Anthropos-Bibliothek 1, 3 (1910).

———. "Religiöse Tänze auf Neu-Irland (Neu-Mecklenburg)." *Anthropos* 26 (1931): 513–32.

———. "Uli und Ulifeier; oder, Von Mondkultus auf Neu Mecklenburg." *Archiv für Anthropologie* 51: 41–75.

———. "Das Zweigeschlechterwesen." *Anthropos* 24 (1929): 1005–72.

Peter, Hans. "Ritueller Haifang auf Neuirland." *Wiener Völkerkundliche Mitteilungen* 28, no. 23 (1981): 9–14.

Pfeil, Joachim Graf. *Studien und Beobachten aus der Südsee.* Braunschweig: Wieweg und Sohn, 1899.

Powdermaker, Hortense. "The Artist in New Ireland: A Comment." In *The Artist in Tribal Society,* edited by Marian W. Smith. New York: Free Press of Glencoe, 1961.

———. "Feasts in New Ireland: The Social Function of Eating." *American Anthropologist* 34, no. 5 (1932): 236–47.

———. *Life in Lesu.* London: Williams and Norgate, 1933.

———. "Mortuary Rites in New Ireland." *Oceania* 2, no. 1 (1931–1932): 26–43.

———. "Report on Research in New Ireland." *Oceania* 1 (1930): 355–65.

Romilly, H.H. *The Western Pacific and New Guinea.* London: John Murray, 1886.

Salisbury, R. F. *From Stone to Steel: Ceremonial Consequences of a Technological Change in New Guinea.* Melbourne: Melbourne University Press, 1962.

Schmitz, Carl. *Oceanic Art: Myth, Man and Image in the South Seas.* New York: Harry Abrams, 1971.

Schnee, Heinrich. *Bilder aus der Südsee.* Berlin: D. Reimer, 1904.

Skinner, H. D. "The Bird-Contending-with-Snake as an Art Motive in Oceania." *Records of the Otago Museum: Anthropology* no. 2. Dunedin, New Zealand, 1966.

Smith, Bernard. *European Vision and the South Pacific: 1768–1850.* Oxford: Clarendon Press, 1960.

Spiegel, H. "Some Aspects of New Ireland Malanggan Carving." Parts 1, 2. *Archaeology and Physical Anthropology in Oceania* 8, (1972): 2: 134–61; 3 : 194–219.

Stephan, Emil, and Fritz Graebner. *Neu-Mecklenburg (Bismarck-Archipel); die Küste von Umuddu bis Kap. St. Georg; Forschungsergebnisse bei den Vermessungsfahrten von S.M.S. Möwe im Jahre 1904.* Berlin: Dietrich Reimer, 1907.

Stephan, Emil. *Südseekunst.* Berlin: Dietrich Reimer, 1907.

Sydow, Eckart von. *Die Kunst der Naturvölker und der Vorzeit*. Berlin: Propyläen-Verlag, 1932.

Tasman, Abel Janszoon. *The Voyages of Abel Janszoon Tasman*. Edited by Andrew Sharp. Oxford: Clarendon Press, 1968.

Turukai, G. "The Malanggan Ceremony." *Oral History* 4 (1973): 43–45.

Vargyas, Gabor. *Data on the Pictorial History of Northeast Papua New Guinea. Occasional Papers in Anthropology 1*. Budapest: Ethnographical Institute, 1986.

Vogel, Hans. *Eine Vorschungsreise im Bismarck-Archipel*. Hamburg: L. Friedrichsen, 1911.

Wagner, Roy. "Cultural Artifacts at Omara and Kistobu Caves." *Oral History* 8, no. 8 (1980): 59–66.

——— . *Asiwinarong: Ethos, Image, and Social Power among the Usen Barok of New Ireland*. Princeton: Princeton University Press, 1986.

Walden, E. "Totenfeiern und Malagane von Nord Neu-Mecklenburg." *Zeitschrift für Ethnologie* (Berlin) 72 (1941): 11–38.

Wawn, William T. *The South Sea Islanders and the Queensland Labour Trade*. London: Swan Sonnenschein, 1893.

Weiner, Annette B. *Women of Value, Men of Renown*. Austin: University of Texas Press, 1976.

White, J. P. "Carbon Dates from New Ireland." *Mankind* 8, no. 4 (1972): 309–10.

Wilkinson, N. "Carving a Social Message: The Malanggans of Tabar." In *Art in Society*, edited by Michael Greenhalgh and Vincent Megaw. New York: St. Martin's Press, 1978, pp. 227–41.

Wilson, Lindsay, "The Panamecho Carvings, New Ireland." *Niugini Caver* 4 (1976): 47–54.

Wingert, Paul S. *Art of the South Pacific Islands*. London: Thames and Hudson, 1953.

Wolf, S. "Bemerkungen zu den Neuirlandischen Reibhölzerer der Völkerkundisches Museum Dresden von Leipzig." *Jahrbuch der Leipzig Museum für Völkerkunde* 17 (1958): 52–66.

Yayii, Phillip Lamasisi. "Some Aspects of Traditional Dance Within the Malanggan Culture of North New Ireland." *Bikmaus* 4 (1983): 33–47.

Photography Credits

Numbers are for catalogue entries.

Ric Bolzan: 27, 34, 37

Ursula Didoni: 32, 38

William Lyall: 14

Jim Medley: 16, 41

Gary Mortensen: 2, 4–11, 15, 17–20, 22, 24–26, 28, 30, 31, 33, 35, 36, 40, 43, 45–48

Mark Sexton: 1, 12, 21

Ron Testa and Diane White: 3, 23, 39, 42, 44, 49

Richard Todd: 13, 29